Brain of the Earth's Body

Brain of the Earth's Body

ART, MUSEUMS, AND THE PHANTASMS OF MODERNITY

The 2001 Slade Lectures
in the Fine Arts
Oxford University

Donald Preziosi

University of Minnesota Press
Minneapolis / London

Published by the University of Minnesota Press
111 Third Avenue South, Suite 290
Minneapolis, MN 55401-2520
http://www.upress.umn.edu

Library of Congress Cataloging-in-Publication Data

Preziosi, Donald, 1941–
 Brain of the earth's body : art, museums, and the phantasms of modernity /
Donald Preziosi.
 p. cm.
 "The 2001 Slade Lectures in the Fine Arts, Oxford University."
 Includes bibliographical references and index.
 ISBN 0-8166-3357-6 — ISBN 0-8166-3358-4 (pbk.)
 1. Art—Historiography. 2. Aesthetics. 3. Art museums—
Philosophy. I. Title: Art, museums, and the phantasms of modernity. II. Title.
 N380 .P67 2003
 700'.1—dc21

 2003004995

Printed in the United States of America on acid-free paper

The University of Minnesota is an equal-opportunity educator and employer.

12 11 10 09 08 07 06 05 04 03 10 9 8 7 6 5 4 3 2 1

Contents

Preface

Brain of the Earth's Body is a series of essays based on the Slade Lectures in the Fine Arts I delivered at Oxford University during Hilary Term, 2001, while a visiting fellow of All Souls College during 2000–2001. The essays are substantially the same as the eight weekly spoken lectures (with the addition of notes where appropriate), and they represent an ongoing meditation on the evolution and current state of the interwoven discourses of art history, aesthetics, ethics, and museology. They divide roughly into two parts, the first four laying theoretical, historical, and methodological foundations for the subsequent "case study" investigations of a number of museums and exhibitionary institutions in Britain and Egypt.

Since their inauguration by John Ruskin in 1870 (in the same auditorium in the Oxford Museum of Natural History where my talks were delivered), the Slade Lectures commonly have not included audience discussion and questions; during 2001, however, by audience request and owing in part to the somewhat controversial nature of the talks, a unique special seminar was added to the final lecture so that some of the many issues raised during the series could be addressed and discussed. As well as reflecting this exchange with the audience, several of the essays echo earlier articles and lectures and build on them in the light of discussions, commentaries, and debates with many colleagues and students in Europe and North America.

The fifth essay, "The Astrolabe of the Enlightenment," a detailed analysis of the organization and functions of Sir John Soane's Museum in London, is a kind of centerpiece around which the series of lectures revolves, in both centripetal and centrifugal ways. This essay both exemplifies the theoretical and historical narratives surrounding the museum and constitutes a material perspective or belvedere on the latter. It offers a way out of the current impasse in which art history, museology, and aesthetic philosophy have found themselves. It has for me a double significance, marking my own personal involvement with the history of museums and museology some years ago as well as being a springboard to an investigation begun as a result of completing these lectures, which is hinted at in the final essay, "The Limit(s) of (Re)presentation" (which I called "Representation and Decorum" in the lectures as delivered).

It is of course difficult to capture the spirit of the lectures as delivered, despite the retention here of much of the same language and conversational tone. In addition, the lectures were accompanied by an ongoing series of slides and overhead transparencies, which usually bore complex relationships to the spoken text. In some cases, the images were indexical in nature, referring directly to the spoken subject, while other sequences of images bore ironic and interrogative connections to the text or ran in parallel and in complementary fashion to what was being heard. Often two images were on the screen throughout the lecture, and in many cases these juxtapositions had a great deal of significance in the context of the spoken text. Very little of this will be apparent here, given the constraints of publication; what is put forth in this book is a reduction of an originally oral and visual presentation, in which ideas and issues were brought out on several fronts, reflecting my usual mode of university lecturing.

These chapters also include a modicum of useful references. A number of the images from the talks are reproduced, but these represent less than one-tenth of what the Oxford audience saw. As the lectures were open to the general public, the Slade audience was diverse, consisting of colleagues and students from a number of academic disciplines but also a fair proportion from Oxford and the general area without such affiliations.

Brain of the Earth's Body was not the general title of the Slade Lectures, which were delivered under the title *Seeing through Art History.* The former title has been hovering about in a number of my earlier publications, often found in notes referencing a "forthcoming volume"

originally intended as a sequel to my book *Rethinking Art History: Meditations on a Coy Science* (1989) and conceived during a graduate seminar with a remarkable group of UCLA students in art history, comparative literature, history, philosophy, anthropology, and cinema from 1989 to 1991, many of whom have subsequently published extensively on these and related subjects. These Slade Lectures, then, may be seen as the result of an ongoing rethinking of *Rethinking Art History,* an unraveling and reexamination of a number of discussions and conclusions along with an evaluation of its reception.

Brain of the Earth's Body represents one frozen moment in this process. It works through much of the reconsiderations of the academic discipline of art history in the wake of *Rethinking Art History* and its parallel and complementary critical literature, including the essays in my more recent volume *The Art of Art History: A Critical Anthology* (1998). Taken as a whole, the present text works toward a new beginning, beyond what I have characterized as the essentially deponent and mutually codeterminant and codependent discourses of art history, museology, ethics, and aesthetics. It will become apparent that the text seeks an opening onto an understanding not only of what it was that academic art history replaced but also of what the modern invention of "art" per se suppressed, obscured, and transformed in European culture. *Brain of the Earth's Body,* then, is intended to lead the reader (in the manner that *Seeing through Art History* as a lecture series was intended to lead its listeners) to a reconsideration of traditional notions of artifice, decorum, and representation.

Acknowledgments

I am indebted to many colleagues and friends during my residency in Oxford, but most of all to Professor Martin Kemp for making these lectures possible, for supporting their preparation, and for offering lively, ongoing engagement with the issues raised both in situ and on many occasions in and around the time of their delivery. They benefited immeasurably from conversation with Oxford colleagues Marius Kwint, Geraldine Johnson, Jas Elsner, Robin Osborne, Arthur MacGregor, Catherine Whistler, and Julian Raby, and from many others from Oxford, London, and elsewhere who attended the lectures. I am also grateful for the hospitality of Warden John David and the staff of All Souls College; Pamela Romano of the Department of the History of Art and Visual Culture Studies; and the staffs of the Ashmolean Museum and Institute Francaise in Oxford.

I had the opportunity to discuss issues raised in the Slade Lectures at talks given during the year at the University of Bristol, Goldsmiths College of the University of London; Central St. Martin's and the Chelsea School of Art and Design, London, and the Edinburgh College of Art. Two of the lectures were also given again at the Slade School, University of London, during spring 2001, and a draft of one lecture was presented at the University of Maastricht, the Netherlands. Subsequent to my residency in Oxford, versions of one or another lecture were presented to lively audiences at the Soros Center for Contemporary Art in Bratislava,

Slovakia; the Karl Ernst Osthaus Museum in Hagen, Germany; and the Central European University, Budapest, Hungary, where a draft of one of these talks was given as the inaugural lecture for that university's new Humanities Institute. Among the individuals to whom I am indebted in various places are Jan Bakos, Stephen Bann, Viktor Bohm, Norman Bryson, Neil Cummings, Yehuda Elkana, Michael Fehr, Judith Field, Marysia Lewandowska, Michael Newman, Matthew Rampley, Irit Rogoff, and Rob Zwijnenberg.

This book is dedicated to Claire Farago, as a crystallization of one season in our continuing conversations and collaborations.

Haunted by Things

With what confidence can we say that we have ever fully left the first museum we ever visited? (That may be less of a question than a confession.)

At the heart of that two-century-old practice of the modern self we call art, the science of which we call art history or museology, and the theory of which we call aesthetics, is a series of knots and conundrums, the *denial* of which we call the relationship between subjects and objects. One of the things I'll be doing here is trying to untie the knot of this opening sentence.

Objects pursue us in our pursuit of objects to sustain and focus our pursuit of ourselves. One of the other things I'll be doing here is trying to cut the infinite loop of this second sentence—a sentence we have been serving for a rather long time.

Which reminds me of three things:

The first is a powerful and poignant poem by one of the great poets of the twentieth century, Constantine Cavafy, published in his beloved Alexandria in 1910. I quote the sixteen lines of "The City" in full:

> You said: "I'll go to another country, to another shore,
> Find another city better than this one.
> Whatever I try to do is fated to turn out wrong
> And my heart lies buried like something dead.

How long can I let my mind moulder in this place?
Wherever I turn, wherever I look,
I see the black ruins of my life, here,
Where I've spent so many years, wasted them, destroyed them totally."

You won't find a new country; another shore.
This city will always pursue you.
You'll walk the same streets, grow old
In the same neighborhoods, turn gray in these same houses.
You'll always end up in this city. Don't hope for things elsewhere:
There's no ship for you, there's no road.
Now that you've wasted your life here, in this small corner,
You've destroyed it everywhere in the world.

"This city will always pursue you." What could it really mean to be pursued by a city? To be haunted by objects? We seem no more separable from the world of artifice we build ourselves into than we are from the bodies we grow into. Yet there remains an enormous gulf between our systems of interpretation and those facets of the world of artifice we habitually fascinate ourselves into, between what Plato referred to as the holy terror, the *theios phobos,* that is the effect of art, and the capacities of the history, theory, and criticism of art—in short, art history and museology—to comprehend or articulate.

The second thing I'm reminded of is an old caution from Jacques Lacan, from his *Ecrits:* "Certainly, we must be attentive to the 'un-said' that lies in the holes of discourse, but this doesn't mean that we must listen as if to someone knocking on the other side of the wall."[1] (Of course something really *is* there nonetheless, but it can never correspond to what one expects it to be.)

That second thing reminds me of a third and final thing: an old midrash that reads "To pray is to turn toward the wall." One prays to the wall not so as to imagine that the god is behind the wall but precisely to understand that (s)he is *not* there.

But the wall stays haunted nonetheless.

Perhaps one reason why the three-decades-old self-critique of art history and visual and material culture studies has ultimately gone in circles, why the crisis in the discipline we all talked about for so long has never really gone away, let alone approached resolution, and why we seem so unable to relinquish our appetites for the teleologies, historicisms, and essentialisms promoted, however indirectly, by the very instruments we

work with—why, in short, we keep walking the same streets, and end up in this same city—is that the exits we habitually find invariably do turn out to be pictures painted on the wall, already sketched out in the blueprints of the protocols of our practice.

That was one of the conclusions of what at the time was a rather controversial book published just over a decade ago called *Rethinking Art History: Meditations on a Coy Science*,[2] which attempted, as the philosopher Giorgio Agamben has nicely put it, to "bring into question the very meaning of aesthetics as the 'science' of the work of art."[3] Aesthetics does indeed remain the deeply unresolvable foundational dilemma of the modern enterprises of art historicism and museology—which is one of the theses I'll be developing in these Slade Lectures.

The fundamental beliefs about the nature of time, history, memory, and identity that have underlain and made possible the art historical and museological practices we know today themselves depend on particular dialogic or dialectical relationships imagined to exist between ourselves as social subjects and the object worlds we build ourselves into. These include assumptions about how the world of art or artifice not only appears to echo but sustains, embodies, and appears to naturalize our individual and collective identities—our subject positions, however fixed, fluid, multiple, or conflicted those are imagined to be. These assumptions are in turn grounded in a secular theologism that is the obverse—and also what I will call an *allomorph*—of a theological aestheticism that imagines that the world could only make sense as the *artifact* of a divine artificer.

I said earlier that objects always seem to pursue us in our pursuit of objects to sustain and focus our pursuit of ourselves. Art history and museology are the heirs to an ancient European tradition of using things to think with, to reckon with (in both senses of that term), and of using them to fabricate and factualize the individual and collective realities that in our modernity they so coyly and convincingly present themselves as merely re-presenting. Museums are our modernity's paradigmatic artifice, modernity's art par excellence, and the active, mediating, and enabling instrument of all that we have learned to desire we might become. These talks are devoted to understanding what it is we imagine we see when we see museums imagining us.

But let me stop reciting the menu and start reading the paper.

I've called this series of lectures *Seeing through Art History*, and I should explain right now that my choice of an obviously ambivalent title was

deliberate. On the one hand, art history will be considered as an instrument for *seeing* in a certain way. Alongside this positive or apparently neutral sense of the phrase there is its negative alternative, emphasizing the "seeing through," the revelation of otherwise hidden agendas or motives that may be invisible on the surface or at first glance.

I wanted my title to be emblematic of what I shall be claiming are a series of ambiguities, ambivalences, and foundational dilemmas that have underlain the history, theory, and criticism of the modern practice of the self that we call art. My aim in these talks will be to foreground the disparities not only between the discipline's claims and its results but between what it does and what *what it does* does—that is, between its immediate effects and its long-term and commonly unintended or unforeseen side effects.

But as these talks try to steer a path between these alternative ways of seeing through art history, or perhaps viewing them as if through a stereopticon, it will become apparent that another way of construing the title will emerge—in addition to seeing through art history, these talks will involve seeing art history *through:* seeing it through if not to an end that it would be precipitous to claim is upon us, then seeing it through far enough along not only to glimpse more of what *what it does* has done but to give it a run for its money, and to do so in ways that might not necessarily occur to those of us impatient with its slowness to adapt to current social and cultural conditions, or to those of us impatient with its all too rapid adaptation to conditions we might rather disapprove of.

This need not imply that we must give art history "one more last chance" at reformation, after suffering through what is now in fact three decades worth of disciplinary crises resulting in alternatives that in not a few cases have turned out worse than what they claimed to cure. I will nonetheless be arguing for throwing the bathwater out whilst keeping the baby, though not without a thorough rubdown with some pretty rough towels. Which is one way of saying in shorthand that at the end of the day, practicing art history or museology as we have done so in the twentieth century may not necessarily be the best way to understand art *or* history. But to say that does entail a certain responsibility to, if not sketch out in detail, at least cogently imagine alternatives.

Since World War II, art history had indeed become a coy science and, at least west of the Atlantic, a system of increasingly codified academic practices that effectively masked or marginalized the theoretical and methodo-

logical complexities and contradictions of the field, not to speak of its ideological and political investments. Art history was rapidly expanding and evolving into an essential service industry on behalf of new museums, galleries, and art markets whose numbers had been growing exponentially during the Cold War. Both reflecting and fueling that growth was the enormous growth of university departments of art history, and the expansion of art departments to include larger and more active historical and critical wings. In North America by 1970, there were three times the number of independent departments of art history than there were in 1945.

The disciplinary crisis beginning in the 1960s and extending to the present was in no small measure due to a mismatch between the theoretical sophistication of current work in fields such as film and literary studies, not to speak of continental philosophy, and what was commonly available to students of art history, who by the early 1970s were at least two generations removed from a time when their own field was rather more directly engaged with intellectual ferment in the humanities.

The post–World War II academic climate was, for a variety of reasons, at least in the Anglophone world, an inclement one for the growth of theoretical and critical self-assessment, and the historiography of the discipline that dominated most university departments was less a critical history of ideas about art than it was a genealogy of pragmatic methods of interpreting artworks or evaluating their worth. Aesthetic theory was confined to departments of philosophy, and many art historians engaged in essentially fruitless debates about the adequacy or primacy of formalist or contextualist interpretations of artworks.

The notorious reputation of *Rethinking Art History*—it problematized not a few of the reigning orthodoxies within the discipline at the time, and not always along expected generational, geographic, ideological, or class lines—has naturally waned over the past decade to the point where for many professionals its arguments and some of its conclusions have come to be seen as either self-evidently unremarkable or simply another eddy in a flood of unpleasant or unwelcome postmodernist critiques of established institutions and professions.

For the former group, the book was one of several rethinkings of art history that were being engaged with by what was mostly, but not entirely, a younger generation of critics and historians. For the others, it was one of a flood of critiques from the academic margins of artistic and museological practice that, appearing to have little or no direct import

in the pragmatic daily work of museums, galleries, and markets, could be either safely ignored or grudgingly (and safely) relegated to the bookshelves of those museum gift shops whose directors might wish to convey to potential customers that their institutions were somehow in sync with the current buzz—whatever that might be in a given month.

At any rate, the effect of this flood of critical writing was to foreground some of the underlying structural or systemic properties of that quite odd amalgam of heterogeneous and often contradictory practices constituting the modern academic discipline of art history, revealing a picture rather more reminiscent of subatomic particle physics with paradoxical spacetimes haunted by even more paradoxical entities and qualities of charm and light or dark nothingnesses than of something resembling a set of interlocked building blocks of concepts. It also began to engage with the history of the desires disciplined by the field, including, especially, the desire for establishing and promoting histories for art as simulations or reflections of social, economic, and political developments. *Rethinking Art History* considered some of what those desires had come to entail, professionally and institutionally, concluding that "the construction of art history's 'history' [was] itself a *theory* of history with very particular ideological and metaphysical investments and naturalizations—an address to the present, transforming it into the fulfillment of a past we would wish to have descended from" (178).

One of the conclusions of *Rethinking Art History* was that art history was best understood as a facet of a broader social enterprise of knowledge production intimately connected, from its beginnings in the late eighteenth century, with the establishment of modern nation-states and of the institutions and practices—both individual and collective—that supported those political movements. The book argued that taken as a whole, the modern profession delineated an epistemological space made up of "metonymies perpetually working to fabricate the same metaphor, the same geomantic scenography" (178–79). It ended by foregrounding a series of enigmas that were taken as emblems of the contradictory directions of the field at the time—that is, a decade ago.

The three sections of the book's final chapter were called "Seeing through Art History," "Seeing through the Social History of Art," and "Seeing beyond the Panopticon," and I have borrowed the first of these as the umbrella title of the present series of lectures. As it was intended then, the revived title evoked the two obvious alternative meanings I've already spoken of—that of using art and art's history as a lens or a me-

dium for seeing the world and its history, and that of seeing through and looking beneath what its surfaces conceal.

The implications of both—along with the third implication I spoke of—are taken up in these talks, which, while linked to the conclusions of *Rethinking Art History,* follow up on the deeper and in some ways more disturbing implications of what that intradisciplinary critical project (of which that book was a small part) began to uncover on a variety of fronts a decade ago.

I noted before that in his book *The Man without Content,* the philosopher Giorgio Agamben observed that "perhaps nothing is more urgent—if we really want to engage the problem of art in our time—than a *destruction* of aesthetics that would, by clearing away what is usually taken for granted, allow us to bring into question the very meaning of aesthetics as the science of the work of art" (6).

What exactly *is* "art" if it could have "problems" that require our urgent attention and engagement? Is some art, then, safely unproblematic? Are its problems "in our time" different in degree or kind from the problem(s), assuming there were any, of past art? Is this problem anything that historians, critics, or theorists of art, let alone artists, can do anything about? What exactly is it about art objects that needs explaining? And why should we care?

These talks aim to foreground what I shall argue may be some of the deep and possibly unresolvable foundational dilemmas of the modern enterprises of art history and museology, not only dilemmas that I shall claim are endemic to the art histories we have had or currently have, but dilemmas that may face art history and museology as such. My aim here will be to address what I take to be the sources and nature of a concurrent conceptual paralysis and practical success. I will be concluding (I may as well say so now)—and one says this with not a little irony, given that both have never been so powerful, so globally entrenched or socially and culturally productive—that neither art history nor museology as commonly practiced may be indispensable to the practice and reception of what we call "art," whether by art we mean the traditional field of what used to be called "fine art," or the artifact worlds into which all societies build themselves taken at large.

Art history could be the name of a certain perspective on the complex and dynamically evolving relations between social subjects, both individual and collective, and their object worlds that may, if we attend to

the claims of some writers in the 1980s, have approached its end; but it may also be the name of an institution and a profession that for a considerable length of time, and not only outside the orbits of Europe, was inconceivable.

But aside from granting the obvious—that most modes of modern disciplinary practice have a transitory nature and are indeed quite different now than they might have been a century or two ago, assuming they existed at all—what are the implications today of the persistence, whether institutionalized or not, of the history, theory, and criticism of the visual arts? And in line with this, and taking up the implications of Agamben's question—which by no means is unique to him—Could art be freed from what I'll be calling art historicism and (perhaps somewhat awkwardly) museologism and remain what we commonly recognize as art? And why should any of this matter beyond the parochial boundaries of an academic discipline paradoxically so powerful and so fragile at the same time?

To even begin properly to address such issues, a good deal of groundwork will have to be laid down, and that again will be one of the tasks of these lectures. To a large extent, then, these talks are organized by "species of dilemma," so to speak, each dilemma the subject of an individual lecture, beginning with the Enlightenment domestication of that divine terrror—the *theios phobos* cited by Plato as an effect of art[4]—and ending with some of the unholy terrors of our present time, which I shall argue are not coincidentally an effect of what might be called that museologizing or art historicizing of social life indispensable to our modernities.

I will begin here with a few general observations. But before doing so, I want to highlight the fact that, as you will have noticed, I have joined together art history and museology. It is my intention to speak of both, jointly and in tandem, for as I hope will become clear, they have been historically inextricable as well as co-implicative as modes of modern knowledge production: the ghosts in each other's machinery, as it were. They are, in short, professional institutions (what I shall call epistemological technologies) that are complementary and historically concordant—designed to work together, as we shall see, even if the professional career paths of their current practitioners, and in some cases the sites of practice, may not always converge. Which raises a related question that will also be taken up here, namely, the complex history of distinct but related sites of professional practice as themselves the complex product of historical and cultural circumstances.

At the same time, I will argue that this conjoint enterprise of art history and museology is itself emblematic of the paradoxical nature of modern disciplinarity itself. In so doing, I will take up the proposition that it may be more productive, and not only in the climate of contemporary debates, to understand museums as instances, as a set of ways of doing things instrumentally common with other, seemingly quite disparate, modes of modern practice. All of which is another way of saying that these talks will attempt to address the fact that we live in a world in which virtually anything can serve as content in a museum and in which virtually anything can serve as a museum. A museum may more properly be a "when" than a "what." As may also be what we call art itself.

What happened to the artifact worlds of premodern or non-European peoples when those worlds became "art" in early modern Europe, when "taste" and "aesthetics"—the practice and theory of the spectator and of reception—were invented? When by making a categorical distinction between artwork and fetish it seemed that one could have one's holy terror *and* consume it as well? The latter subject, the taming of holy terror, will be the subject of the third essay, "Holy Terrors and Teleologics." I would like to begin here with some general remarks about the discipline of art history as it has evolved in modern times.

For several centuries, historians, critics, and connoisseurs of art have taken the problem of causality as their particular concern, construing their objects of study—individual works of art—as evidential in nature. They have been guided, typically, by the hypothesis that, in a number of determinate and reconstructible ways, an artwork is reflective or emblematic of its original circumstances of production. The *form* of a work, in other words, is commonly taken as a *figure* of its historical truth—a truth deemed to reflect the intentions of the artist or maker or the character of an age, race, or place. I'd like us consider the nature of this "figuration" as it has evolved in the discursive practice of art history and museology.

Typically, art objects have had the status of historical documents in the dual sense that (1) each object is thought to provide significant and often uniquely rich evidence for the character of an age, nation, or mentality, and (2) each object's formal appearance may be read as the resultant product of its historical milieu such that the artwork may not be adequately understandable without a concomitant understanding of its circumstances of production—which may be taken to include the

entire set of historical, social, political, economic, philosophical, and religious forces in play at a given time in a particular place.

Characteristically, disciplinary practice is devoted to the reconstitution of these ambient forces so as to make artworks—and their historical environments—more completely legible in the present, to allow objects to serve as facets of an evolving history of events, and to serve as a method of explaining events by linking them causally to the present. Among art historians, substantial differences have existed and continue to exist regarding the aims, methods, and theoretical foundations of disciplinary practice, and there is no consensus about the efficacy or legitimacy of various paradigms for rendering given works adequately legible.

There is significant disagreement, for example, regarding the scope and scale of the circumstances required to account adequately for the appearance of given artworks, the question being just how much historical information is necessary and sufficient for understanding a work. There is also considerable disagreement regarding the extent to which an art object can be taken, legitimately, as reflective or emblematic of its historical milieu. "You may not like the art," one New York aesthetic philosopher recently wrote, "but it goes to the heart of our current historical circumstances." The same writer concluded his review by saying, "Not knowing what you are looking at is tantamount to not knowing who you are."[5]

For some, art historical interpretation is complete and sufficient with the explication of a work in the context of the evolving stylistic corpus of a particular artist or of a particular aesthetic movement. For others, explication is adequate only with the fixing of a work in a fuller historical context, as a document of an age, place, or people, or as a consequence of certain social, political, religious, economic, or philosophical developments. Traditionally, art historical interpretation was concerned with questions such as, Is the form of a Gothic cathedral the expressive product of late medieval scholasticism? Or is it the result, primarily, of the evolution of building technologies and their particular economies? And if it is to be seen, reasonably, as the product of both, does art historical practice rightly concern itself with the latter, and not at all, or only marginally or secondarily, with the former? Or vice versa? And why should this matter to us in the present?

And if, as has been cogently argued by some, debates such as these have implied a blind adherence to a metaphor derived from not entirely unproblematic oppositions between text and context, does a recognition

of this provide sufficiently compelling reasons for reforming art histori-cal practice? Or is that practice so wedded to problematic or untenable premises as to render even the possibility of a scientific or systematic practice that might be called "art history" (or for that matter museology) null and void?

At any rate, differences such as these lie at the heart of the identity of modern art history and museology, and there has been no constant consensus among art historians regarding the overall aims and goals of disciplinary practice. While this may seem strange to other academics who (at least to art historians) seem so confident of their own profes-sional aims, methods, and histories, it is nonetheless a constant subtext of anxiety for professionals of various generations, and not least because of endemic disagreements regarding the nature of the domain of study itself. Michel Foucault was expressing a more than generic anxiety about objects of knowledge when over three decades ago he set out to demon-strate that disciplinary objects were as much created as found, as much *capta* as *data*.

Increasingly, scholars are asking if art history is in fact a justifiably distinct discipline in its own right, or if it is (if it really is an "it" and not a "when") more properly a facet of historical, anthropological, archaeo-logical, sociological, philosophical, psychological, economic, or ethno-graphic study of (certain portions of) the material culture of various times and places and of various societies and nations. What claim does the modern academic field of art history have to disciplinary distinction on a par with, or in some way analogous to, that of other modern pro-fessional institutions of knowledge? It will become evident throughout these lectures that art history is in fact not on a par with other academi-cally compartmentalized disciplines.

What, in short, is the object of art historical study? And how, in fact, has that object changed since the days of art history's early modern found-ers or hindsight fathers such as Vasari, Winckelmann, Diderot, Quatre-mere de Quincy, Kant, Hegel, Taine, Ruskin . . . ?

There has been no constant consensus within the field about the lim-its or boundaries of art history's object domain. For some, that domain is properly circumscribed by a corpus of masterworks of the traditional (Western or Eastern) fine arts of painting, sculpture, and architecture, or by the corpus of luxury items produced under the patronage of the wealthy at various times. Such a domain has normally been defined by certain criteria of quality or skill or self-conscious formal intent

(not necessarily consistently agreed upon by professionals, it should be added)—a domain characteristically excluding the greater mass of images, objects, and buildings produced in given times and places. For others, the purview of disciplinary attention has ideally incorporated the latter, the traditional fine arts sometimes forming a distinguishable subset of historical artifacts, sometimes not; sometimes seen as different in degree or in kind from other artifacts.

In short, there has been considerable disciplinary disagreement regarding the proper object of art historical attention: Should that attention be given primarily or solely to a corpus of objects known to have been produced within a culture-specific aesthetic tradition or discourse? Or should art historians properly attend to all cultural artifacts of historical and art historical pertinence? And who defines pertinence, and by what criteria?

Compounding the situation is the fact that professional concern with the visual arts (however loosely or strictly defined) is not in fact confined to one academic or institutional field but is fragmented across a number of disparate institutions and practices, each with distinct immediate missions. These include academic art history, museology, libraries and archives, art galleries and the marketplace in cultural commodities, as well as various aspects of the tourist and heritage industries, both secular and religious. Among all of these modern institutions, often strikingly different conceptions of art (not to speak of that form of art we call history) dominate.

It should be clear that these circumstances contribute substantially to the difficulties facing the construction of a coherent historiographic account of art historical disciplinarity. Art history has been, and remains, more than a singular institution, discursive practice, or profession, and it may not—even if institutionalized—constitute a "discipline" in quite the same way as others established and formalized during the nineteenth century and on which, in fact, early art history was wont to model itself. Moreover, not only is the professional concern for the history and development of the visual arts spread across a number of different institutions, but even within the purview of the academic field, differences in understanding, methodology, and theoretical assumptions seem at times to divide art historians into groups with little or nothing in common, even to the extent of what might be taken as the object of study or the proper purview of art historical practice.

But lest you conclude that I am claiming that art history is an archi-

pelago of disparate devices and desires, I should say straightaway that I shall in fact be arguing something quite different: that art history and museology, taken, as they properly should be, together—an assertion I will expand upon later—constitute something not unlike the very paradigm of modern knowledge production, and occupy a position epistemologically central to many modern arts and sciences. To follow through with such a claim will entail adopting a voice, or, if you will, a perspective on the issues I've been raising at a scale that is rather different from what has characterized most recent debates.

In other words, I shall be arguing that the history of art as it has been practiced over the past century and a half not only is unique as a field of knowledge production—it is *not* like other subjects in the humanities and social sciences, even though we try to squeeze it into university curricula as if it were yet another beast in our increasingly commodified and corporatized menagerie—but exists at a level and at a scale fundamentally different from many other academic disciplines. The only field of academic inquiry to which it might justly be compared is not literature or sociology or history but rather philosophy itself. And as such, the history of art is indispensable to the very idea of the university.

These may well be large claims. But to even begin justifying them, I shall have to continue laying down a fairly extensive foundation—hence these first two introductory lectures. In general, these talks are an attempt to identify and isolate some of the primary *epistemological technologies* common to modern art historical and museological practices. Their aim is to foreground certain characteristic *ways of knowing* in art history broadly construed in order to begin to isolate what the pervasive concern for the history of art has meant (and still means) to our modernity.

I fear that I may have opened up an overstuffed closet of conundrums, quirky complaints, and dilemmas, all of which now lie as a mass of confusing rubble beneath our feet, and that I may have overwhelmed our attention by laying out beforehand issues perhaps more economically left revealed piecemeal over time. But I felt it more useful to begin in medias res; to plunge us into the midst of some of the concrete dilemmas and obstacles facing art history and museology today, to present a more realistically complex picture of an exceedingly complex and, in a number of important ways, rather misperceived field so that we may be in a better position to understand both what has been at stake in its historical formation and what is at stake today, when opinions about its

possible fate are so radically divergent as to make many casual observers suspect they are hearing talk of totally different subjects.

Art history and museology have been paradigmatic modes of knowledge production not only *in* our modernity but *as* engines of modernity as such, in ways I hope to illustrate over the next few weeks. I have thought it better, in clearing the air or breaking new ground, to see from the start what monsters lie ahead in our path. Even if we were to "bring into question the very meaning of aesthetics as the science of the work of art," as Agamben suggested, then "clearing away what is usually taken for granted" may entail rather more than has usually been taken for granted in current debates. These lectures can be taken, then, as a form of heavy housekeeping.

Practicing the Self

Art is troublesome not because it is not delightful, but because it is not more delightful: we accustom ourselves to the failure of gardens to make our lives as paradisal as their prospects.

—Robert Harbison, *Eccentric Spaces*

I began the first essay with words that I'd like to repeat here: "At the heart of that two-century-old practice of the modern self we call art, the science of which we call art history or museology, and the theory of which we call aesthetics, is a series of knots and conundrums, the denial of which we call the relationship between subjects and objects." I then said that I'd be trying to untie the knot of that opening sentence. You may recall that in fact I never did, but I'd like to begin doing so today. When I said first of all that art was a (two-century-old) practice of the modern self, the implication was two-sided: that to make art is to practice one's self, and that practicing one's self constitutes, in modernity, an art—in a manner that conflates ethics and aesthetics.

To begin unraveling that, let's look at two images. Figure 1 is a view of the heart of Sir John Soane's Museum in London: a three-story space called the Dome, on the east side of which is an unlabeled bust of Soane, facing, on the west, a cast of the Apollo Belvedere (Apollo's right arm is on the left of the slide). The space and its contents remain much as they were in 1837; Soane bequeathed his collection to the nation with

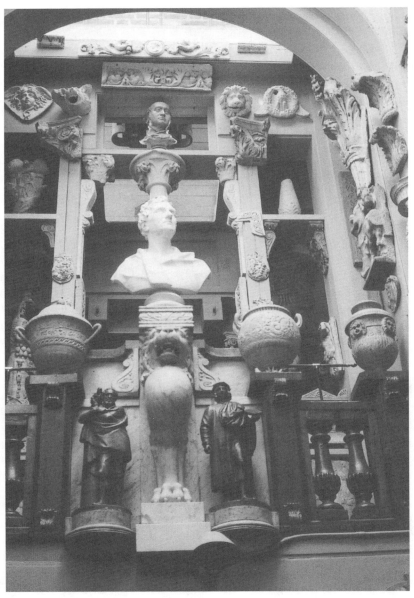

Figure 1. Interior of the Dome, Sir John Soane's Museum, London.

the stipulation, confirmed by an act of Parliament in 1833 that it remain in perpetuity the way it was at his death, which was four years later. The second image (Figure 2) is of part of an exhibition hastily mounted by the Metropolitan Museum in New York in 1996 in homage to the fashion designer Gianni Versace, who had recently been murdered in front of his Miami home, allegedly by a jilted lover.

We might be tempted, as art historians most typically have been, to take these images as palpably emblematic of their times and places, and indeed you may well imagine contrasting the coolly marmoreal neoclassicism of Soane with the baroque hot flashes of Versace, or meditating upon contrasts between the age of Enlightenment and the neofeudalist spirit of globalization, or the spirit of early Victorian London versus that of late Clintonian New York. Or we might meditate upon the differences between an exhibition designed to make you think seriously about the world and one aimed at making you think about how you look and what to buy—in full but normally suppressed knowledge, of course, that no matter how much you buy, you may never look as good as these extraordinary mannequins in the vitrine. But then again, you very well might.

There are a number of points that can be made here, but I don't want to argue for the validity or cogency of these or any other conclusions,

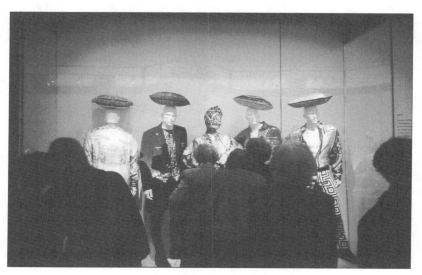

Figure 2. Gianni Versace exhibit, Metropolitan Museum, New York, 1996.

however attractive, that might be drawn from a close comparative reading of these or any other images. Nor am I trying to make a point about museological commodification, which in any case is quite ancient, and indeed coterminous with the history of the institution itself. Rather, I want to call your attention to something rather different. The kind of comparative analysis that I briefly satirized—which is commonly taken to characterize art historical practice in its essence—is very much an artifact of the photographic technologies of the nineteenth century, which allowed the rapid and universal comparison and contrast of virtually anything with any other thing. Photography afforded and pragmatically realized in a compact and easily disseminable manner the European Enlightenment's taxonomic vision of universal commensurabilities, which was also realized in the extraordinary institution we will look at closely in the sixth lecture—namely, the Great Exhibition of the Arts and Manufactures of All Nations at London's Crystal Palace in 1851.

But again my point is only tangentially about photography as such and more about art historical practice as an artifact of film. (The first American department of art history, begun at Harvard in 1870 and directly inspired by Ruskin's inaugural Slade Lectures of that year, established its introductory courses using photographs of uniform size, preferring that students study art through photographs before spending time with actual artworks, so that they would come to them with a solidly "scientific" understanding.)[1]

In 1960, in his inaugural address as the first Ferens Professor of Fine Art in the University of Hull—a lecture entitled "What Is a Professor of Fine Art?"—Sir John Summerson made some astute observations about art historical practice that might be pertinent here.[2] The moment a work of art achieves a certain uniqueness, he said, and I'm paraphrasing here, it becomes a historical phenomenon that must then be peered at, classified, and compared with others. It comes to be "behind glass," as he put it—the "history glass," which so resembles what you see from the observation car of a train, whose windows, he said, "so resemble the vitrine in a museum; the history museum." Summerson, who was director or keeper of Soane's Museum for some years, also referred to large museums as "totalitarian institutions."

He likened writing art history to riding toward the future in a train, which leaves behind it a landscape of artworks arranged as "charming or grotesque" instances of the historically unfolding phenomenon of Art. Artworks make sense by falling into an evolutionary order by hindsight,

a situation presupposing a particularly teleological mode of vision. The field of art history is seen as a kind of railway train, traveling on the straight steel rails of stylistic development. The museum for Summerson was a powerful time machine in which the "professor of fine art" was in the position of an engine driver. His clear implication was that it is this railway, this formalized profession and institution, that articulates and gives order to the landscape through which it travels—a remark, one might say, that was positively Foucauldian in character beneath its deceptively commonsensical style.³ The other metaphor that Summerson used was cinematic, and he likened the glass of a museum's vitrine to a cinema screen.

I said that artworks make sense by falling into an evolutionary order that is itself a product of hindsight. In point of fact, they don't exactly fall into some order; they are made visible *as* art precisely *by* a taxonomic system of chronological ordering. Each object occupies a place in historical time, which in the history of art history has been construed both as generic drift fueled by the logic of stylistic evolution and as arrowed and ordered as the effect of an evolution of spirit or mentality.

Previously I quoted a New York art critic who claimed that "not knowing what you are looking at is tantamount to not knowing who you are." But not knowing what you're looking at is also, in modernity, tantamount to not knowing *when* you are. Art history, in this regard, may be seen as one facet of the modernist configuration of time and space as inherently evolutionary or progressive. There is a TV ad that was recently aired in California, an ad for one or another car company, which features a conversation between two ten-year-old boys. They are sitting in the upstairs bedroom of one of them and trying to guess by their sounds and without looking out the window the make and model of the cars passing below in the street. You see in the background a car passing, and one of the boys screws up his face and says something like "a 1994 VW Golf with a twin-cam suspension, ten-liter engine, etc., etc." His friend then looks over skeptically and says, "Yeah, but what color?" The other immediately screws up his face, and the commercial ends, but you're left with the impression that, yes, the kid really is going to tell you that it was light blue.

Objects, then, are time factored and are assumed to bear within themselves traces of their origins; traces that may be read as windows into particular times, places, and mentalities. The late historian of science Cyril Stanley Smith once coined the term "funeous" to refer to this quality of

things, a term he took from the name of the protagonist of Jorge Luis Borges's famous story "Funes the Memorious," about a man cursed with the inability to forget anything he ever experienced. Smith, a materials scientist, was concerned with analyzing the traces within minerals of their historicity, their geological formation. But as a kind of archaeologist of matter, he also put his finger on a key modernist belief in what I might call the *funicity* of things: a conviction that the astute enough observer might be able to discern in an object the signs and traces of the origins and circumstances of production of that object or indeed of any artifact—not unlike our ten-year-old auto experts.[4]

In referring to art as the (two-hundred-year-old) practice of the self, my aim was threefold. First, I wanted to call attention to aesthetic activity as central to the fabrication, maintenance, and transformation of modern identity, both individual and collective. The construction of identity is linked to the orchestration and composition of a world in which we endeavor to find our place, and the growth of, and changes in, character are customarily linked to changes in one's object world, which is, in turn, commonly taken as reflective of some inner truths, intentions, or motivations, however construed. What I mean to say is that in modernity, you are made desirous of being convinced that you are your stuff, so that you may become even more desirous of being convinced that even better stuff will even more truthfully reflect your continually evolving character—what you shall have been, in other words, for what you are in the process of becoming. The desire to be so convinced, of course, is itself already prefabricated.

My second point has to do with what my opening sentence referred to as "the relationship between subjects and objects," a relationship that I suggested was built on a *denial* of the actual ambiguities, complexities, and contradictions at the heart of the modern practice of the self. Something of what was intended by that sentence will have become somewhat clearer in what I've just been saying. In modernity, in short, we live in a world in which we paradoxically believe *and* do not believe in a correspondence between subjects and objects—between, that is, character and possessions, either palpable or virtual. We believe that possessing—identifying with—a Versace gown enhances and reflects our character, and we disbelieve it, in that wearing such an outfit constitutes a form of masquerade, the donning of a costume whose relationship to our inner character is largely or even entirely specious, ironical, or as "real" as act-

ing. The real, if you will, as the artifact of masquerade.[5] Recall the quote from Robert Harbison.

My point is that the idea that there is a direct correlation or correspondence between subjects and objects itself covers up a highly complex series of context-specific, time-factored, indirect, and paradoxical relationships related to the genesis of personality and identity in the modern world, wherein we are both mirrored in the environment we grow into and semiautonomous of it. Objects always seem to pursue us in our pursuit of objects to sustain and focus our pursuit of our selves. That infinite loop or Möbius strip on which subjects appear to occupy different surfaces than objects—the denial, if you will, of that knot—profoundly characterizes our modernity. We construct our selves by apprehending their apparent and desired reflection in others and in other things so that there is always a part of us that is an other. Our selves are, in a manner of speaking, hybrids. In a comparable manner, we learn to speak by adopting a system of signification that is from our perspective entirely someone else's preexisting and prefabricated language.

There's much more to this issue, which will be pursued, in fact, in some detail in subsequent lectures; my third point here returns us to the business of art history and museology, which I referred to as the science of the modern practice of the self, that is, art. I contrasted this science with its theory, which I referred to as aesthetics. What I'd like to do here is to talk about the genesis and nature of the scientific object of art history and museology.

The most pervasive theory of the art object in art history, as well as in traditional aesthetic philosophy, has been its conception as a medium of expression or communication: as a vehicle by means of which the intentions, values, attitudes, messages, or emotional state(s) of the maker—or by extension the maker's milieu—are conveyed (by design or chance) to targeted or circumstantial beholders. Correlative to this is the assumption that synchronic or diachronic changes in form will signal changes in what the form is presumed to convey (intentionally or not) to beholders. This is connected to the widely held presumption in the field that formal changes exist so as to effect changes in an audience's understanding of what was formerly conveyed before the in(ter)vention of the new object. For some art historians, artworks are seen as primary catalysts of social and cultural change; others (most notably in the tradition of

critical thought initiated in the first third of the nineteenth century by Hegel and shared equally by formalist and contextualist art historians) have construed works as largely reflective of such wider or deeper changes. It is fair to say that among art historians, the latter perspective has been the dominant one. It has also been the one that most closely meshes with the broader social and political functions of modern art history.

Art historians characteristically attend to the finest formal and material details of work in no small measure because of a conviction that everything about an object may, potentially, be evidentiary in import. This may be summarized in the following principle: everything about an object is meaningful in *some* way, but not everything about an object is meaningful in the *same* (or in *any*) way. From connoisseurship to stylistic analysis to social history, art historical practice has been grounded in this matrix of assumptions, this theory of the object as a representational or expressive medium. The artwork is always in some sense a sign, trace, effect, or product of individual or collective mentality.

In professional practice, the object of study—whether that be a Picasso drawing, a Shinto shrine, or the citadel of Mycenae—is understood as a significant cultural and historical document insofar as it may be situated in a particular interrogative framework—insofar, that is, as it may be shown to be pertinent to a particular family of questions. The most fundamental of these is this: In what way is this object an expression or embodiment of its particular time and place? That is, of the values of the person, people, society, or place that produced it.

In the century and a half of its academic institutionalization, the discipline has elaborated a finely detailed series of criteria for classifying artworks according to their relative capacities for conveying such information. In traditional Western art history, for example, certain kinds of objects have been conventionally assumed to embody certain kinds of historically pertinent information. To a large extent, these relative capacities were taken to be consonant with perceptions of the semantic density, subtlety, and complexity of objects within the boundaries of particular historical and aesthetic contexts and genres.

Generally, traditional hierarchical distinctions between "fine" and "applied" arts, masterpieces and ordinary works, art and craft, have had as much to do with criteria of craftsmanly subtlety and complexity in a material or formal sense as with the presumptive semantic weight or "carrying capacity" of certain types of objects (cathedrals versus train

sheds, portraits versus cutlery, sculpture versus idols), and to a certain extent this hierarchy of quality has been aligned with comparable social or class distinctions, even if, in Western art history until the early twentieth century, most of what art historians dealt with were what the wealthy owned. Moreover, the proportions of the nave of a medieval cathedral might be seen as less semantically dense (in terms of what they might convey about contemporary religious, social, or philosophical attitudes) than a painting depicting an Annunciation. This does not, however, preclude the opposite possibility: in the history of art history, notions regarding the semantic carrying capacity of objects have varied widely, and similar variations may be observed in the history of museology and art criticism. Nonetheless, an implicit hierarchy of value and cognitive weight is invariably present.

Disciplinary practice has been concerned, broadly, with the formatting of knowledge in such a way as to render the particular "truth" of a work legible and visible. Common to all theoretical and methodological perspectives in the field has been a basic interest in *siting* the work in a discursive field (or in museological or exhibitionary space) in such a way that the work's specifiable relation to pertinent aspects of its original environment and circumstances of production and use may be construed causally in some sense. Art historical and museological practices have been devoted, overwhelmingly, to this fixing-in-place of individual objects within the (ideal) horizons of a (potentially) universal history of artistic form—in short, the assignment of an "address" to the work within a nexus of synchronic and diachronic relationships.

From the sequential juxtaposition of objects in museum space to the curricular composition of university teaching, disciplinary practice has been nearly universally grounded in this desire to construe the meaningfulness of works as a function of their position in an unfolding historical schema. In short, disciplinary practice has commonly unfolded by being staged within a metaphorical landscape, a real or virtual space of practice, which in some manner is taken as bearing a relationship of resemblance to historical processes themselves. I'll address this question of exhibitionary stagecraft and dramaturgy in the coming lectures.

What this has meant in effect is that this immensely extended and finely detailed historical system (of which many variations have been articulated, from the intensely teleological to the randomly agglutinative) has itself functioned as a determinative, explanatory field. Crucial to the development of art history as a systematic, even scientific, historical

discipline in the nineteenth century was the fabrication of a central data mass, a universally extensible archive within which every possible object of study might find its place and locus relative to all others. Within which, in other words, every item might be seen as bearing the traces of others, as referencing or indexing another or others: as being seen to have been influenced by others.

The result of this immense and extraordinary taxonomic labor, carried forward for well over two centuries in Europe and America, and touching millions of objects, has been an astonishingly detailed and complex network of specimens of artistic activity, linked together by extended chains of causality (artistic influence) over time and space and across the kaleidoscope of the world's cultures. This labor forms the basis of the ability of trained professionals to identify, classify, and assign a place in the historical evolution of art to any object in their purview; to assign any object its position in a formal and stylistic sequence of production; and, further, to relate the given work to the more general webs of causality and determination assumed to exist between objects and their social, historical, cultural, and philosophical milieus.

A variety of characteristic disciplinary practices developed in the service of the articulation of this universal history of artistic activity. These have included the attribution of works to known *or* hypothetical individuals, or to historical moments, periods, and places; the production of *catalogues raisonnés* fixing in reasonable and systematic order the sequence of works produced by an artist, school, movement, or society; and the growing refinement of the semiological practices of the connoisseur, enabling the professional to distinguish original works from copies or forgeries, to distinguish the (presumably) unique hand of particular artists or studios, and to distinguish works of superior or inferior quality within the frameworks of certain (albeit changing) criteria. Developments came to be distinguished by certain tendencies in style, composition, coloration, modeling, and use of materials, or of dominant tendencies in the treatment of particular ideas or themes. Characteristics of national or regional practices came to be articulated, along with characteristics in form and content grouped together diachronically, in periods of varying duration.

And museums came to be collections of "tendencies" grouped according to one or another master narrative in fashion at a given place or time—as for example with the new Tate Modern, whose chief curator last year announced that the new museum would not be organized

chronologically, or by artist, or geographically, but by "tendencies"—tendencies toward abstraction, toward the body, toward costing a fortune, etc.

Underlying this labor was the presumption of a certain demonstrable *sameness* among the works produced at a given time or a particular place—the assumption, as it were, that the artworks of an individual, school, nation, or ethnic group should share certain common properties of form, certain features distinctive of that place or time or group. An enormous amount of disciplinary energy has been expended in demonstrating this proposition since the early nineteenth century. And today, despite a finer sensitivity to the complexities of practice in given times and places, and to the multiplicities of aesthetic tendencies frequently demonstrated in various periods, art historical practice remains guided by this ideal, and partisan debate within the discipline remains focused on this problem. It is, of course, an ideal fundamentally and indissolubly linked to a singular and uniform notion of identity—identities, that is, whether on an individual or communal scale, that are not at base hybrid or heterogeneous. An identity that is itself well-composed. A belief, for example, that in the delineation of the human figure, the Venetians will never be Florentines, and vice versa.

The disciplinary task of fabricating a universal history of artistic form, and of marshaling evidence for developmental patterns characterizing that history, achieved a degree of efficacy and systematization in the nineteenth century with the use of photography and filmic reproduction as a means of disseminating images of artworks. Although the projection of images from transparencies by means of backlighting had been developed as early as the seventeenth century in connection with Jesuit educational reforms designed to foster the propagation of the faith in the Catholic Counter-Reformation, the later capacity for the mass production of images made possible the instantaneous comparative and combinatory analysis characteristic of the modern discipline, affording the fabrication of running narratives of explication and genealogical modeling of styles, forms, and subject matters in dramatically persuasive ways.

The importance of filmic technology for the development of the modern discipline should not be underestimated (as it routinely is within the field, where photographic reproduction is still commonly seen as ancillary to, rather than determinant of, or conditioning art historical practice). Indeed, it may be argued that photography became determinative of the directions in which art history developed: not only did film afford

the possibility of constructing exhaustive and encyclopedic archival systems for the classification of artworks according to various criteria, but it came in fact to be an indispensable component in thinking art historically—indeed, in thinking historically more generally, in which each object might be imagined as a still in a historical film. It came, in short, to constitute a mode of demonstration and proof in art historical argumentation, allowing historical and evolutionary principles to be derived from the mass of data assembled therein.

Through the juxtaposition of multiple images (slides and photographs), the distinctive salient features of all kinds of objects could be dramatically (and endlessly) staged, allowing the art historian to concretely demonstrate the evolutionary development of genres, styles, and themes; to link up parallel and complementary developments across genres and types of forms; and to display information in a self-evident manner with respect to postulates about the historical laws of formal development. At the same time, artwork of different periods or national groups might be compared and contrasted, allowing for the articulation of general tendencies peculiar to times and places. Photography afforded art history the possibility of becoming an ordered, systematic discipline, a kind of laboratory science in its own right, not without parallels, in the late nineteenth century, to chemistry, evolutionary biology, or forensic medicine (it will be recalled that the first professional connoisseurs of the late Renaissance in Italy were doctors).

In this regard, the disciplinary laboratory constituted an interrogative field: an environment already predisposed to consider data pertinent only to the extent that they could be shown to be relevant to particular questions. Art historical texts came to be veritable "bibles of begatting," tracing the genealogies of causal connections among artworks from antiquity to the present, surveying the historical development of aesthetic objects, and setting forth hypotheses regarding the patterns and directions of change. The patterns so elicited might then be accounted for either by the internal formal logic of the diachronic system itself or by circumambient social and historical external forces.

In the former case, historical change might be accounted for primarily on aesthetic or formal grounds, according to the rhetorical economy of artistic problem solving and experimentation, each object being construed as responding to (i.e., as influenced by) previous solutions to an aesthetic problem—for example, ways of representing a religious story involving multiple episodes and characters in a bounded, rectilinear,

two-dimensional plane. In the latter case, formal transformations might be linked to external social and cultural developments (textually documented or hypothetical) such that the new work might be construed as reflecting the changed circumstances.

In either case, it is the logic of the archival system that affords and legitimizes historical interpretation: in appearing to collect data for interpretation, the system in fact is also a paradigm *of* such interpretation. In this regard, the central archival system of the discipline (of which every particular departmental or institutional collection is invariably construed as a fragment of an ideal plenitude) functions as a simulacrum of scientific demonstration, wherein the actual deployment of evidence—like so many charts, tableaux, lists, or diagrams—itself constructs and naturalizes the truth of what is intended. The system is what might be termed *mythomorphic,* reflective of that of which it speaks.

These truths have to do with origins, descent, influence, affiliation, progress, historical direction, or the homogeneity (or heterogeneity) of the mentalities and ideologies of an age or place or of an individual artist or studio. Every item in the disciplinary archive is, in short, a still in a historical film portraying the evolutionary progress of Art, as manifested in concrete works of art, over the ages. And each item is meaningful, in this system, in a differential manner. Objects known and unknown will (eventually) have their fixed and proper locus in an encyclopedic and universal history of art projected onto the horizon of the future.

At base, the disciplinary archive situates its users in what I will term *anamorphic positions* from which the history of art may be seen as unfolding, on its own, almost magically, before one's eyes. The archival mass, in other words, is made accessible (or legible) from particular prefabricated stances designed to elicit (confer) additional sense from (on) the diachronic and differential system. Common anamorphic perspectives include artistic biography, periodization, stylistic evolution, and the evolution of particular thematic or semantic contents. The greater bulk of modern art historical scholarship involves the crafting of narratives organized around particular stylistic or thematic perspectives: portrayal of women or blacks in Renaissance art, the development of Matisse's sense of color, changes in the representation of the American frontier in landscape painting, the patronage of the House of Orange and its effect on religious portrayals of Christian iconography, German historical consciousness as reflected in the work of Anselm Kiefer, Paul Klee's political views as reflected in the mythological motifs he drew

from classsical antiquity, traces (or not) of Hellenistic realism in Indian sculpture, painters and beholders in eighteenth-century France, the social history of modern painting, the evolution of the kouros figure from pharaonic Egypt to archaic Greece, and so on.

These anamorphic perspectives on or probes into the central data mass (both virtual and material) of the discipline have shifted and changed over the history of institutional art history, and the bulk of partisan debate in recent times has consisted of controversies regarding the efficacy or adequacy of one or another perspective or methodology. All too little discussion has taken place in recent times regarding the nature of art historical disciplinarity as such, or of the epistemological technologies that have underlain all these debates, common to both older and newer art historical methods of exegesis. And while a good deal of discussion has taken place over the past two decades regarding the political and ideological implications of various modes of modern art historical practice, the more fundamental inquiry into the origins and nature of art history as itself a historical artifact and as a modality of knowledge—as an epistemological technology—has remained in a nascent state.

As I have said, these talks constitute a kind of housekeeping aimed at clearing a space for such a discourse to mature. I will continue in the next essay to try to explain how the forms of practice I have been describing came about in the first place, what (if anything) they replaced, and what their immediate goals and missions may have been.

Holy Terrors and Teleologies

It is not uncommon to believe that the post-Enlightenment modes of knowledge production familiar to us today—including, in particular, the history of art—constitute a clean break with pre-Enlightenment systems of knowledge, including, especially, religion. We assume that our astronomy is rightly seen as superseding astrology, that our history constitutes a break from mythology, or that the disciplines of physics, biology, botany, and so forth have superseded and to a great extent broken with and redefined the earlier divisions of knowledge production of the old medieval trivium and quadrivium. Our post-Enlightenment system of knowledge is that reflected in the organization of the modern university, however much that may have metamorphosed over the past two centuries. But it can be argued that in the case of some modern disciplines, and especially art history, the break may not have been as clean as we might have assumed or might once have preferred to believe.[1]

I raise this question in connection with this essay, which deals with the origins and evolution of art historical systems of meaning in the late eighteenth and early nineteenth centuries. I am concerned here with the history of how works of art or artifice were thought to be meaningful, or how they were said to signify, then and now. The problem is by no means straightforward, but a close consideration of several key issues may help to broadly illuminate what was at stake in the establishment of the new subject of the history of art at that time.

29

I want to start by drawing our attention to a few of the more general contemporary notions about signification, as found in both literary and visual studies. To begin with, we commonly distinguish between two primary ways of making meaning—what are usually referred to as *metonymy* and *metaphor*. The terms refer to the two general kinds of relationship thought to exist between things: the metonymic being a relationship of contiguity or juxtaposition; the metaphoric being a relationship of similarity or (re)semblance. Metonymic relations are often termed "indexical," and metaphoric ones are often called "iconic."

Historical interpretations are narratives generally organized as events juxtaposed or in sequence, whose meanings are a function of their metonymic relations to other events, both previous and subsequent. Psychoanalytic interpretations entail accounting for events that bear metaphoric relations to each other, as where a current behavior is read as a replacement or substitution for an earlier experience it resembles. The psychoanalytic categories of displacement and condensation refer to a complex mixture of such relationships. Now all of this, as you may well imagine, can become extraordinarily complex, both at this level of abstraction, and with regard to how we might see these relationships, and relations among relationships, played out materially. Smoke may indeed be an index of fire, and thus may be said to bear a metonymic, contiguous, or cause-and-effect relationship to it—or a picture of a man on a horse slaying a dragon may indeed be an icon of St. George—but this is just the barest beginning: the resemblance of a foot fetish to a given foot either in the present or in some long-buried past is in no way direct, simple, or even remotely straightforward, nor the same kind of relationship in different personal or cultural contexts. While a foot can be a sign of or for many kinds of things, it's not a sign for every other thing, either.

Before going any further, I should say that underlying all of this is the idea that meaningfulness is relational, concerned with the linkages or relationships between things, and that in dealing with signs of any kind, we are dealing with them not as things but as relations between or among things. Systems of meaning, or semiotic systems, to use a generic term that is in fact quite ancient (*semiotiki* in ancient Greece referred to the behavior of signs or symptoms, particularly in medicine), are systems of relationships. The basic notion of the sign in Western history is expressed in the medieval Latin phrase *aliquid stat pro aliquo*—something standing (in) for some (other) thing, even if, as not uncommonly, that *aliquo* is (or is identical to) the original *aliquid* itself (we'll get into that

later). At any rate, the most fundamental notion here is that a sign is not a kind of thing but a relationship between things (of any kind).[2]

But let's get back to metaphor and metonymy for a moment. As you may well imagine, such a system can become quite finely ramified and complex, and in fact we spend our lives negotiating such relationships. Both of the two principal founders of the modern study of semiotic or sign systems, the American philosopher Charles Sanders Peirce and the Swiss linguist Ferdinand de Saussure, developed and inspired quite extensive theories of sign relations. Saussure built his system on a notion of the sign as comprising a binary opposition between a signifier and what it signified, whereas Peirce built his upon a tripartite system of relations between signifier, signified, and the individual or group for whom such a relationship was pertinent (he called that the *interpretant*). Peirce distinguished some sixty-four basic permutations of these relations, which I will refrain from even beginning to describe, let alone discuss. Peirce was one of the most brilliant logicians of the nineteenth century, and Saussure was a brilliant linguist and philologist who (it is less well known) modeled his system of language on a series of metaphors inspired by listening to the lectures on the history of art by the great French historian Hippolyte Taine.

But I do want to bring up one semiotic detail here, since historically it is one of the most significant and powerful problems in the whole system of Western semiology, and in a certain sense it is literally the exception that proves the rule of the whole structure of meaning; its negative keystone, as it were. I've discussed this (as well as linguistic semiology's indebtedness to nineteenth-century art history) at some length in *Rethinking Art History,* so what I'll do here is summarize (and update) the main points of the argument you can find there.

The most fundamental problem facing a theory of meaning in Europe, in fact, was the problem of the Eucharist, which occupies the absolutely key central position in traditional Christian religious dogma. It can be signified by the phrase *hoc est corpus meum* (from which we get the distinctly Protestant derisory term "hocus-pocus"). The point is that this bread and this wine cannot be signs; that is, they cannot stand for something that is distinct from their material substance: this bread must *be* the body of Christ, as this wine must *be,* and not simply signify, Christ's blood.

At the heart, then, of traditional semiotic theory is a sign that is not a sign—the Eucharist, which is not something material that stands

for something absent or distant or immaterial; it *is* what it is said to be(come) when blessed by a priest. Furthermore, to eat of that bread and wine is to eat not a substitute, sign, or simulacrum of Christ's body and blood but literally to eat that body and blood. The grammar (or semiotic system) elaborated several centuries ago by the philosophers and theologians of Port-Royale sought precisely to contend with this problem, which they solved to their satisfaction by asserting that the Eucharist was the one phenomenon in nature that was the exception to the rule.

You may well wonder what all this might have to do with the history of art, and so before going any further with what I've been doing so far, we need to begin talking about these issues in relationship to the world of artifice. I've said before that in both its discursive and museological facets, art history has labored to legitimize its truths as original, preexistent, and only recoverable from the past. It has aimed at the dissolution of troubling ambiguities about the past by fixing the meaning of its objects of study and locating its source in the artist, the historical moment, or the mentality or morality of an age, place, people, race, gender, or class. It has sought to accomplish this by formatting the past teleologically or as rationalized genealogy: a clearly ramified ancestry for the present, for that presence that constitutes our own modernity. The narrative panorama of the history of art serves simultaneously to represent and explain history, to in effect create a description that is its own interpretation. It has been this reality effect as the end product of disciplinary investigation that has constituted the point of the historicist agenda motivating art history as a mode of writing (or staging) addressed to the present.

In short, it was the character and direction of the present that needed working on in connection with the rise of modern nations: art history in all its facets has been a primary instrumental force in this essentially political labor of defining and promoting the progressive ambience of the modern bourgeois nation-state. It is clearly the case, for example, that the rise of a professional discourse on the arts has been deeply complicit with the promotion and validation of the idea of the modern nation-state as a natural entity ideally distinct and homogeneous on ethnic, racial, linguistic, religious, and cultural grounds. Art museums in particular have played a central role in fabricating and maintaining national and folk heritage and identity, working to promote such identities as characterized by coherences over space and time in aesthetic sen-

sibility: the Lascaux cave and its paintings as the dawn of a particularly Gallic sensibility, for example, or Stonehenge as quintessentially British. Notions of style and historical period, with their concurrent assumptions of shared values and attitudes, have been essential instruments in this historicist—and invariably nativist—enterprise.

Underlying and fueling this teleological labor has been a family of metaphors reflecting and fabricating and promoting a certain vision of an ideal human selfhood—a communal persona with an indelible style of its own through the ages, with an exterior aesthetic face directly expressive of and consonant with an inner spirit, mentality, or essence. What stamps the art of a people at one period will ideally be reflected at another time, even many centuries removed. Similarly, the mark, say, of Picasso's persona will be adduced as much from his signature as from his ceramics, glasswork, sculpture, and painting—even his doodles or sketches on café napkins or laundry lists, not to speak of the essence marketed by the perfume company of his daughter Paloma.

It may not be hyperbolic to suggest that art history and museology have been guided by a more deeply set metaphorical syllogism: that in some sense art is to man (and it is necessary to stress the markedness of this gendering) as the world is to (the) God—that human creativity in all its variety is a shadow, trace, or simulacrum of divine creativity: its mortal echo. It is in this respect that the confrontation of beholder and art object in the landscape of the museum finds no easy parallel in other historical and critical practices in the (allegedly) secular corners of modern life.

The museological artwork (which in contemporary contexts may be anything staged within the auratic frameworks of the museum) is inevitably deployed as an object of contemplation paradoxically both inside and outside history: as an occasion or catalyst for the imaginative reconstitution of a world, a person, an age, or a universe of aesthetic or ethical sensibility with which the object is to be construed as materially congruent in its finest details. A window, so to speak, on a world made all the more desirable through the theatrically heightened quiddity of the object at hand—the object staged at the same time as a medium of aesthetic meditation and erotic fetishism.

The problem of designing a system of knowledge production—a history of art or a museology—that might afford both of these kinds of relations between subjects and objects is, I would claim, akin to that which faced Christian theologians, philosophers, and logicians in their

attempt to bring into the same framework what I might call Eucharistic and mortal semiology. If we look at the problem museologically, we can see that two modes of knowing might thus be seen as embodied in the work of the modern museum; two kinds of propositional or interrogative frameworks: one that is reliant for its poignancy on a metonymic, indexical, and differential encoding of phenomena, and one deeply imbued with a metaphoric orientation on the things of this world and on history. With the former, facticity and evidence are formatted syntactically, with the order of the system constructing and legitimizing questions that might be put to data that are in effect *capta,* artifacts of the interrogative system itself. With the latter, form and content are construed as deeply and essentially congruent, and the form of the work is indeed the figure—the metaphor, icon, or emblem—of its truth.

In effect, this double epistemological framework for rendering the artwork legible within the discursive framework of art history (and in the spatiotemporal frames of museology), recalling contrastive but co-present domains of knowledge, may suggest that the discipline has preserved an older analogic order of reasoning alongside a more recent epistemic order of difference and change, the former based on metaphoric relations, the latter on metonymic and synecdochic (or part-to-whole) relations of juxtaposition. Both, in short, oscillate together in modern practice.

It is here that we may begin to appreciate one of the foundational dilemmas that confronted the design and development of a discipline of art during the nineteenth century—in both its discursive and museological facets—namely, how to construct a science of phenomena (works of art or artifice) simultaneously construed as unique and irreducible (indeed, like individual selves, simulacra of subjects) and as specimens of a class of like phenomena dispersed over time and space, and apparently universal to all human societies.

The solution to this dilemma, in short, has been a network or matrix of codeterminative and contingent institutions (academic art history, museology, the art market, art criticism, connoisseurship, the heritage industries) that maintain in play contrasting but not necessarily conflicting systems of evidence and proof, demonstration and explication, analysis and contemplation, with regard to objects taken both as semantically complete and as significant by their distinction from other objects.

While art history may at times appear as a paradigmatic instance of the scientific labor involved in establishing a historical field modeled on the epistemological protocols of historical and literary studies, that labor

was at the same time in the service of an ethical practice of the self and its works—which, ultimately, is what the contemplative appreciation of art is all about. In that sense, this labor bears no small resemblance to that accomplished with the rise of the modern novel. Art history is thus not a simple or uniform mode of disciplinary practice but rather a family of institutions housing multiple anamorphic orientations on an object of study at once semiological and Eucharistic: a trompe l'oeil of astonishing power and tenacity.

In a general sense, then, "seeing through" what art history as a discipline sees entails considerably more than what came to be commonplace during the 1970s and 1980s, namely, attending to the inadequacies of one or another theoretical or methodological position on the interpretation of artworks. Today it entails refusing to see that art history and its various institutions are practices that have failed, for in fact, the discipline has never been so powerfully successful as it is at present: the academic discipline is today at home in nearly every contemporary society, and according to one recent survey, a new museum opens somewhere in the world every two or three days on average.

What is needed is to understand both globally and in fine detail what its successes are founded upon—why, in short, art history and museology have become essential to every established and developing modern society. You may have already concluded from what I've been saying that no small part of art history's effectiveness has been its close but occluded relationship to traditional religious practice, that in one sense art historical and museological practice constitute a kind of secular or secularized theology, or a kind of theologism, that may in fact go well beyond the commonplace associations of museums as temples of art or of artists as divinely inspired, or of works of art that reveal the "soul" or "spirit" of the artist, nation, people, race, place, or time period.

A critically effective understanding will begin by exploring the mechanisms of that success: with the stage machinery and epistemological technologies of the discipline as a modern practice of enframing vision and knowledge, and as a visionary historicism and aestheticism, whose seemingly obscure object of desire has always been, and still remains, right on the surface, in bright light. I'd like now to turn to some of the historical problems faced by establishing art historical modes of meaning production.

What was pragmatically afforded by a discipline called art history was the systematic assembly or re-collection of artifacts constru(ct)ed as material

evidence for the elaboration of a universalist language of description and classification. Art history could only work, in other words, if it was based on a notion of art that was in essence panhuman. Even the most radically disjunctive differences among artifacts could be reduced to differential and time-factored qualitative manifestations of some panhuman capacity, some collective human essence or soul. In other words, differences could be reduced to the single dimension of different (but ultimately commensurate) "approaches to artistic form" (*the* Aztec, *the* Netherlandish, *the* Greek, *the* Chinese, etc.): each work as approximating, as attempting to get close to, the ideal, canon, or standard. (The theoretical and ideological justification for a practice that came to be called "art criticism" is thus born in an instant, occluding while still instantiating the magic realisms of exchange value.)[3]

In short, the hypothesis of art as a universal human phenomenon was clearly essential to this entire enterprise of commensurability, intertranslatability, and (Eurocentrist) hegemony. Artisanry in the broadest and fullest sense of "design" is positioned—and here of course archaeology and paleontology have their say—as one of the defining characteristics of humanness. The most skilled works of art shall be the widest windows onto the human soul, affording the deepest insights into the mentality of the maker, and thus the clearest refracted insights into humanness as such. The "art" of art history is thus simultaneously the instrument of a universalist Enlightenment vision and a means for fabricating qualitative distinctions between individuals and societies. One may well ask how this astonishing ideological legerdemain could have survived for so long.

Consider again that essential to the articulation and justification of art history as a systematic and universal human science in the nineteenth century was the construction of an indefinitely extendable archive, potentially coterminous (as it has since in practice become) with the material (or visual) culture of all human groups. Within this vast imaginary edifice—of which each museum is but a fragment—every possible object of attention might then find its fixed and proper place and address relative to all the rest. Every item might thereby be sited (and cited) as referencing or indexing another or others on multiple horizons (metonymic, metaphoric, or anaphoric) of useful association. The set of objects displayed in any exhibition (as with the system of classification of slide and photo collections) is sustained by the willed fiction that they somehow constitute a coherent representational uni-

verse, as signs or surrogates of their (individual, national, racial, gendered, etc.) authors.[4]

The pragmatic and immediately beneficial use or function of art history in its origins was the fabrication of a past that could be effectively placed under systematic observation for use in staging and politically justifying or transforming the present.[5] Common to the practices of museography and museology was a concern with spectacle, stagecraft, and dramaturgy, with the locating of what could be framed as distinctive and exemplary objects such that their relations among themselves and to their original circumstances of production and reception could be vividly imagined and materially envisioned in a cogent and useful manner—useful, above all, to the production of certain modes of civic subjectivity and responsibility. The problematics of historical causality, evidence, demonstration, and proof constituted the rhetorical scaffolding of this matrix or network of social and epistemological technologies.

Much of this was made feasible by the invention of photography—indeed, art history is in a real sense the child of photography, which has been equally enabling of the discipline's fraternal nineteenth-century siblings, anthropology and ethnography. It was photography that made it possible not only for professional art historians but for whole populations to think art historically in a sustained and systematic fashion, thereby setting in motion the stage machinery of an orderly and systematic academic discipline.

But photography also, and most crucially, made it possible to envision objects of art as signs. The impact of photography on determining the future course of art historical theory and practice was as fundamental as Marconi's invention of the wireless radio sixty years later in envisioning the basic concept of arbitrariness in language—which, as linguists of the 1890s rapidly saw, paved the way for a new synthesis of the key concepts of modern linguistics.

As we have seen, a clear and primary motivation for this massive archival labor was the assembly of material evidence justifying the construction of historical novels of social, cultural, national, racial, or ethnic origins, identity, and development. The professional art historian was a key instrument for scripting and giving voice to that archive, providing its potential users, both lay and professional, with safe and well-illuminated access routes into and through it. But we should also not forget that beginning in the nineteenth century, each citizen comes in fact to participate personally in this vast modernist enterprise of art

history, and in the modes of self-definition and self-construction this entails, in ways we'll be considering in subsequent talks.

Let me try to summarize all of this in formulaic shorthand. The edifice of art history may be pictured, in this thought experiment I want to try out on you, as a virtual space with three dimensions, each of which affords and confers a specific mode of legibility on objects in their relationship to subjects. This social and epistemological space may be imagined as having been constructed, historically, through a triple superimposition of hypotheses beginning in the second half of the eighteenth century.

 1. The first superimposition (this might be called the dimension or axis of Winckelmann) entailed the superimposition of objects and subjects wherein the object is seen by a subject as through a screen of the erotic fetishization of another subject: the object, in short, is invested with erotic agency.[6] In effect: The object is deployed as an object of sublimated erotic desire.

 2. The second superimposition (this might be called the dimension or axis of Kant) afforded a linkage of erotics and ethics, or the hierarchized markedness of eroticized objects: their ethical aestheticization. This hierarchization constituted a spectrum or continuum from the fetish to the work of fine art. Aesthetics are thereby entailed with a superior (Protestant?) ethics, fetishism with an inferior (Catholic?) one; but both were commensurate as ethical. Once again, recall the (Catholic) problem of the Eucharist: for Protestants, the Eucharist was a sign of Christ's body.[7] In effect: The ethically eroticized object of desire is rescued from cultural and ethical relativism.

 3. The third superimposition (this might be called the dimension or axis of Hegel) afforded the historicization of ethically eroticized objects, a hierarchization of time in terms of teleology. This museographic space in which ethically eroticized objects are rendered legible is thus a storied site, within which objects became protagonists or surrogate agents in historical novels (one version of which was the modern art museum) with a common underlying theme: the search for identity, origins, and destinies. In effect: Ethically superior objects of desire are teleologically marked, their time-factored truth positioned in contradistinction to objects exterior (and thus always already anterior) to time's leading edge, which is the European present; the point of seeing and of speaking; the vitrine in which is re-collected the rest of what has thus become a remaindered world: Europe as the brain of the earth's body.[8]

 The result of these superimpositions is the virtual space-time of our

modernity: an incomplete, unending, and unfinishable process. These superimposed coordinates are realized on a variety of fronts, which include but are not exhausted by the museum and art history. As a key component of the operating engines of the modern nation-state, museology and art history worked toward the systematic historicization of ethically eroticized objects of value as partners in the enterprises of the social collective.[9]

At the same time, the framed and storied artifacts or monuments were invested with a decorum, wherein objects would be legible in a disciplined manner, construable semiotically as emblems, simulacra, or object lessons; as illustrating (or representing) desirable and undesirable social relations in the (perpetually and endlessly) modernizing nation. Whose faults, it may be added, would consequently seem to lie not in its nature but in the relative abilities of its individual citizens to realize the national ideal or the potentials of their race or class—a gesture of social disciplinarity of truly surpassing brilliance.

In addition, artworks, monuments, archives, and histories are the sites where the hidden truth of the citizen, the modern individual, is to be rediscovered and read. (Of course there is never a final monument.)[10] The art historical object is the elsewhere of the subject, the place where it is imagined that unsaid or unsayable truths are already written down. Art history might have been a "science," then, both of the idea of the nation and of the discovery of the truth of individuals (nations, ethnicities, races, genders) revealed "in" their objects and products. All of which is centered upon and as that practice of the modern self—simultaneously semiotic and Eucharistic—we call art.

Such a "science," however, has never quite been a single professional field, but rather as one of several allomorphic applications of the protocols of modern disciplinarity as such; as "method" itself. It existed perhaps at such a scale as to be invisible in the ordinary light spectrum of individual perceptions. It might be known and recoverable today through an examination of traces and effects dimly legible in its later twin progeny (separated, so to speak, at their disciplinary birth), namely, history and psychoanalysis,[11] or through a critical historiography of a discursive practice—art history—that was always a superimposition of the two before their modern schism, and that in its oscillatory and paradoxical modus vivendi continues to bridge, albeit at times in the dark, what has since become their difference. Its oscillations *are* that bridge, and the name of the bridge is art history.

Art history might also thus be seen as a relationship, a sign of the

disparities between history and psychoanalysis; but that's another topic for another time. For the moment it may suffice to say that traces of this superimposition are palpable in that ambivalent and paradoxical object that has constituted the *art* of art history since the Enlightenment, with its perpetual oscillation between the ineffable and the documentary, the Eucharistic and the semiotic.[12] The art of art history circulates in a virtual space whose own dimensions are the result of the triple superimpositions described earlier.

Modernity is thus the paradoxical status quo of nationalism, existing as a virtual site constituting the edge between the material residues and relics of the past and the adjacent empty space that the future is imagined to be, demanding to be filled. That which is perpetually in between two fictions: its origins in an immemorial past and the destiny of its fulfilled future. The fundamental labor of the nation and its parts, this cyborg entity of people and their things, this conjoining of the organic with the artifactual, was to use the image of the latter fulfillment as a rearview mirror oriented back toward the former, so as to reconstitute its origins, identity, and history as the reflected source and truth of that projective fulfilled destiny. A hall of mirrors, in fact.

It might be pictured this way, to appropriate (yet again) a quote from Jacques Lacan: "I identify myself in language, but only by losing myself in it like an object. What is realized in my history is not the past definite of what was, since it is no more, or even the present perfect of what has been in what I am, but the future anterior of what I shall have been for what I am in the process of becoming."[13]

Comprehending the past of the profession of art history would mean at the very least abandoning certain easy academic habits of imagining it as some kind of "straightforward" practice—as simply a history of ideas about, or "philosophies" of art, or as genealogies of individuals who had ideas about art and its "life" and its "history," or as an episode in the evolutionary adventure of the history of ideas—as increasingly refined protocols of interpreting objects and their histories and their makers: all those "theories and methods" from Marxism to feminism, or from formalism and historicism to semiology and deconstruction; and all those disciplinary object-domains from fine art to world art to visual culture, which by hindsight, today, all seem cut from the same coarse cloth.

Art history has been a complex and internally unstable enterprise throughout its two-century-long history. Since its beginnings, it has been deeply invested in the fabrication and maintenance of a modernity

that linked Europe to an ethically superior aesthetics grounded in eroti-cized object relations, thereby allaying the anxieties of cultural relativ-ism, such that Europe (and Christendom), in their expanding encounter with alien cultures, might be saved from reduction to but one reality among many.[14]

You may recall that this lecture is entitled "Holy Terrors and Teleologies." I've spoken so far only of what might be construed as the (un)holy tele-ologies constituting art history and museology, so it behooves me to wind up by talking about "holy terror"—or rather starting to talk about it, as it will be a theme (the undeniably powerful effect of objects upon us; their inescapably haunted relationships to us) threaded throughout the rest of these talks. You may have inferred in what I've been saying here that insofar as art history is concerned, teleology should be under-stood as one side of a larger historical picture of these evolving discursive and museological practices. The obverse I have in mind is hinted at in the words of Lacan just quoted: "I identify myself in language, but only by losing myself in it like an object." How, one might properly ask, can we conceive of actually "losing oneself" and becoming "like an object" in art? This uncannily recalls the medieval Christian practice of *lectio* as prescribed by Hugh of St. Victor: transforming and assimilating a text into one's self.[15]

Had I been efficient enough, I would have been able to include here an image that may be familiar to some. It is of James Murray in the midst of his Herculean labor in forging what was in the process of becoming the *Oxford English Dictionary.* The image is taken from a complimentary bookmark distributed by Yale University Press a number of years ago advertising their publication of Elisabeth Murray's biography entitled *Caught in the Web of Words.* I've had this bookmark pinned to the board above my desk for some time.

It is precisely the domestication and taming of that potential and perhaps inevitable loss of the self in external phenomena, in language, in things, in *art,* that constituted the practice of the modern self that became the art of art history and museology. This is a practice aimed at forestalling the holy or divine terror, the *theios phobos* that Plato warned about as the destabilizing effect of the powers of art over the soul neces-sararily banished from his ideal polis; powers that Augustine no less than his religious progeny indicted as responsible for the distraction and ulti-mate death of the soul. There can be only one Eucharist.

It is not easy today, after two centuries of the anesthetizing effects of the social and philosophical project of aesthetics, to appreciate adequately the power that art was felt to have over the soul in Greek antiquity, a power equally alarming to early Christian philosophers such as Augustine, not to speak of those wrestling with this power in European religious thought for many centuries: not only philosophers and theologians but artists themselves, for whom the production of a work was perennially associated with risk to sanity, health, and life itself.

There is no "art history," no museology, that was not founded in the attempt to domesticate, discipline, and tame this power for the modern republic. Let me end here by quoting again the philosopher Giorgio Agamben, who observed that "the entrance of art into the aesthetic dimension—and the understanding of it starting from the *aisthesis* (the feelings and senses) of the spectator—is not as innocent and natural a phenomenon as we commonly think. Perhaps nothing is more urgent—if we really want to engage the problem of art in our time—than a *destruction* of aesthetics that would, by clearing away what is usually taken for granted, allow us to bring into question the very meaning of aesthetics as the science of the work of art." He then added: "The question, however, is whether the time is ripe for such a *destruction,* or whether instead the consequence of such an act would not be the loss of any possible horizon for the understanding of the work of art and the creation of an abyss in front of it that could only be crossed by a radical leap. But perhaps such a loss and such an abyss are what we most need if we want the work of art to reacquire its original stature" (i.e., its auratic power) (6).

We may not want that after all, but if we do, then an understanding of the semiotic foundations of the aesthetic project of the European Enlightenment will certainly entail articulating the extent to which the concomitant projects of art history and museology need to be not simply politely prodded, as we've been doing now for over two decades, but radically problematized.

I said at the beginning of these talks, and will once again repeat the words, "At the heart of that two-century-old practice of the modern self that we call art, the science of which we call art history or museology, and the theory of which we call aesthetics, lie a series of knots, folds, and conundrums, the denial of which we call the relationship between subjects and objects." I hope that it will have begun to be clear what the semiological underpinings of this science and this theory have been. The knots and conundrums characterizing the by no means straightforward

relations between subjects and objects are in no small measure an artifact of a deep ambivalence within the entire system, which is perforce reflected in the grand product of art history and museology that we call modernity. The fourth lecture will take up some of these subject-object conundrums in some detail.

But now I'd like to leave you with a thought experiment. I recently visited a new and quite interesting museum in the city of Maastricht in the Netherlands. It was designed by the architect Aldo Rossi and in 1997 won the "best museum design in the world" award for that year. But it's not the museum I want to leave you with but rather something I saw in the gallery of "Old Art." I don't have a picture of it, but it's easily described for our purposes here. It is in fact a medieval reliquary in the shape of an upraised arm and hand. As a reliquary, it was hollow and contained a relic, in this case the hand of the (unknown) saint. What I want to leave you with is a question. Based on what we've discussed, what kind of sign is that object? How are we supposed to understand its meaning? Is the reliquary and its relic an index of—a metonym for—the saint? Is this a portrait?[16] What kinds of behavior does it elicit and afford? And how can art history make sense of this (pre–art history) object?

Romulus, Rebus, and the Gaze of Victoria

The first three lectures in this series have laid down theoretical, methodological, and historical foundations for what will begin with this essay, namely, a close examination of several museum institutions that have been central to what I've been calling the fabrication and maintenance of that Möbius strip of phantasmatic dualisms of subjects and objects we call modernity, and which in my view includes its various self-trumpeted "post–s."

But I'm not coming to this subject unencumbered or unbent. It will become immediately clear in my talk about museums (let alone art history) that I am implicated in the subject in a number of ways, so that it behooves me to at least try to talk a bit about where I'm "coming from," and what my own stake in these issues concerns, at least in broad outline.

I preface what will follow with one reference, to the process of writing history, as argued by Walter Benjamin, which, he says, no longer means to describe events "the way they were" but rather to grab a piece of the past and separate it from the course of history, to "seize hold of a memory as it flashes up at a moment of danger."[1] I want to seize hold of some dangerous memories and, in wrestling with them, triangulate on the issues before us today. This lecture, "Romulus, Rebus, and the Gaze of Victoria," has three parts, as the title suggests.

ROMULUS

I've been spending time recently at the U.S. Holocaust Memorial Museum in Washington, D.C., in connection with research on museums and the manufacture of modernities; and a chapter in one of the books I've been writing forever is devoted to that museum (Figure 3).[2] Last summer, during my final visit to the parts of the permanent exhibition I had just gotten permission to photograph, I came across in one of the galleries a photograph of a large anti-Nazi demonstration in New York City in 1937. The photograph was an overview of a large crowd in the street, and in its midst was a young man wearing a gray fedora hat too old for him, wrapped in an overlarge overcoat and, like most of the adults around him, looking with rapt attention at the invisible speaker addressing the crowd (Figure 4).

I'd known about this man's artistic and political activities in the 1930s for a long time, but not about his participation in demonstrations of the kind recorded here. The shock of recognizing a young man who years later was to become my father (and who had just died two weeks before my visit to this museum) effectively derailed my photo-documentary program, and after quickly finishing that part of my work, some of which you see here, I left the building and wandered around the city for quite some time. I haven't fully stopped walking, and so this lecture's perambulatory quality might be seen as a continuation of that walk, and perhaps a way for me to begin slowing down.

In seizing hold of this memory that, in Benjamin's words, "flashed up at a moment of danger," I want to talk here about two other events that the experience itself evoked or "grabbed from the past," which can now no longer be fully separated in my memory from the first one. Taken together, all three give me an additional way to triangulate upon the articulation of art historical and museological systems of meaning we began looking at in the last lecture. Starting here we'll begin looking more explicitly at museums as archival artifacts or institutions.

Two incidents took place a few days apart several decades ago, their alternating juxtaposition and superimposition in my memory since that time a source of continuing fascination. Although I can't remember ever not remembering both incidents as closely linked together, they had remained mostly latent until my visit to the Holocaust museum in Washington last summer wrenched them back into view.

Figure 3. Interior view, United States Holocaust Memorial Museum, Washington, D.C.

Figure 4. Crowd at anti-Nazi rally, New York City, 1937. Photograph on display at the United States Holocaust Memorial Museum.

The first event was the reading of the "Prepositions" chapter in my first school grammar book. Each chapter of the textbook was headed by a diagram or picture relevant to the current lesson. The illustration to this chapter was the most intriguing, being made up of a whole roomful of prepositions all placed relative to each other in a spatial field delineated minimally by certain features—a raised dais on which there were a schematic table and chair, and, nearby, a very large red ball on the lower ground line of the scene. That picture has remained extremely vivid to this day: it occupied the upper two-thirds of the left-hand page of this yellow hardcover book. I also remember that the vanishing point of the picture was in the upper right quadrant of the scene.

All the common English prepositions were there: *in, on, over, under, above, around, outside, beside, before, behind, beneath,* and more, all in their proper places relative to each other and to some shape or outlined form. I learned my prepositions by learning to "picture" the picture in which each word had its correct relative position, as I remember learning the other parts of speech, and the syntax of sentences, in analogous ways, thanks to our illustrated grammar book. I was to learn many years later about the 2,500-year-old European tradition of the memory arts; at that time, these were simply neat tricks that actually worked, that any kid in the class seemed able to learn, thanks to having an intelligent and creative teacher and this magical textbook. Now that I think about it, she would also act out prepositions, adverbs, and other parts of speech by crouching under tables, standing behind doors, or dramatically hovering over the head of the girl (her name was Sandra Savin or Monica Brady) whose persistently plaid back sat squarely in front of me for the first hundred years of primary school.

One of my favorite things not long afterward was learning to parse sentences, because we got to draw those amazing line diagrams with their many subtended branches charting levels of affinity, conjunction, and dependency. In making out those sketches, you got to actually *see how the words meant:* how they worked together to map or build an idea or a sentence. It made you imagine that maps were machines to really produce what they somehow also seemed modestly to represent. It was like drawing and writing at the same time (or some different, third thing) and was interesting not least because it blurred the temporal separation of the two activities of art and grammar, allotted as they were—oddly, as it seemed then—to different periods in the same classroom each school day. Our teacher taught us to zip through whole

paragraphs after a while, and we also practiced visualizing words when spoken, and speaking and hearing them when written. Our homework often resembled pages and pages of intricate diagrams that would have delighted a Victorian botanist.

The second event took place that same week, I think, probably the Saturday after or the Saturday before: the first museum visit I can recall as a relatively sentient and ambulatory child. It was a trip with my father to the American Museum of Natural History on the west side of Central Park in New York City, a building constructed about two decades after the Oxford Museum that is the site of these lectures. This was my choice; given his background as an artist, he normally haunted the Metropolitan Museum of Art and other places of chromatic tranquillity on the East Side (Figure 5). The walk across the park I remember as endless, and subtly disorienting: you emerged at a differently numbered east-west street on the other side, as if the park were a distorting mirror separating two different cities, each slightly askew from the other, or each a different view, a different dream, of the same city. My father's city to the east, what was to become mine to the west. Across a space never to this day successfully sutured together . . .

What remains most vivid about the visit was the magnetism and seductive gravity of the place, the visceral feeling of being pulled everywhere by the museum, and of not wanting to leave, not being able to leave, before I had seen everything. (Everything in the world seemed to be there in one place; who could leave?) The fascination was so powerful

Figure 5. Museum of Natural History, New York.

that I was sucked away into the great swarms of other noisy children, the parent no doubt wishing by then that he were communing with well-lit contemporary paintings on white walls over in that other (East Side) city, his city, on the other side of the looking-glass meadows, places that were at any rate devoid of dim and dusty dioramas of Mohawk campsites and tottering tyrannosaur skeletons.

I remember scrambling up the cool, smooth, stone stairs to the next floor in the museum and very nearly being lost forever among the increasingly tightly packed displays and vitrines, ending up in a mazelike gallery stuffed with big glass cases. It was only after the museum had closed and the lights had dimmed that I became aware I was alone, apart from the distant voices of museum guards and an irate and extremely embarrassed parent gradually intruding upon my (now increasingly nocturnal) fascination. I had found myself in a place where you really might have seen everything in the world, where each thing had its real name attached, where every label demanded to be read aloud, and where all things were arranged according to their true relationships in time and space.

Unlike the famous carpet in Italo Calvino's temple at the center of the city of Eudoxia in his book *Invisible Cities,* where each colored line and pattern reminded visitors of parts of their lives arranged in their *true* relationships to one another, the objects in my museum were parts of the real world put together according to their true relationships that were obscured by the noise of the city outside.[3] A place of pure and lucid geomancy.

I had found a place where you could walk through time by walking through space. It was easy to disappear and not be found for a very long time, and I could have happily stayed there forever. It was a great revelation to learn that people spent whole lives working there. It was more surprising to learn, much later, that not only had numerous children had similar experiences or dreams with this and other museums, but that some adults had even written about it. Could my own unique personal experience have really been just another modern literary trope? An inevitable artifact or by-product of the museum itself? Was my museum a blueprint for (re)building the world outside? Or was it something else—a geomantic or grammatical machine that both organized and produced, realized and factualized, what it seemed merely to collect and record?

I have tried over the years to reckon with this enduring fascination with paired memories now decades old, which still oscillate back and

forth like the alternating states, perhaps, of an optical illusion. Did these events actually occur in the same week, or were they separated by weeks or months? And why do they always remember themselves and continue to this day to *insist themselves simultaneously* on me? This is a fascination that haunts the writing of this lecture. My attempt to reckon with this fascination itself oscillates between the two common senses of the word, in *coping with* my fascination (that fascination itself involving at the same time a seduction and a binding) and my *thinking with* it: learning to use its own language to think with; to think myself through (as I am continuing to do here).

The compound valences of such fascinations and reckonings are not unrelated to understanding archival, art historical, and museological phenomena as such, and I say this not to gloss over what might be taken as an unwarranted universalizing of my own idiosyncratic experiences. I'm not speaking of delineating some deep grammar of museums, or some museo-semiology. I want us to consider just what might be revealed by juxtaposing and superimposing (for example) prepositions and museums, by construing museology as an orchestration of valences of expressivity.

Which reminds me of the description of the notorious turn-of-the-century New York architect Stanford White, recorded not long before he was shot dead by the husband of his mistress, which insists itself here: "He walked Broadway like an active, transitive verb, amidst a rabble of adverbs, prepositions, and other insignificant parts of speech." What if the objects we find in museums were not strictly speaking the nominal phenomena beloved of art historicism but adverbial or prepositional entities? One can imagine vast museums made up of galleries devoted to the sum of all the rhetorical tropes imagined and named by the most brilliant Greek philosopher, Roman orator, or Derridean literary critic: the Litotes Gallery, say; or the Memorial Rotunda with statues of Metonymy, Metaphor, Synecdoche, Anaphora, and their sisters, all arranged in space according to their true relationships to each other; or even the Aristotelian Sculpture Gallery of Formal, Efficient, Material, and Final Causes. Or one might even imagine a Tate Modern, literally organized, to paraphrase what its chief curator described a few months ago, as a collection of artistic "tendencies"—immediately conjuring up a kind of zoological garden of caged tendencies growling at passersby: Abstraction! Corporeality! £250,000! (Figure 6).

Looked at in one light, the twin(ned) memories I've described could seem to take on the character of a catalytic, originary, or even traumatic

Figure 6. Gallery view, Tate Modern Museum, London.

experience (especially given that my first museum experience involved an encounter with the police), an experience that might plausibly account for some subsequent behavior—in this child's case, reasonably perhaps, his enduring adult fascination with the antics of that music hall quartet of art history, art criticism, art making, and art marketing (whose greatest act is always to convince us that they have finally broken up).

Yet it may also be an emblem of something that my memory will not permit me to dis(re)member. A mental artifact constituting an archive— an archive inscribed in me; in and as me, one might want to say, as an origin; an anchor to the future anterior of a curriculum vitae. An exhortation to remember a future that by hindsight one might find pleasure in claiming its portents. I'll return later to this problem of the essential futurity of archival events and of the museum; the idea, in short, that museums and archives are artifacts and effects of a certain concept of the future, the products of a particular system of time, a modernist temporality whose skin poorly disguises the Euro-Christian teleological muscle wrapped around the Judaic messianic skeleton beneath.

But if this twinned memory is an archive, it may be so precisely because of the obstinate indeterminacy of which "came first"—the grammar book or the museum. The notion of the archive is equally bound up with the notion of beginnings; of a beginning, an *arche,* the root

word, after all, being an ordinal term; the designation of a firstness in a series of events *(en tei arche ein o Logos).* The archive literally enumerates who or what is first, second, third, and holds out the possibility of the idea of a last thing—which it also perpetually postpones; I'll return to that later.

You may also have heard the story I told as a classic instance of interpellation, a description of some of the circumstantial mechanisms of one child's being fashioned as a social subject: of becoming a subject by being sub-jected to and being summoned by (by being seduced and fascinated, literally bound to and hooked into) the peculiar topological matrix of devices and desires we associate with our modernity. Being *fascinated into* a museum was like being walked through the innards of a metaphor.

It may be, then, that this small hyperactive synopticist in his Museum of Natural History (every word in that title an irony of immense proportions) understood by his behavior that once inside, there's no real outside ever again, or at least not in the way he knew it before—the irony, perhaps, of all exit signs. Certainly, after the museum, things outside the museum came to be transformed from just plain ("real") stuff into *things-not-in-museums.* Things were just never the same; once through the museum, the rest of the world is a vitrine, and everything in the world a maquette of every thing in the world.

It appears that what was set in motion (or put in place) more than four decades ago was the germ of an awareness of the paradox of fixed, clear boundaries or distinctions between subjects and objects. There was an extraordinary fascination with enacting these ambivalences, of losing one's self in the frame (whatever that self could have been at that time), of "putting oneself into the picture" as a way of finding one's own place in this world of objects: to become in a way a kind of object in one's own right, and thereby to represent something or be somebody.

Which reminds me of the startling effect of seeing myself reflected in the glass of vitrines looking at their contents—seeing myself seeing; seeing myself as a mirrored image adjacent to other images in the display case. And of course seeing the images of others seeing; even images of others seeing me seeing myself, and seeing them seeing me watching them . . . This in fact became a favorite museum game to be played sometimes alone but mostly with a gaggle of friends: to hold perfectly still, in just the right light, aligning one's reflected image in a precise manner so as to have the whole display appear to naturally incorporate

one's self. (Childhood really *was* different before computer games.) Wishing earnestly to be seen by passersby as objects in an exhibit, rather like pretending to parents to be asleep. Before breaking up into giggles at the consternation of passing adults and especially of museum guards who really didn't appreciate your lying under the tyrannosaurus skeleton pretending to be wounded, dying prey. (Some of my friends grew up to make a living at doing this kind of thing.)

That first flight into the museum, that first seduction, engendered a powerful desire for some singular panoptic point implied—really, one felt, *promised*—by each of the teasingly partial panoramas and views within that great building. A point from which to take in the whole and see it all together, all properly parsed and set in amber once and for all: the Big Picture and the Whole Story. But this manufactured appetite for a genius loci—for finding the spirit or meaning of a place whose underlying system or logic was visible only from a singular point—had many other venues in which these socializations were staged. One of the more hyperactive of these (the last story for now) was the game of what we called Big Tag, which involved chasing each other at breakneck speeds across the rooftops of (mostly contiguous, often not) high-rise apartment blocks in Lower Manhattan. The aim being to find places to really *see* the city, to rise above the maze of individual streets, each block of which seemed, at ground level, a whole walled world in itself. One of the objects of the game was to get to a point high and remote enough and far enough away from the half dozen or so others chasing you that you could then shout out the names of all the landmarks you could see from where you were, before you were tagged. It entailed a certain honesty among peers, since the claim that, say, the Chrysler Building was visible from where you stood could always be checked out; dishonesty was rewarded by being readily and very soundly beaten up.

Often this game was played in the neighborhood of one grandmother (her building was usually home base, since I had the key to the door to the roof), who, with what I learned years later was her incipient Alzheimer's, was never able to remember names of particular relatives (including me) but always knew them by whose child, cousin, sibling, or parent they were (my structuralist grandma Rose, the grandmother of all metonymies), which led her to amazingly baroque circumlocutions bearing an uncanny resemblance to diagrams of parsed sentences, or prepositional tableaux. She always knew the diagram, but the words in the lined spaces were increasingly being erased from her mind (as be-

came the case in recent years with my father and will someday, perhaps already, be my own fate).

To repeat: any such panoptic desires that might have been encatalyzed in the child would thus have been elicited by the frustratingly partial synopticisms of museum, archive, or city, the fact that there are places where one can see large portions or sections (but never the whole thing; as Merleau-Ponty famously reminded us, that view is reserved for the God whose view is, so to speak, perpendicular to all possible mortal viewpoints). Any desire for lucid totalization would thereby be simultaneously engendered and frustrated.

It seems reasonable to conclude that in some obscure way the child sensed that the two things recalled (the museum and the grammar book, fused together like an enigmatic image in some ancient or medieval *ars memorativa*), and since joined here by the litany of other things being evoked by this lecture as having been in the same childhood time frame, may have been versions of some obscure greater thing, or different ways of doing something similar, or perhaps a similar attitude taken up toward different things. He may simply have sensed that the deployment of objects in the museum was meant to be understood as akin to the relative deployment of prepositional parts of speech, the branching of affinities in a parsed sentence, or the topology of kinship relations. Rooms, galleries, as sentences or episodes; the whole place a great episodic chain making up an epic story, endlessly parsing itself or being parsed, to be spoken, to be enunciated bodily, choreographically, by its perambulating users or visitors. It is as if the stories, objects, people, and spaces of the museum were a rebus—not made up of words and pictures on a page but actively produced choreographically, gathered and sewn into sense by movement in space and time. Every man a genius loci.

The museum and/as (hi)story. Or at least *his* story. The "he" here, the "me," becomes increasingly anonymous, of course, as these mnemonic ripples expand outward. Michel Foucault described archives as built around emptiness or lack. Can an absence itself be a document? An archival event? Can an empty space or passage in a museum (one thinks necessarily of Daniel Liebeskind's Berlin museum) be read unambiguously as documenting a specific absence? What kind of semiological relationship is the equation of emptiness and absence? How might the sign or mark of evacuation or removal signify? Is a circumcised penis—a genital mutilation that, in marking and displaying an absence of skin, claims to denote a distinction and a subject position, an identity—a monument

or a document? Is this mark of an erect penis visible on a penis in a flaccid state simply the sign of incipient arousal? How is a sign of future potency an archival marker of ethnicity? The marker of potency, inscribed (or, in fact, excised) onto a currently nonpotent or quiescent state of an organ, of the desire or anticipation of future power? Is this merely the adopting, at the behest of a God, as essential to a compact with, a compacting and juxtaposing of oneself to, the God who is by definition immaterial, of the sign of a current or previous enslaving power, adopting a practice indigenous to the enslavers (the ancient Egyptians), as a mark of future power and independence of those enslaved?

Jacques Derrida began to look at some of this problem in his book *Archive Fever,* where, juxtaposed to his all too brief discussion of what he terms the *enigma* of circumcision as an "archival act," is the following: "I must put it aside here (this question of the enigma of circumcision), not without some regret, along with that of the phylacteries, those archives of skin or parchment covered with writing that Jewish men, here, too, and not Jewish women, carry close to their body, on their arm and on their forehead: *right on the body (à même le corps)* like the sign of circumcision, but with a *being-right-on (être-à-même)* that this time does not exclude the detachment and the untying of the ligament, of the substrate, and of the text simultaneously."[4]

We need to press Derrida further here, and to superimpose his juxtapositions. Derrida astutely "re-members" circumcision by suggesting its obverse or twin (really two points on the same Möbius strip that only seem separate because of the fold)—the application of the phylactery, the skin inscribed with text, onto the skin of the circumcised male. Let's think these together for a moment. Here we have a transferral, a translation, one might say (displacement *and* condensation), of severed skin into text; and not without some echo, one might also say, of that superimposition of Word and Godhead at the opening of Genesis ("In the beginning was the Word and the Word was with God *[pros ton theon]* and the Word was God"), which begs the question as to what exactly comes first. Which is, of course, the essential question, after all, of the archive as such, the question that always remains the same: what or who comes first? (the question of the *arche* or origin or beginning, or, literally, the first [thing]: *en te arkhe ein o Logos . . .*). In archiving was the Word. In the beginning was the foreskin. But the true new beginning, the archiving repeated in every generation, was its replacement (but elsewhere on the body) by a new skin of text. The skin of text as a scrim on

the forehead (and/or left arm—the arm that generally does not write), a reminder of the pact, a promise. How can the represencing of an absence be a promise?

Derrida puts aside this question of circumcision (the removal of a portion of skin) and of the phylactery (the application of a piece of skin [parchment, paper] covered with writing onto the body of the genitally altered male) "with some regret," as he says. He neither returns to this question nor addresses his regret. What I'd like to focus on is the double question of who (or what) is the "artist" (aside from the God or her representative performing the circumcision) in this archive, and I'd like us to consider the archive as the marker of loss—a mark of mourning. And a mark of sexualization, of gendering, as itself, as Judith Butler has put it, the mourning of a loss that was effected in order to think its loss and to act, to engender, perpetually to repair the rift. A rift it (gender) perpetually and futilely re-creates.[5]

I have been trying to speak here in a complementary doubled register that in part may be heard as the trace of an incompletable centripetal trajectory aimed at finding/founding a subjectivity as a triangulation; as a correlation between the visual practices of a father (and artist) and the ubiquitous practices of a lost grandfather (and poet) of whom I've not spoken but who died the year that the paternal photo in the museum was taken, and whose own writings were put onto the shelves of a certain child's room before the time of the primary school events just described. I haven't even begun to deal here in all this talk of doubling and oscillatory identities with the implications of the possibility that the man in the museum photo may have been his twin brother, whose name, of course, was Remus.

Rebus

At the center of an archive is a tomb . . .

All of what you have just heard has dredged up another event in another museum: another traumatic rift, which insists itself here. Figure 7 reproduces an 1841 lithograph of a scene in the Jewish cemetery in the Kasim Pasha district of Istanbul, depicting the reading of prayers for the deceased, whose tomb we may believe is the one represented here, next to which is seated a woman whom we may also believe to be the grieving widow. A grieving widow whose powerful engagement with the viewer—and, we may also believe, the young painter, who was to marry the following year—elicits desire in the midst of death, framed by death,

Figure 7. Scene in Jewish cemetery, by Amadeo Preziosi, Istanbul, 1841.

rejecting death while juxtaposed to it, superimposed on it, and the dead
body in his tomb.

I first saw this lithograph in the Jewish Museum of Greece in Athens,
and I remain haunted by it for various reasons, some of which are im-
possible to speak of here, not only because of time (the painter, whose

name was Amadeo, was an ancestor of the young man whose picture I saw in the Holocaust museum in Washington this past summer) but also for two reasons that relate directly to what I've already said and concern what has brought us together here and about which I am continually trying to talk, that is, to circum-*locute,* to circle around and wrestle with.

The first reason concerns the relationship between archival activity and the death drive, the impulse to flee a death that always pursues us like a night that never ceases rolling up behind our backs and consequently propels us forward archivally, which is to say, perforce, erotically. The economy of *eros* is that of the archive, of the museum; *eros* properly denoting want or lack, a sign of what is missing. Both loving (what the late Roland Barthes called the pure elixir of anxiety) and archiving depend for their perpetuation on maintaining a state of tension that guarantees the nonachievement of final closure or completion, beyond the transitory satisfactions of answers, beyond the satisfactions of being sated. This is not unrelated to my own perambulatory wandering around this nexus of proliferating memories, a spiraling, centripetal walk whose center point continually recedes into smaller dimensions, fractally connected. Like a picture of someone looking at a picture that contains someone looking at a picture of someone looking at a picture . . .

The second reason concerns the double tension between understanding subjects as homogeneous and heterogeneous, and between the desire for a synoptic point of resolution in which all things disparate are resolved into uniformity—like some kind of Last Judgment, where all the dispersed body part relics of a saint are rejoined together in heaven—and the desire for its antithesis, in which all uniformities are construed as masking a more fundamental heterogeneity and disjunctiveness. There is a related phenomenon called up by this tension, which I've alluded to before. This is the practice of explanation by origins, which is commonly taken to refer to a progression of states from a simpler unity or *punctum* to a complex, compounded, evolved, or degraded and chaotic current condition.

In fact, in the work of this recently arrived, twenty-five-year-old European painter, who lived the rest of his life in Istanbul, recording the costumes, customs, and scenes of daily life both there and in Egypt, Palestine, and the Balkans, this is an unusual scene not only in its somber narrative character (he made his living painting colorful scenes of the city and its characters for visiting European, and especially British, tourists) but also in its unabashedly direct engagement of a figure—and a

female figure at that—with the viewer. The widow is a player in a highly charged emotional scene in which her behavior contradicts artistic conventions and social expectations. What might be expected as a depiction of grief and mourning is transformed by the woman's gaze into not only a defiance of death but a challenge to the viewer that is not simply proprietary but erotic. She is not merely a person challenging our presence as intruders into a private scene of family mourning; she is a woman erotically engaging the viewer directly and openly, while prayers of remembrance are being read right in front of her.

Of course I am projecting into this scene, am I not, something that may be wholly fictitious? She—and I like to think that her name is Hannah—may be the daughter of a dead parent, or the sister of a deceased sibling or other relative, performing filial duty on a day of remembrance. She may not in fact be the widow of a husband recently dead. Yet precisely because of the manner of her engagement of the viewer/artist, not long after to be married to a young widow in this community, the speculation may not be off the mark.

What I want to call attention to is the presumed (auto)biographical and archival act of an artist depicting (semifictional?) characters, the dramaturgy and stagecraft presented here closely engaging what I've just been talking about. I've dredged up into the present certain "historical" matter; I've foregrounded the depiction of a singular act in its ceremonial setting, seizing a piece of something—an erotically engaging gaze—that for a variety of intensely personal reasons is absolutely present and alive, and staging it here as a beginning, an *arche,* of a life. In fact it is *I* who is seized up by this seizure, in recognizing a moment of drama and danger in an act that ruptures the ceremony taking place in what was—an instant earlier—in front of her. She is seated with her body facing the reader, but her turned head changes the entire topology: her eyes are outside the frame. She no longer attends to the reader looming over her with his book; she is engaging us, or at least the young foreign painter. Like a character in a novel directly addressing the reader while remaining on the whole within the third or "historical" person: describing while problematizing, ironicizing the objectivity of description itself. In fact the scene is a picture of desire and its effects on the frame of life in what Lacan called the symbolic order of daily life; destabilizing, blasting open, flooding out beyond the boundaries.

Which raises several obvious questions regarding the nature of pictorial figuration, questions of integrity and homogeneity, and of the interdepen-

dence of artifacts or objects and subjects—which, again, is the key issue haunting this series of talks. Here the picture surface is a screen that both separates and connects the past and present. My Hannah looks away from the man reading, away from the tomb of her husband, toward a future on our side of the screen, a future she engages with—and not in some general way (she's not merely looking out over the city in the background, meditating on her future)—specifically and concretely in the eyes of the viewer, the artist, us. Her future as our reading of her. Of my reading of her. Of my reckoning with her effect on my shifting subject position(s).

An understanding of the depiction is dependent on a concept of the image as essentially incomplete, as part of a process, perhaps indefinite or infinite, linked to the future. To read the image is to sew together the pieces of a rebus of disparate things into an archive that by its nature is dependent on the concept of the future, of futurity; in which parts of this artifact are composed into an *arche*, a beginning, a firstness, eliciting, calling forth and engendering, what will henceforth be subsequent. So where is the archive's beginning, its *arche*? What this figure I'm naming Hannah ostensifies, in short, is the indeterminacy of beginnings and ends. To read an image, an archive, undoes it. To remember is literally to dismember memory.

A common rebus is sewn into sense by pronouncing it in a way that takes literally certain elements—say letters—and the sounds of the names or parts of the names of objects or part objects interspersed with them. What sews *this* rebus into sense is not voice as such, even though my art historical voice is narrating this tale, but rather the tracing of a trajectory; a lineage, a history, of desire, of female desire and its eliciting engagement; the inscription of a line, an arc, linking the remains of a man being committed to memory by the reading of a text, being transformed into and becoming (a) text, a phylactery, even—through the surviving partner whose turning away from him articulates him as past, rendering him dead—into a future elicited, seized up by a gaze engaging the eye of the viewer, and initiating a chain of events that will have led to this act being legible here, at this moment and in this place, as a beginning; not least that which I am voicing here, and not at all anonymously, and for the first time, as my own, in a painting by a man who is painting the distracted mourning of his future wife for her previous husband. Let's be clear about this man.

Let's be clear about this woman: she embodies at the same time, but

in different directions, mourning and desire, melancholia and performativity. She is at the same time a relay and a link in an endless chain of episodes, of men, stretching back to a compact with a God who demanded that henceforth there should be worn on the body a sign of futurity devised out of a sign-token of the severed piece of flesh that rendered the appearance of the remaining phallic organ a pointer to future potency and power in its impotent or quiescent state.

There's much more, including the third part of this text ("and the Gaze of Victoria"), that time precludes me from reading, and which in any case would principally have been a foretaste of the next two lectures. The next two institutions we will examine constitute together our collective foundation in the modernity that I have been trying to perform here in a series of anamorphic oscillations.

Our promised selves are always hidden in the holes in discourse, or just around the next corner, or outside the frame of the painting, or beyond, before, or posterior to, the margins of our lives. Or further along the continuously twisted Möbius strip making up the modernist deployment of subjects and their objects, whose opposition, as I suggested at the beginning of this series of talks, is the artifact of a refusal to see them as the dynamically variable effects of the forces of power and desire; as the two anamorphic states of the same modern self that, while materially singular and contiguous, are each invisible to the other from the place of the other. Taking that seriously could be tantamount to beginning to appreciate the indistinguishability of artist and archive: a most dangerous and terror-laden proposition, to be sure. In the next essay, we'll look at one institution where an artist, Sir John Soane, and an archive—his museum in Lincoln's Inn Fields in London—grew together and in tandem over a quarter of a century. In the following essay, we'll look at Queen Victoria's archive, the Crystal Palace, and consider the proposition that the effective father of modern art history (its Aristotelian Efficient Cause) was not Winckelmann, Kant, or Hegel, but Queen Victoria herself.

In the next two lectures, then, we'll consider the implications of these two institutions for understanding the roles of art history and museology in fabricating, factualizing, and maintaining the phantasms making up the realities that, in our modernity, they seem simply to reflect and recount.

The Astrolabe of the Enlightenment

The previous essay raised a variety of issues concerning our individual investments in the business of art and museology, and that talk completed the first or more general half of this series of lectures. Now we're going to look at a number of art institutions that I'll be presenting as what I'll call case studies to illustrate and expand on many of the points raised in the first four lectures about art, art history, museology, and the modernities they have worked to establish, maintain, and exemplify. Admittedly, the very notion of a case study that presupposes an already given set of ideas is not unproblematic.

One of the central theses that might be distilled from the previous lectures is that art is an organizing and orienting concept that makes certain notions of the (individual and collective) subject visible and therefore legible and intelligible. The principle of such notions concerns the subject's appearance as unified, substantive, selfsame, and unique. In this regard, notions of art and of the aesthetic are essentially bound up with fantasy—and much of the rest of this series of talks will revolve around fantasy and the historical role of the museum as the siting of personal, national, ethnic, religious, and racial fantasies. My interest will be in how art was invented to sustain modern notions of identity, and how museums in the nineteenth century evolved as orchestrations of such notions. We'll be concerned with understanding *how* such institutions worked, whom they served, and what was at stake in their successes and failures.

We begin with an institution that has haunted some of the previous lectures, Sir John Soane's Museum in London, about which I have spoken in a general way, but which it is now necessary to look at concretely and in some detail. I've said some things about Soane as a collector, and I want now to look at how his collection worked. But first a simple reminder of the etymological origins of the term: to collect literally means to *read* (things) *together*, at the same time and in the same place. There is a fundamental tension between the fixity of a collection of things and their reading or perusal, which commonly takes place over time, in effect dis-membering the collection's unity, what the collection re-members. It is then an active term and is in line with an observation of Stephen Bann's that the early modern collector was the model through which the unity of the self was progressively and retrospectively achieved, and with a study by Mieke Bal on the narrational functions of collecting.[1] Objects, if you will, are made to become relics of one's evolving personhood, fragments woven together—read together—in and as a narrative recounting and giving shape to one's life. A shape in time or a trajectory or journey: a curriculum vitae. A reading, it might be added, that is endless, and moving in not necessarily predictable ways.

Today I want to do a close reading of Soane's Museum, about which the following observations may stand for the great range of reactions to this remarkable house, museum, and collection: "Never was there, before, such a conglomerate of vast ideas in little. Domes, arches, pendentives, columned labyrinths, cunning contrivances, and magic effects, up views, down views, and thorough views, bewildering narrow passages, seductive corners, silent recesses, and little lobbies like humane mantraps; such are the features which perplexingly address the visitor, and leave his countenance with an equivocal expression between wondering admiration and smiling forbearance."[2]

"This labyrinth stuffed full of fragments is the most tasteless arrangement that can be seen; it has the same kind of perplexing and oppressive effect on the spectator as if the whole large stock of an old-clothes-dealer had been squeezed into a doll's house."[3]

While it may be difficult to capture in words the complexities and nuances of architectonic artifice of an ordinary kind, those that characterize Sir John Soane's Museum in London (1812–1837),[4] the object of the two conflicting observations just quoted and the subject of this essay, present virtually insurmountable difficulties, and not only because of the restricted space available here. The few illustrations in the following text, then, must serve as synopses of the most salient portions of the

following narrative; more complete discussions of the present subject may be found elsewhere.[5]

Soane's Museum has received unprecedented attention in recent years from many architects and art historians due in large part to its seeming resonance with certain postmodernist or poststructuralist design tendencies (wherein Soane [1753–1837] is often framed as a proto-poststructuralist).[6] What follows is an attempt to articulate some of the original aims and intended effects of this extraordinary institution in the light of its relationship to early modern museology and art history, relationships largely unexamined in the contemporary discourse on both the institution and its creator.[7]

A. Let us begin by walking through it. Our walk-through will be in aid of addressing the question: What exactly were you expected to see (or indeed to have become) in the bizarre labyrinth of a place known as Sir John Soane's Museum, a place that seems to bespeak a *horror vacui* of monumental and encyclopedic proportions and seems obsessed with death and commemoration: a haunted house, teeming with ghosts? What was legible in what was visible here? And in what ways can we speak of this extraordinary fabrication as a "museum"?

What you see at first (Figure 8) is a rather unremarkable building on the northern side of the large square called Lincoln's Inn Fields: a four-story light brown brick facade set back behind an iron fence (numbers 12, 13, and 14), virtually indistinguishable from the others on the street.[8] There are in London many thousands like these three contiguous row houses that today make up Sir John Soane's Museum. The main distinguishing feature here is the white stone facade of number 13, built out several feet from the face of the brick wall, comprising a glassed-in loggia spanning two full stories. This is extended up into the central portion of the third story.

There is white stone trim delineating each of the stories, extending both horizontally and vertically from the projecting stone facade. Simple classicizing decoration can be seen on the facade and roofline: there are strips of meanders carved into the stone, and small *akroteria* surmounting the third story and the fourth-story roof balustrade. Between the three windows on the first and second stories, there are twin Gothic pedestals in the form of column capitals affixed as brackets to the facade. Two stone caryatids, recalling those of the Erechtheion on the Athenian Akropolis, stand on either end of the top of the second-story stone facade. Parts of the side windows of this stone loggia are of colored glass.

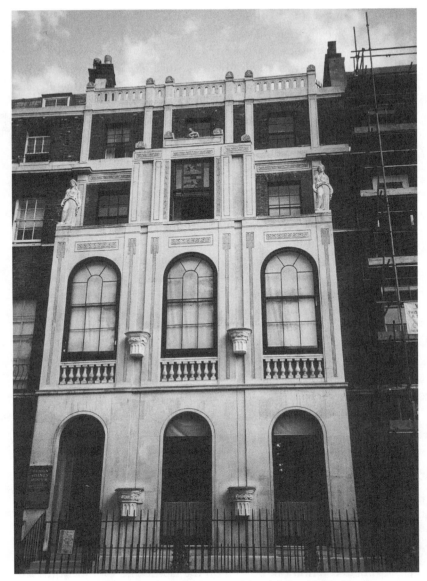

Figure 8. Facade of Sir John Soane's Museum, Lincoln's Inn Fields, London.

You walk up the short flight of steps to the main doorway on the left side of the central part of the building and enter into a modest hallway, which, beyond a cantilevered spiraling stairwell, opens out suddenly into one of the most astonishing domestic interiors in the city, resembling at

first glance a three-dimensional mock-up of a trompe l'oeil wall painting of the Fourth Pompeian style, with buildings resembling fantastic stage sets, airy garden pavilions the size of palaces, and spaces of logic-defying, Escher-like complexity (Figure 9).[9]

The interior is truly kaleidoscopic, replete with light wells, skylights in both clear and brilliantly colored panes of glass: a maze of rooms interspersed with open-air courts of varying size and surprising position.

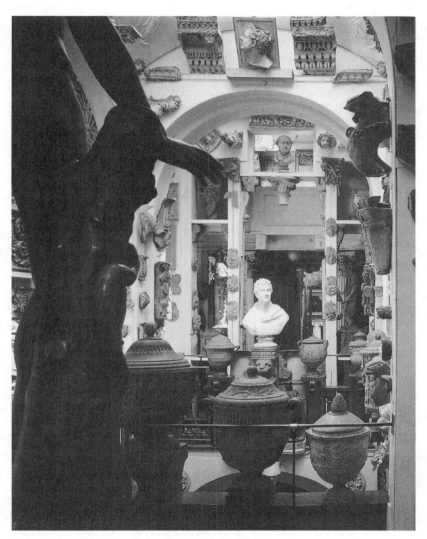

Figure 9. Interior of the dome, Sir John Soane's Museum.

Some spaces have low ceilings; others are two stories or more in height. Parts of some floors are of glass block, admitting light into the lower basement rooms. Changes of level and scale occur unexpectedly, and there seem to be several different ways of getting from any one room to any other.

You also become aware that there are scores of mirrors everywhere. They are flat and convex, large and small, and are fixed to walls, on concave or square indented ceilings, in pendentives, and in countless recessed panels that collect, focus, and pass on direct and indirect light, enriching and juxtaposing colors, and multiplying the spaces of each room in such a way as to collect the contents of adjacent rooms into the space you're in. Ceilings are divided into recessed and projected panels—many carved, others plain, and all richly colored. The room colors that predominate are Tuscan red and antique yellow *(giallo antico),* and some walls are painted to imitate marble and porphyry. Some of the wood trim is painted a greenish color suggestive of weathered bronze.

Everywhere you look there are statues, busts, bas-reliefs, paintings, stone and clay vases, medallions, architectural motifs, full-size fragments of buildings, as well as models of both ancient and modern buildings made of wood, stone, plaster, and cork, standing on tables, wall brackets, balustrades, shelves, and even embedded in ceilings. To virtually every surface of every room is affixed some object or part object, some fragment of a thing. And each is often visible several times over, and from different angles, in the many mirrors and mirrored panels on walls, ceilings, windowsills, and the tops of bookcases; indeed, it is hard at first glance to tell what is mirrored and what is not. The scale of things often changes dramatically from one object to the next: a piece of a fifteenth-century roof abutting a miniature figure of a Greek goddess; an architectural model forming the plinth of a life-size statue (Figure 10).

One room, whose walls are covered solely by paintings (the Picture Room, in the northeast corner of the building), contains three walls (north, east, and south) made up of hinged leaves of superimposed panels, with paintings hung on all surfaces. The hinged leaves make it possible to hang several times the number of pictures than might be accommodated by a room of this size with normal walls (Figure 11).[10]

The south panels in fact make up the wall itself: they may be opened up to reveal a two-story light well beyond, revealing the basement-story Monk's Parlour below. Out across that two-story space, and surmounting

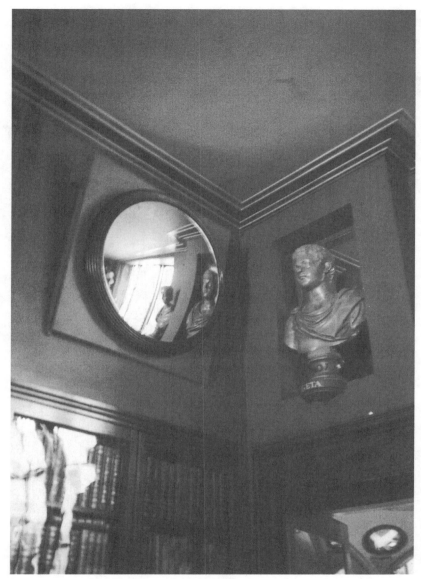

Figure 10. Mirrors in library, Sir John Soane's Museum.

Figure 11. Picture room with open eaves, Sir John Soane's Museum.

a model of the facade of the Bank of England, of which Soane himself was the architect, is a semidraped female statue, a white plaster nymph by Sir Richard Westmacott, seen against a window originally made up of brilliantly colored panes of glass (as were most of the building's windows).

You might indeed want to make some academic art historical sense of the place by assigning a particular area, tableau, or decorative schema

to a single style (classicist, romanticist, Egyptianizing, neo-Gothic, etc.), responding to sets of obvious questions that pop up as you walk by: Why is this image of Britannia in a basement recess adjacent to one in which there are those wooden models of Soane's tomb? What is a second-century Roman altar doing near two Twenty-second Dynasty Egyptian stelae made a millennium earlier? And so forth.

The place was no small scandal to more than one nineteenth-century continental (and usually German) art historian or connoisseur of the predictably historicist or Hegelian bent.[11] You sense that any such pursuit in this case would be one that somehow sets off on the wrong foot and misses something basic about the place: not merely Soane's (rarely acknowledged but very great) wit but rather something else, and something rather more critical, guaranteed to strip the gears of your common or garden-variety art historical Hegelianism, or to dampen many of your postmodernist enthusiasms.[12]

The place was in fact a rather remarkable critical instrument, one closely attuned to the museological atmosphere of the first third of the nineteeth century in its carefully calibrated commentary on the galloping historicist gloom that was taking place elsewhere at the time, notably in the British Museum nearby in Bloomsbury.[13] Soane's Museum has what by hindsight seem some powerful and startling things to say about history and art, and about ourselves as subjects of artifice and history. The legibility of this has been a long time coming, given the universal dissemination and success of a museological modernism that now itself might seem on the wane.[14] But let us leave this for the moment and look at the plan (Figures 12 and 13).

At what seems the approximate center of the building—on the north-south axis of number 13, and adjacent to the east-west axis of the structure—is a small, open-air court (18), which contained at its center a large-scale pasticcio, a composite pylon made up of ancient and modern (and non-Western) architectural pieces, erected in 1819.[15] It was surrounded by fragments of a Roman frieze whose forms echoed those of the branches of an ash tree found in the woods of Sussex, which were hung nearby. The court is visible on all four sides through glazed windows on the first floor—from the dining room on the south, the breakfast parlor on the west, Soane's study and dressing room on the east, and, on the north, from a passageway forming part of the southern section of a colonnade running east to west (10).

This latter, about twenty feet in length, consists of ten low Corinthian

Figure 12. Plan, first floor, Sir John Soane's Museum, 1837. Modified by the author from John Summerson, *A New Description of Sir John Soane's Museum* (London: Trustees of Sir John Soane's Museum, 1987, 1991); copyright Trustees of Sir John Soane's Museum. Reprinted with permission.

columns carrying a room above (the Upper Drafting, or Student's, Office), which is detached from the ambient walls, allowing light into side aisles on the north and south. Following this to the west, you come upon a brightly lit area known as the Dome (11). This is a three-story space capped by a conical skylight, with smaller, colored glass skylights on three sides. The brightest interior part of the building, it seems for various reasons to be a climactic or focal point of the museum. The

Figure 13. Plan, basement floor, Sir John Soane's Museum, as existing. Modified by the author from John Summerson, *A New Description of Sir John Soane's Museum* (London: Trustees of Sir John Soane's Museum, 1987, 1991); copyright Trustees of Sir John Soane's Museum. Reprinted with permission.

room carried by the Colonnade—steps lead up to it at the east end, and you will find there a drafting room (34) whose walls were hung with classical bas-reliefs—has a small window at its west end, which looks down into the Dome.

The first-floor balustrade of the Dome is mostly surmounted by stone funerary urns (whether authentically antique or not is not readily discernible) and several busts. On its east side stands the bust of John Soane himself (Figure 14). Opposite him and across the space to the west is a cast of the *Apollo Belvedere,* made from the original in the Museo Pio Clementino in Rome.[16] Apollo, originally bright white, since darkly varnished, and John (still white after all these years) face each other across

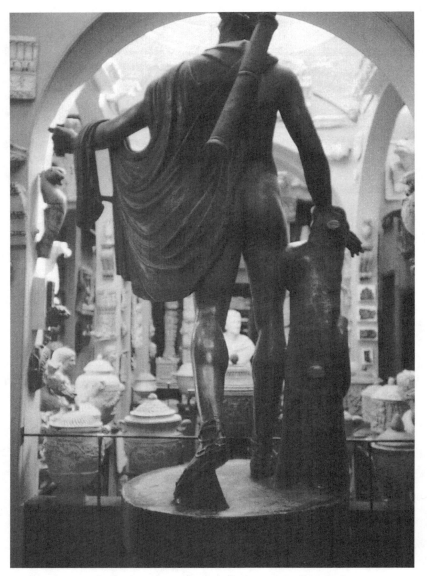

Figure 14. Bust of John Soane seen through the legs of *Apollo Belvedere*.

the space that is open down into the basement story. The small window of the drafting room above the colonnade looks down over Soane's shoulder. Standing in that window is a bust of the painter Sir Thomas Lawrence, whose portrait of Soane stands in the first-floor dining room.

On the wall surfaces and pendentives of the Dome are masses of architectural and sculptural fragments, heads, medallions, and vases on

brackets. Looking down, you will see, in the area known as the Sepul-chral Chamber (28), a large Egyptian sarcophagus, made for the pharaoh Seti I circa 1300 B.C.E., excavated at Thebes by the famous archaeologist, adventurer, and entrepreneur Giovanni Belzoni (Figure 15).[17] Faded to virtual invisibility inside is the full-size image of the goddess Nut, whose

Figure 15. Sarcophagus below first-floor balustrade, Soane's Museum.

outstretched arms would have protected the mummy of the deceased Seti. Only faint traces remain of the extensive hieroglyphic inscription, some of which was incised and filled with colored paste, much decayed since the sarcophagus was installed here in 1824. The installation of this item occasioned a three-night lamplight celebration with colored lanterns, costumes, music, and scores of notables from Coleridge to Turner jostling each other in the gloom for a glimpse of glyph and a piece of cake.[18]

You can enter that lower floor by returning through the Colonnade (what Soane at times called the "museum" of his museum) and descending a staircase to the left (north), where you find a gloomy sepulchral underworld, a crypt of many chambers and recesses strewn with epitaphs, memorials, ancient and medieval ruins and relics, and several tombs and tomb models apart from the Egyptian sarcophagus.

Parts of this basement receive shafts of light through the (post-Soane) glass block floors in the Colonnade's south aisle and south end of the corridor to the west of the Picture Room. There was a chamber to the east of the sarcophagus beneath the Colonnade known as the Egyptian Crypt, which originally was unlit and made of massive stone blocks on walls and ceilings; it was remodeled and its back eastern wall cut through in 1891. The tomb of "Padre Giovanni" can be seen in the Monk's Yard (17) on the east of the building, through a south window in the Monk's Parlour (20, under the first-floor Picture Room). It is surrounded by ruined fragments of an anonymous (and imaginary) medieval building (actually a fifteenth-century piece of old Westminster, staged as a medieval ruin). The Monk's Cell is to the north, beyond the Parlour (Figure 16).

The Yard and its tomb are also visible from above and to the west, from a small set of rooms to the southeast of the first-floor Colonnade. The one to the south (6) was Soane's tiny and ingeniously outfitted Study (after his wife's death in 1815, Soane took to referring to this room as his "Monk's Cell," a title he later applied to the room beyond the Monk's Parlour in the basement). The room to the north (7) was Soane's Dressing Room. If you look upward, you will see lead busts of Palladio and Inigo Jones surmounting the lintels of these two first-floor rooms, each reflected in a mirror placed on the surface below the other as you pass through the room. Above these opposed and "conversing" busts, you will also see the small lantern skylight in the Dressing Room (originally placed in the small Lobby room to the north). This is a model of the one designed by Soane for the dome of the "Temple" Hall within the

Figure 16. View upward to picture room from Monk's Parlour, Soane's Museum.

Freemason's Hall in 1828 to 1830, a building whose twentieth-century successor stands in Great Queen Street several hundred meters to the west of the museum, and on a site connected with Masonic gatherings since the early eighteenth century.[19]

Standing between the Monk's Yard below to the east and the Monument Court below to the west, these two rooms form a bridgelike passage linking the Colonnade area (itself connecting the Dome on the west with the Picture Room on the east) with the Dining Room and Library (4, 5) to the south. The latter two rooms open into each other, being separated only by short projecting piers.

Completing our walk-through brings us to the Library, whose south end constitutes the building's front facade.

B. What kind of museum or collection is this? Let's begin by noting two things that do *not* happen here.

1. Moving from the Colonnade to the Dome (or the Dome to anywhere else) does not seem to bring you from the ancient to the medieval, from the classic to the romantic, from the Egyptian to the Greek, from groups of works of one artist to those of another—or indeed along any clear diachronic trajectory mapped onto sequences of space such as would be familiar later on, in more explicitly historicist institutions, such as the British Museum in its present form. You can look everywhere in most every room or passageway, and you will not find items arranged in any apparent chronological or genealogical order: this is not a monument to the ideologies of romantic nationalism. To walk through Soane's is not to travel through time or dynastic succession (as one did in the Louvre), with each room corresponding to a period (a century or political epoch) or an artistic tradition or school.[20]

2. The items in any delimited space—a room, a recess, or an alcove—are rarely homogeneous on strictly stylistic, chronological, cultural, or functional grounds. They do not necessarily constitute tableaux of fragments or relics drawn from a particular historical environment, such as the reign of a given monarch. Indeed, the Parlour of Padre Giovanni seems almost a parody of such period tableaux common in some museums of the time. In other words, the "medieval" character of the basement rooms devoted to the mythical Father John is not a function of an aggregation of genuine medieval artifacts but in fact a pastiche of old or old-looking things staged in a gloomy, faux-medieval manner.

The building's organization is thus not apparently "historical" in any familiar museological or art historical sense. Objects seem rather to be placed where they might fit together on a wall or ceiling, on a pendentive or over a bookcase, on the basis of associations that seem to make some kind of aesthetic sense, perhaps of shape, color, or material. But

exactly what kind of sense would any such aesthetic relationships make? Are we confronted with morphological, stylistic, or thematic compatibility or complementarity? Complementary referential subject matter? On many such grounds, it is difficult to account for the placement of the hundreds of sculptures, architectural fragments, paintings, models, medallions, reliefs, and other items visible from almost any point (which moreover are frequently multiplied and transformed in the many mirrors everywhere).

Nor is it at all immediately apparent what the presence of a particular object might be intended to symbolize or represent—or if indeed the very notion of representation in its familiar contemporary senses would be at all pertinent or apt here. Semiotically and epistemologically speaking, just what significative value may be assigned to all these originals, models, and copies; these objects and part objects? How are we to construe them in a meaningful manner? What, if anything, are they supposed to mean? And for whom (apart from Soane) would they be meaningful?

Let's look more closely at the material scenography and architectonic order(s) of the place itself—the stage on which whatever seems to be played out is afforded and/or constrained. In the process, we may arrive at a better position to appreciate whether the museum can be construed as a stage in the common sense of the term, as a platform on which things take place, or whether the stagecraft itself has a full speaking role of protagonist in the cast of characters.

The isometric diagram (Figure 17) presents a simplified sketch of the sequence of spaces, on the two levels making up the museum as such, and apart from the more private quarters on the second floor of number 13, or the rooms devoted to other purposes in numbers 12 and 14.

You become aware right away that certain spaces are *physically* traversable, whereas a few are only accessible *visually*, through the windows of those spaces that are accessible. (Three stories or parts of stories are in fact accessible, from the basement to the first floor to the "mezzanine" constituting the Upper Drafting Office above the Colonnade on the first floor. I'll refer to these—the basement, first floor, and Drafting [or Student] Office levels—in shorthand as levels A, B, and C.)

The spaces only visually accessible include, on level A, the Monument Court (18) and the Monk's Yard (17), along with the Recess (16), which may be seen from the Picture Room (15) above to the north, once the hinged wall panels are opened, or through a window in the corridor

Figure 17. Isometric diagram of main parts of Soane's Museum.

(14) to the west. The Recess of level B is, on level A, the south third of the Monk's Parlour (20), which is traversable.

The Sepulchral Chamber (28) of the Dome (11) is visually but not kinesthetically accessible on B; you can walk into it only on A. On A, the Monk's Cell (21) is visible from the Monk's Parlour, and the Monk's Yard and Monument Court are visible, respectively, only from the Parlour and spaces 23 and 24 on A (below Soane's Study [7] on B). But on the west side of the building, there is an area—the New Court (or Yard) (33)—that is not at all physically accessible from the museum proper, being only visually accessible, and then only on level A, from the West Chamber (32) beyond the Sepulchral Chamber/Dome area. This Court lies to the south of a room that is physically and functionally part of the number 12, level A portion of Soane's properties in this final state of the building; in fact, that room was once part of Soane's original working office when he first occupied number 12.

It may be seen, then, that there are several kinds of spaces in the Museum:

1. Those physically accessible on A (19, 20, 23–24, 26–32).

2. Those only visually accessible on A (21, 22, 25, 33; and [16], [11] of B).

3. Those physically accessible on B (1–15).

4. Those only visually accessible on B (16, 17, 18).

5. Those physically accessible on A but only visually accessible on B (two-level spaces) (28 [11], 20 [16]).

6. In addition, a distinction may be made between multilevel spaces that are exterior to the museum's physical areas and only functionally part of it visually—22, 25, 33—and multilevel spaces that are interior to the museum, visually part of it on two levels, such as 16, 28 (11), and kinesthetically functional on one level.

One space (21; the Monk's Cell, on A) is entirely interior, functionally a part of the ensemble, but only accessible visually.

One whole level (space 34, or C; the Drafting Office level) is physically accessible via the stairwell off 14 on B. It is also *visually* connected to the Dome and Sepulchral Chamber areas (11 on B; 28 on A) by means of the window in its west wall.

It becomes apparent, then, that there is a simple and marked distinction or hierarchy among the spaces that make up the museum, looked at merely (and for the moment) in terms of their physical accessibility to the visitor or user of the institution. This distinction might be referred to as making up an opposition between *physical* and *virtual* spaces.

To reiterate, Soane's Museum is differentially accessible, in three ways:

1. Some spaces are fully accessible, physically or kinesthetically, to the visitor: you can walk into and/or through these.

2. Others are only virtually accessible to the visitor: they can only be seen and not touched or physically entered.

3. Yet some spaces are virtually accessible from one level in the building (B and C) and physically accessible from another (A and B).

We are dealing, then, with a highly complex spatial domain: an architectonic organization that stages, affords, and constrains whatever is meant to be experienced here, in several dimensions or formats. This is done, moreover, in a manner that is materially extremely rich and varied—indeed, rather kaleidoscopic. The domain of the museum consists of a series of juxtaposed and interleaved spaces, some physical and some virtual, along with some that, in the visual purview of the visitor, are compounded of both, where visually the visitor is confronted with virtual (physically inaccessible) and physically accessible regions simultaneously. Moreover, the virtual spaces take on a vitrinelike quality of their

own, as a kind of museum-within-a-museum: some interior (Monk's Cell), others exterior (Monk's Yard, Monument Court, New Court).

In other words, there are many places where one can stand in the museum and see, superimposed *and* juxtaposed at the same time, physical *and* virtual places: like a stage set made up on the principles of Fourth Style Pompeian architectural painting (illustrations of which may in fact be found in several places in the museum), interleaving diverse, accessible, inaccessible, and impossible or improbable spaces on the same stage, as it were, or from a single perspectival point. A veritable Los Angeles in a cabinet.

But that's not all.

Recall the plethora of mirrors of all shapes, sizes, and degrees of convexity scattered throughout the spaces of the museum. Here too is another dimension of the virtual spatial order of the place, for in addition to areas that are only virtually accessible visually (such as the various courts or yards, or two-story spaces such as the Dome/Sepulchral Chamber, or the Recess/Monk's Parlour), spaces are extended, multiplied, and altered by the many mirrors of different kinds in many rooms (but interestingly, mainly on level B; apart from a large mirror on the north wall of the basement Monk's Parlour, there appear to have been few if any mirrors on A or C).

The simple result of this is to render yet more complex the spatial character of a number of rooms otherwise fully accessible physically. In other words, a number of first-floor rooms have a double or multiple visual dimension: some walls, wall areas, or recesses open up and reflect other areas, and in fact in a couple of spaces (most notably the Dining Room [4]) there are mirrored surfaces close to the windows opening on to the virtual space of (in this case) the Monument Court, bringing its reflection back into these physical spaces. The skylight in the Dressing Room (7) also has mirrored edges and sides, providing extraordinary upside-down reflections of the room and ceiling ornaments, along with slices of views of the adjacent exterior courts. There are, in short, very few areas of level B in which there is *no* virtual space of one kind or another.

But not only are other spaces reflected within a given room, thereby becoming the (often miniaturized, often not) virtual components within a physically accessible room; what is also transformed is the perspectival angle or point of view of the other spaces that are revealed in the mirror(s). For the visitor standing in a given room, then, not only can she or he see multiple spaces—both within the present room and outside—

reflected in the mirrors, but those reflected spaces exist in multiple perspectival positions.

Thus from any given standpoint, one sees the geometric order of the room one is physically in, and the geometric order of a space only accessible virtually. But within the latter may be several kinds of virtual space, of which at least two may be distinguished: (1) that which is visible but not physically accessible, and juxtaposed to the space you are in, where you see in effect the one superimposed on the other; and (2) that which is visible in one or more mirrors in the space you are in, which, depending on a mirror's position and angle, transforms the geometric order of the reflected space(s) to an order that requires (projects) a perspectival point different from that represented by the viewer's present position in space. In other words, there coexist views within a single physical space that have divergent vanishing points. There are, then, a number of anamorphic transformations within this dimension of the museum's virtual space.

I have referred to these spatial distinctions as simply physical (kinesthetic accessibility) and virtual (visual accessibility). The latter may now be divided between what may be called perspectival spaces (virtual spaces accessible only visually, but conforming to the perspectival order one is physically positioned in) and anamorphic spaces (virtual spaces that are visually accessible by means of mirrors yet transform the perspectival geometry of a reflected space in single or multiple ways). The architectonic and visual effect, then, is astonishingly complex, with many different perspectival points, geometric orders, and topological dimensions of accessibility, all palpable from a given singular position in any one of many rooms in the museum's domain. We are dealing with a most extraordinary spatial domain. But to repeat our original question, what exactly is all this in aid of?

We see what appears to be a multiply refractive and dynamic theatric experience being staged: that is, a performative domain with what might well have been multiple possibilities for construal. Places of several different kinds and in several different dimensions are both juxtaposed and superimposed, reflected singly, multiply, and in different angles, and anamorphically transformed in relation to a given viewer's point of view. Moreover, the most startling and powerful effects obtain (architecture, after all, being a four- rather than a three-dimensional art) when one moves through the place. Views expand and contract, reflections of rooms (and rooms beyond rooms) go off at multiple and often divergent angles, and spaces open up both kinesthetically and visually, on one level or two, as

one passes through a series of rooms. Not to speak of what happens to the objects that any given room contains: many are accessible to sight from multiple angles to begin with. In addition, in its original state, the museum's light was vibrantly and richly colored, as most of the skylights and many windows were of old and reused stained glass and modern (nineteenth-century) colored panes.

The stagecraft suggests not only that some kind of narrative is unfolding in space but that the stage itself is unfolding in a series of cascading metamorphoses: an architectonic dramaturgy. A labyrinthine, kaleidoscopic, spatiotemporal domain, one that moreover demands of the visitor a degree or level of attentiveness beyond what we commonly take, today, to be the ordinary run of museological experiences of reading discrete objects, whether they may be seen in a narratological light or not.[21] These visual and spatial complexities were commented upon and appreciated by not a few visitors to the museum during Soane's day and afterward.[22]

I would like to suggest, in conclusion, that we may begin to appreciate the significance of Soane's stagecraft and his museum's dramaturgy by recalling something that has become largely invisible today in the modern discourse on museology and art history: that the rise of the modern museum as an instrument of individual and social transformation during the Enlightenment was a specifically Masonic idea. It is not simply the case that virtually every founder and director of the new museums in Europe and America in the late eighteenth and early nineteenth centuries was a Freemason; in addition, it may be suggested that the idea of shaping spatial experience as a key agent in the shaping of character was central to the Enlightenment mission of Freemasonry from the beginning. The civic museum institutions founded in the late eighteenth and early nineteenth centuries in Europe and America were a Masonic realization of a new form of fraternization not dependent on political, religious, or kinship alliances, and tied to the social revolutions on both sides of the Atlantic—that is, citizenship. As with the most influential institution, the Louvre Museum (explicitly organized for the political task of creating republican citizens out of former monarchical subjects), they provided subjects with the means for recognizing and realizing themselves as citizens of communities and nations.

Soane's Museum is in fact unique today because in its actual physical preservation, it has retained a palpable flavor of the articulation of

the Masonic program that Soane shared with contemporaries such as Alexandre Lenoir, founder of the Museum of French Monuments in the former Convent of the Lesser Augustines,[23] the original Ashmolean, the first public museum in Europe and founded by one of the first known British Masons, Bernard Ashmole,[24] and, in part, the British Museum during its Montague House period, the antecedent of the present classicist confection of 1847 to 1851. In Berlin, Karl Friedrich Schinkel's Altes Museum exemplified similar organizational principles.[25] Of all these Masonic foundations, only Soane's retains the character that all these others (where they still exist) have lost. The earliest American museum, Peale's Museum in Philadelphia, occupying the upper floor of the newly inaugurated American government, no longer exists.[26] Soane's collection of Masonic books also included those of Lenoir, and he was well acquainted with Ledoux's 1804 volume *L'architecture considerée sous la rapport de l'art, les moeurs, et de la legislation.*[27]

Free or speculative Masonry, which was set in opposition to practical masonry as theory to practice, was founded on a desire to reconstitute in modern times simulacra of the ancient Temple of Solomon, said to have been designed by the Palestinian (Philistine) architect Hiram of the old coastal city of Tyre for the Jews of the inland kingdom of Israel—a building that, in its every, tiniest detail, was believed to encapsulate all knowledge.

It may well be asked how this might have been materially manifested in Soane's Museum. The museum, as far as the archival records examined to date indicate, was not used as a Masonic lodge or temple. Yet there is a passage through these complex spaces that uncannily replicates the stages illustrated in the Masonic "tracing-board" presentations of the three stages or degrees of initiation—that is, the three stages of enlightenment the individual is exhorted to follow.[28]

Where this route may have been is given by a single remaining clue—the name Soane gave to a small space in the basement on the south side of A (28), namely, the Anteroom, indicated with an arrow in Figure 13. Today this is a room a visitor would pass by on the way to the public restrooms, but in Soane's day it could be directly entered from the outside. This constituted the other or lower ground floor level access into the building. If you were to begin your visit to the museum in this anteroom or vestibular space, you would then proceed into and through the dark and sepulchral basement, with its reminders of death and mortality, the (no longer extant cul-de-sac of) the Egyptian tomb ahead of you, and

into the realm of the medieval Padre Giovanni—his Parlour, Cell, and Tomb Yard to the east.

This would then lead you to the stairwell to level B, the first floor, with its classical decoration, and you would pass through the Corinthian order colonnade toward the back of the bust of Soane confronting the

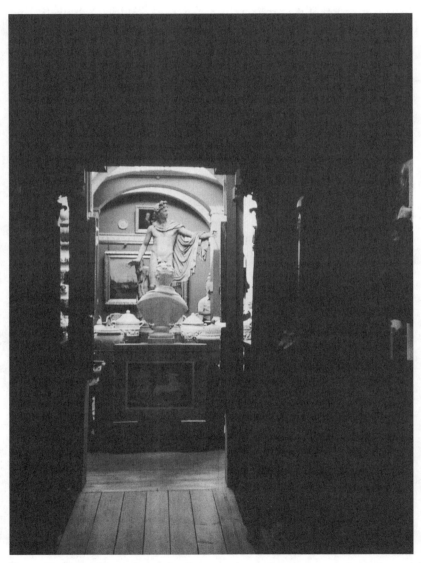

Figure 18. Bust of Soane facing Apollo across dome, from colonnade behind.

Apollo Belvedere across the open space. From behind, as you approach the back of Soane's bust, Soane and Apollo are superimposed, Soane's head in fact hiding the (now fig-leafed) god's genitalia (Figures 18, 19, and 20). The position of Soane's bust on the Dome's balustrade was the place where the fragments of the collection fell into their proper perspective,

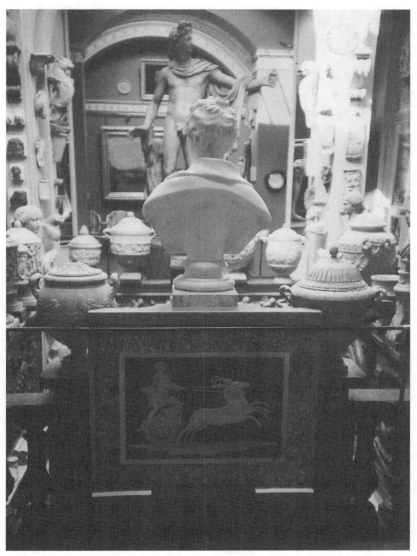

Figure 19. Soane and Apollo.

Figure 20. Apollo, from below.

and where, standing with Soane, the veritable genius loci or spirit of
the place, you would see laid out vertically before you the progression
from the sarcophagus in the basement to Apollo to the brilliant light of
the Dome skylight above. This vertical tableau corresponds, in Masonic
lore, to a passage from the death of the old self to rebirth and enlighten-

ment. The sarcophagus on these tracing boards symbolically holds the dead body of the artist or architect before rebirth and enlightenment.[29]

You have, in other words, a series of progressions mapped out throughout the museum's spaces—from death to life to enlightenment; from lower to higher; from dark to light; from multiple colors to their resolution as brilliant white light; from a realm where there is no reflection (basement level A) to one where everything is multiply reflected and refracted (the mirrored spaces of the first-floor level B). Soane stands at the pivotal point of all of this and moreover ostensifies his role as a Master Mason devoted to community outreach, charity, and education by (if you stand across the Dome by Apollo) appearing to carry on his shoulders the future generation of student apprentices who study and work in their office above and behind his bust. In Masonic tracing boards, the Master Mason is frequently depicted as carrying a child on his shoulders (Figure 21).[30]

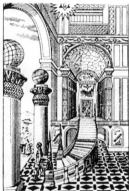

Third Degree Tracing Board

The Tracing Board of the Third Degree can be interpreted in two ways. First, like the other Boards it shows a picture of the human individual. In this sense it indicates that the ordinary concept of human life is as death compared with the potential human capacity. Second, the view of the temple's interior suggests that through dying to one's concept of one's self one can realize that potential.

Second Degree Tracing Board

The Tracing Board of the Second Degree is a detailed drawing of the human individual who was shown in his environment on the First Degree Board. Here Jacob's Ladder is shown as a symbolic interior staircase which the individual must climb as he turns his attention away from the physical world to examine the nature of his soul and the workings of his own psychological processes.

First Degree Tracing Board

Tracing Boards are visual aids used to illustrate the principles taught in each Degree. This First Degree Tracing Board represent in highly formalized symbolism the individual human being and his place in the Four Worlds.

Figure 21. Masonic tracing boards, showing First, Second, and Third Degrees. Reprinted from W. Kirk MacNulty, *Freemasonry: A Journey through Ritual and Symbol* (London: Thames and Hudson, 1991); copyright 1991 Thames and Hudson; reprinted by permission of Thames and Hudson Ltd.

Soane—who as a Master Mason (and as grand superintendent of works within the upper echelons of British Freemasonry) was obliged to dedicate his life to communal or public service, and created this as a kind of secular Masonic institution—here provided his visitors with a set of techniques, derived from Masonic practice, for creatively and concretely imagining a humane modern world, a world that reintegrated the lost social and artistic ideals being rent asunder by the early industrial revolution, that is, by capitalism. It did not portray or illustrate a history of art or architecture, and in this respect, Soane's Museum was a critical rather than representational artifact. At the same time, Soane ostensified, revealing by his pose and position, the taking up of a point of view—literally a telling perspective—that provided keys to the narrative sense and compositional order and syntax of the fragments in the museum.[31] In seeing Soane seeing, the visitor could learn to envision a new world out of the detritus of the old.

Soane's Museum was thus neither a historical museum nor a private collection in their more familiar recent senses. It was among other things an instrument of social change and transformation. To visit it was to enter not a warehouse but a kaleidoscopic machinery designed to proactively engage the imagination. It was a collection in the root meaning of the term: an assemblage of objects given to be read together, in which the process of reading—the visitor's active use of the spaces over time—was dynamically and metamorphically productive of sense.

Whatever art historical values we may attribute to the objects we see today in Soane's Museum, they did not, in Soane's time, have primarily autonomous meanings that were fixed or final; they were, to use a linguistic or semiotic analogy, more phonemic than morphemic, being indirectly or differentially meaningful rather than directly significative. Their significance lay in their potential to be recombined and recollected by the visitor to form directly meaningful units—what Soane himself referred to as the "union of all the arts."[32] They are thus not strictly objects at all in the common (modern art historical or museological) sense of the term, and still less are they historical in any historicist sense.

John Soane's Museum ostensified a mode of perception understood as proactive and constructive, rather than passive and consumptive. Emblematic of Soane's practice as an architect and designer, the museum existed to enlighten and to project a vision of a humane modern environment in response to the massively disruptive forces of early-nineteenth-century industrialization. That world came to be apotheosized a decade

and a half after Soane's death in the Great Exhibition of the Arts and Manufactures of All Nations, at the Crystal Palace of 1851.[33] The latter's many progeny—and not Soane's more radical (Masonic) Enlightenment visions—constitute the museological and art historical institutions and their associated professional practices so familiar to us now as to seem natural or inevitable.[34]

The Crystalline Veil
and the Phallomorphic Imaginary

I begin this lecture by quoting the opening stanzas of a rather remarkable poem published anonymously in 1852, "Recollections and Tales of the Crystal Palace" (Figure 22):

> *I, who late sang Belgravia's charms—and strove*
> To paint her beauties, and her merits prove,
> Now sing the CRYSTAL PALACE!—theme sublime,
> That shall astound the world throughout all time!
> Aid me. Ye Muses! Aid! Your seat is here!
> Ye murmuring fountains, charm my listening ear!
> Fair sculptured forms, whose classic beauty bears
> The spirit back to Rome's enchanted years,
> Lend to my strains the power of art divine,
> And let your soul poetic breathe in mine!
>
> Lo! As I roam o'er this unequalled spot,
> Earth and its drearier scenes are all forgot;
> The mighty minds that with resistless will,
> *Raised the fair temple, seem to haunt it still!*
> A solemn glory shines along these aisles,
> And in the violet-tinted distance, smiles;
> And Peace, with dove-like pinions, seems to brood
> Above this swarming, countless multitude.

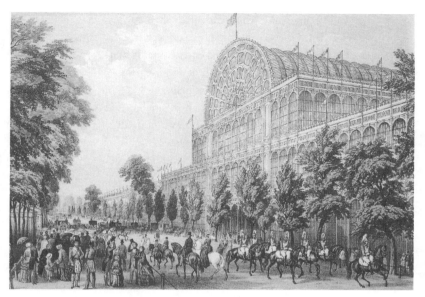

Figure 22. Lithograph of exterior of Crystal Palace.

Ah! Priceless boon! Ah, blessing unconfined!
All hail to thee! Benignant power of *mind!*
Where'er I turn, are wonders wrought by thee!
And still, in these, the *great First Cause* I see,
Whose mercy gave that spark of Heavenly fire
To light man here, and direct him higher.
I gaze around—and thousands meet my eye—
I look within—the smallest unit, I!
Yet, with that wondrous power—my living soul,
I soar above, and contemplate the whole;
Nor only through these various scenes I range,
But search the shadowy future, and its change,
Far times—when this assembled crowd shall rest,
"Dust unto dust," within earth's quiet breast,
And all the glory of our golden age,
Shall be a word—no more—in hist'ry's page!

Yet shall this crystal pile—this mighty plan,
An influence wield upon the mind of man,
Free as itself, as wondrous and as vast,

And lasting still—whilst time itself shall last.
No narrow views—no rights exclusive, bar
This brilliant scene—nor its enchantments mar!
The prince and serf, the peasant and the peer,
Alike may revel in the beauties here;
Alike must feel how feeble and how small,
Each man alone—how great, how glorious all!
And in this fairy world of labour, see
A type of what the actual world should be.

Here, in one Brotherhood, the nations greet
With but one heart—as 'neath one roof they meet.
How wide soe'er their home—uncouth their name,
Or wild their nature, *here* they feel the same.
The same bright visions glad their eager eyes,
The same strange marvels strike them with surprise;
Their bosoms beat with rapture, or with woe,
Whether from India's heat, or Russia's snow;
And each high work of art, or priceless gem,
Calls forth responsive, tear or smile from them.
They meet—as all in this cold world should meet,
(One Heaven above—one Earth beneath their feet),
In peace and simple faith—a quiet band
Of Brothers—greeting in a foreign land.
From East to West—from North to South they come,
As to a father's feast, a common home;
Partake with joy of all that varied store,
And part at last—to meet again no more.[1]

This is but the smallest fraction of what was a poem of epic proportions—it was 150 pages long—by an unidentified woman author who in the same year (1852) also published the second edition of her popular book *Belgravia, A Poem,* itself of great length. Her Crystal Palace poem was divided into six parts, devoted, respectively, to (1) an overview of the half year of the exhibition from its opening on 1 May 1851 to its closing on 15 October of the same year; (2) morning in the Crystal Palace (with the "joyous arrival" of the queen, who in fact visited virtually every other day the building was open); (3) a discourse on the great building's resemblance to even greater natural edifices of ice—icebergs—seen by

Arctic mariners; (4) the lamentation of a mother for a daughter lost in the crowds and (apparently) finally recovered; (5) a description of the progress of two anonymous persons through the exhibition during a single day; and (6) a closing meditation on "the ties that exist between a great Author and those of his Readers who appreciate his works."

I've called the present lecture "The Crystalline Veil and the Phallo-morphic Imaginary," and my aim in doing so was to call attention to what I'll be referring to as the "optics" and spatial logic of this extraor-dinary building, and to the ways in which the Crystal Palace was the lucent embodiment and epistemological summa of the principles of modern order and identity themselves—principles that at the same time served to found the practices of art history and museology as we know them today. It cannot be emphasized too strongly how fundamental and essential this remarkable artifact was to so many facets of what we have come to recognize as our modernity over the past century and a half (Figure 23).

I'm aware that these are strong claims; in order to sketch even the outline of a justification, we shall need to look closely at what this blindingly brilliant object both revealed and veiled. Accordingly, I will be delving into what I might call for the moment (and explain as we go along) the "orthopsychic" construction of subjects in representation. This will entail questions of vision and blindness, the modern gaze, desire,

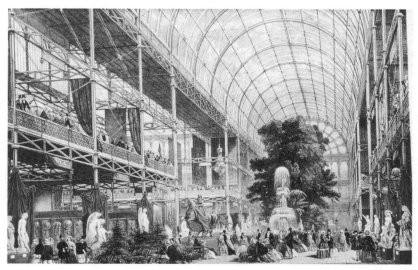

Figure 23. Interior transept, Crystal Palace.

narcissism, and the problem of what does or does not lie behind representation, as well as the question of why any of this should matter for practices that we might still avidly desire to be simple and straightforward, namely, art history, art criticism, and museology. So I'll begin with some reflections on the latter and then work my way back through the previous sentence. The Crystal Palace will occupy a double position in all of this, constituting both the object of our interest and what in fact has already founded and determined that interest. I'll be speaking both in and of that "theme sublime," as our poet calls it.

It has been customary for some time to believe that artworks are historically significant phenomena, and that art itself has a history, the astute delineation of which would provide us with significant insights into the (presumably parallel or complementary) histories of individuals and of peoples—insights that, not least of all, may be legible as providing lessons for our own time. The modern institutions of art history and museology are of course grounded in this enabling assumption, one of whose several corollaries has been that changes in form are taken to correspond (in any of a variety of direct or indirect ways) to changes in beliefs, attitudes, mentalities, or intentions, or to changes in social, political, or cultural conditions. This has long been (by which I do mean to suggest that it does indeed have its own history) a virtually irresistible fiction, and it has been one of the cornerstones of the edifice of the modernity that we have built ourselves into, whose exits have yet to lead elsewhere but to other, identical spaces.[2]

There was no more brilliant stage on which this was delineated, demonstrated, and factualized than the Great Exhibition of the Arts and Manufactures of All Nations at the Crystal Palace in London in 1851.[3] This most radically translucent—and simultaneously stubbornly opaque—of nineteenth-century constructions may well have been our modernity's most unsurpassable artifact. It was the lucent embodiment and semiological summa of the principle of modern order itself: infinitely expandable, scaleless, anonymous; transparently and stylelessly abstract. A "mighty plan," and a "type of what the actual world should be," that is in fact "lasting still," everywhere in us and around us. The very diagram of the modern symbolic order, it was, again in the words of the poem, "as wondrous and as vast" as "the mind of man" itself. I shall argue that we ourselves are no less the products and effects of this extraordinary object.

Simply put, the Crystal Palace offered—as Freud was later to say of psychoanalysis—an "impartial instrument, like the infinitesimal calculus"

for making legible both the differences and similarities, and the cognitive, aesthetic, and (consequently) ethical hierarchies among peoples by means of their juxtaposed and plainly seen products and effects.[4] All the world " 'neath one roof," in a single room: at once the modern apotheosis of the *Wunderkammer,* in which objects were catalysts for a fraternal intercourse bent toward making conversational sense of a jumble of things.[5] As the ideal horizon and logical fulfillment of the arcades of London, Paris, and other European and American cities, the Crystal Palace was the system of modern museology (and art historicism) as such, stripped to the skin. A dream from which we have yet to awaken (Figure 24).

I would contend that modern museology and art history cannot be appreciated or substantially understood apart from this "impartial instrument," this "father's feast." A feast, moreover, that was itself haunted by the presence of the greatest patriarch of them all, Victoria, who was herself present (as a sort of permanent strolling exhibit) virtually every other day of the building's 165-day in situ existence, and the mortal representative of that "great First Cause" seen behind all the "wonders wrought" here in this "common home"—the projective *Urbild* or *Umwelt* ("one Heaven above—one Earth beneath") of a British imperial imaginary; this "fair temple" whose "classic beauty bears / The spirit back

Figure 24. Pavilions of Persia, Turkey, and Greece in the Crystal Palace.

to Rome's enchanted years." In seeing Victoria seeing, a whole world learned what and how to see. Victoria, in short, ostensified the spectator as consumer.[6] The queen wept for joy at the Great Exhibition's opening ceremony, declaring here, in this prototypical temple of imperial consumerism, that the exhibition "fills me with devotion, more so than any (religious) service I have ever heard."[7]

The modern disciplinary practices of art history and museology are among the more powerful effects of this "mighty plan," and its indispensable *mode d'emploi*. Art history was and remains the ghost in that crystalline machine, as it perpetually carries the memory of this "Muses' seat" as its innermost fixation. The blinding quiddity of this "crystal pile," whose image is permanently imprinted, eidetically, on the art historical gaze, was bourgeois modernity's *stade du miroir,* its mirror stage. It is also the unconscious of every museum in the world; every museum's imaginary lost origin and the image of an ideal plenitude, containing all things no less than all peoples.

The Crystal Palace's grand and "styleless" system was replicated in countless expositions, museums, and city plans created throughout Europe and the European-dominated and -influenced world (rapidly becoming, in the nineteenth century, coterminous with the world as such). Its exhibitionary order was the ideal horizon and the blueprint of patriarchal colonialism; the epistemological technology of Orientalism as such, as we shall see in the next section.[8] It was the laboratory table on which all things and peoples could be objectively and poignantly compared and contrasted in a uniform and perfect light, and phylogenetically and ontogenetically ranked. All this in relation to a Europe that had been learning to stage itself as the eyes and ears of the world, as the brain of the earth's body. The Crystal Palace—whose "bright visions" and "brilliant scene" were so effusively celebrated in the 150-page paean of 1852 whose opening stanzas I have quoted—was the paradigm of the loom of modernity on which sexuality, capitalism, and art have come to be woven tightly together into a sturdy, enduring fabric that has in fact hardly frayed since (or, like something from Disney's *Fantasia,* seems uncannily to weave itself back together after the occasional critical rip).

The enterprise of the modern discipline of art history prefigured by Winckelmann, Kant, and Hegel was fully and lucidly figured in the 1851 Great Exhibition—itself a phallomorphic imaginary for rendering visible Europe's Others.[9] This visibility is both the proof and condition of the presence of the Other, whose existence is thereby guaranteed by

its exhibitionary representation—which in effect precludes recognition of the Other's difference in favor of its phallocentric makeup: a covering up of difference by a uniform visibility which de-others others and domesticates all difference. This universal lucidity (what our poem calls this "common home" and "father's feast") is thus a transparency that is opaque, a crystalline veil. The dream of a totally transparent society is, so to speak, the *hijab* (veil) of Europe's modernity (Figure 25).

Most importantly, the Crystal Palace grounded and gave substance to an art history as a practice of the self, of the self's commodification, demonstrating that the history of art was a supremely practical business. Its erasure of difference (this "abstraction") in favor of a "universal" and uniform "fairy world of labour" endows everything (as the effective condition of its visibility in modernity) with a phallicized, commodified, and fetishized value, making it evident that at the core of modernity is precisely the conflation of aesthetics, ethics, and sexuality in the commodity.

It is perhaps fitting that (despite its own material descendants on other sites, and even the incorporation of some of its actual physical members into these other "crystal palaces") the Crystal Palace was a momentary, six-month phenomenon: a brief and blinding flash in midcentury that revealed, as would the quick shine of a torch in the night, an unexpected and

Figure 25. Pavilion of India in the Crystal Palace.

uncanny landscape. The flash has remained imprinted on the European optic nerve now for well over a century; the uncanny landscape revealed is, in Walter Benjamin's words, capitalism, that catastrophic "new dream sleep (that) fell over Europe."[10]

I've again invoked the name of Walter Benjamin—a reflex that has recently been customary among contemporary art historians searching for yet another "hindsight father" whose writings might be scoured to clarify or highlight the underlying conditions of our modernity. But I'd like to suggest now an opposite tack and situate Benjamin's work, in particular his "Arcades Project" and his "Theses on the Concept of History," as the effects of—and as impossible without presupposing—the Crystal Palace itself. This is not, as I hope to make clear as we proceed, a putting of a cart before the horse, or of misconstruing cause and effect: I really *do* mean to say that rather than using Benjamin to understand or read phenomena such as the arcades or the Crystal Palace itself, more will be gained by reversing this: reading Benjamin—and by what I take to be a justifiable extension, art history and museology themselves—through the Crystal Palace.

What I want to do, in other words, is to think with the Crystal Palace in a manner not unlike what we did in our reckoning with Soane's Museum. As we proceed, moreover, the methodological parallels should clearly emerge. So: rather than rereading art history through the optic of Benjamin, it may be more useful to reread Benjamin through the optic of that nineteenth-century museology (whose most lucid European epitome was the Crystal Palace) of which his own quasi-messianic practice (at one with the art historicism of his time) was the product (Figure 26).

In an 1868 essay, the linguist Michel Breal wrote that in standing before a picture, "Our eyes think they perceive contrasts of light and shade, on a canvas lit all over by the same light. They see depths, where everything is on the same plane. If we approach a few steps, the lines we thought we recognized break up and disappear, and in place of differently illuminated objects we find only layers of color congealed on the canvas and trails of brightly colored dots, adjacent to one another but not joined up. But as soon as we step back again, our sight, yielding to long habit, blends the colors, distributes the light, puts the features together again, and recognizes the work of the artist."[11]

What is being constructed here as well in this perfectly commonplace observation, one of scores one can find in the literature of many

Figure 26. Indian Pavilion in the Crystal Palace.

fields, is the subject itself as an economy of vision, as an instrument for making sense of things in its discovery of a point of resolution and legibility. What I'd like to call an orthopsychic subject: a self whose agency is a product of spatial alignments and positioning. A "putting things in perspective," as we say.[12]

The masses of objects in a museum or exhibition came to be understood as analogous to the gobs of color and the abstract dots and dashes described by Breal as on a painted canvas. Only if one takes up a proper (orthopsychic) perspective and distance may these bits and pieces be seen as joining up to create the image, the figure, the physiognomy, of the character or mentality of a person, people, or period. It is precisely the pursuit of such a perspectival position that constitutes the modern discipline of art history as an epistemology of the gaze for the modern subject, as constituting that subject. At the same time, in resolving ambiguities— that is, appearing to do so—the subject instantiates the fiction that what is in fact the nothingness behind any representation is *something*. The result historically was an instrumental technology for fabricating genealogies of value, character, race, spirit, and mentality through the mediating fictions of style, intention, authorship, and reflection: what we call with disingenuous modesty "art history" (Figure 27).

It was the Crystal Palace that powerfully put all this in the proper

Figure 27. Pavilion of China in the Crystal Palace.

scale and perspective for all to see, in the same place and at the same time. In so doing, this supreme taxonomic and comparative instrument was arguably the first fully realized modernist institution. It was in fact the historical realization and the implicit ideal, the ur-form and *Gesamtkunstwerk,* of what Benjamin's *Passagenwerk* was aiming to evoke in bits and pieces from the Parisian arcades (and also the Paris 1937 Exposition). Benjamin, however, quoting another verse about the Crystal Palace, saw it as an ur-form of the Paris Exposition's Pavilion of Solidarity and never in fact addressed the Great Exhibition in any substantive way.[13] What makes Benjamin's *Passagenwerk* so frustrating is not its fragmentary nature as such but rather the absence of that which each and every arcade implied and presupposed, even *avant le lettre,* namely, the Crystal Palace.

As I've said before, the key metaphorical conundrum, the central obsession, of modernity is that the *form* of your work is (and should properly be legible as) the *figure* of your truth. This is in fact built upon what I referred to in an earlier lecture as a secular theologism, the modernist continuation and obverse of centuries of Christian practices of the self, wherein one's (good) works were an index and direct reflection of the worthiness of one's soul. As if by a materialist masquerade of Christian piety, every art historical object comes to be framed as an object lesson, and a window into the spirit of a time, place, person, or people. Art his-

tory, as a key facet of the nineteenth-century enterprise of historicism, was designed quite pragmatically to render the visible legible, to reveal and reconstitute what lay within or behind objects. The entire theory of mimesis or representation is based on this supposition (Figure 28).

During the middle of the nineteenth century, museological and art historical, theoretical, and critical practices were becoming interlinked sites for the manufacture of the present, in fact a presence that constituted Europe in its relation to all possible Others—that modernity, that co-option of all possible ethnocentrisms, that has since come to cover the planet through its extensions, imitations, and recapitulations everywhere. Art history is no less a factory for the production of the fictions that make up the load-bearing walls of that modernity: the phantasms of ethnicity, race, gender, nation, sex, indigeneity, class, all grounded and enabled by the keystone fiction of art itself—art as representation.

Art history has since its origins been the site of a modern semiotic and epistemological problem and paradox, one born out of a powerfully enabling set of assumptions: that the art object's visibility is a function of its legibility as a symptom of everything and anything that could be plausibly adduced as contributing to its appearance and morphology. A symptom of lack, of what is absent and lacking, in short. It became eminently reasonable to believe that the astute delineation of formal or stylistic genealogical relationships among artworks would provide significant

Figure 28. U.S. Pavilion in the Crystal Palace.

insights into the (presumably parallel, complementary, or homologous) histories of individuals and peoples. The modern institutions of art history and museology are of course founded on this enabling assumption, wherein changes in form (or a lack thereof) are taken to correspond to and reflect or embody changes (or a lack of change) in beliefs, attitudes, mentalities, or intentions, or to changes (or not) in social, political, or cultural conditions. An assumption that simultaneously projects the effects of a science of palpable causes and effects and derails any effective fixities of causality—as our poet displaced causality onto "Mind" or "Soul."

Simply put, the artwork (and perforce any palpable cultural artifact, object, or practice) is taken to bear a relationship of resemblance (a metaphorical, and hence substitutional, relationship) as well as a part-to-whole relation (a synecdochic, and hence metonymic or juxtapositional, connection; an index) to its circumstances of production. This situation—this synecdochic metaphoricity—is precisely that of the pantograph, that horizontal, scissorlike artistic implement by which one can scale up an image from a smaller to a larger size (or vice versa), thus retaining all the picture's features and qualities at an expanded size. As a pantographic enterprise, the analytic practice of the historian or critic may justly be said to comprise the projection of the figure of the object onto a larger screen or horizon of the social, cultural, historical, ethnic, racial, national. In this regard, the artwork is a homuncular entity, whose finality is the horizon of its ideal, projected fullness.

Such metaphorical instruments may aid us in appreciating a deeper truth: the fact that art and history are coconstructed artifacts of the great enterprise of modernity; interdependent epistemological technologies linked to a larger matrix of practices and institutions, which for lack of a better term I might call museography (itself, then, a species of pantography, which in turn is a dimension of allegory). Since the late eighteenth century, these co-implicative practices have functioned to render an object domain called "the past" synoptically visible so that it might operate in and upon (while at the same time distancing itself from) "the present," so that this present might be seen as the demonstrable product of a specifically delineated past, and so that the past so staged might be framed and illuminated as an object of genealogical desire in its own right, configured as that from which a properly socialized and disciplined modern subject (the citizen of the nation-state) might learn to desire descent (or, conversely, might learn to abhor and learn how

to reject). In the most basic terms, art history is a mode of staging and envisioning thought—about nations, individuals, ethnicities, races, genders, and classes, on behalf of social agendas or political desires projective of that other dimension of the present, that obverse of the past and its complementary fiction, "the future." No art, no history; and, to look the other way across the pantograph, no history, no art. The Crystal Palace simultaneously made this legerdemain perfectly visible and completely opaque.

Art history is thus also a pantographic instrument for the evocation and connection of two imaginaries, for unceasingly shunting an insatiable desire for wholeness between two temporal poles—two Edenic realms of integrity (where might be projected, for example, a concordance or commensurability between the subject and its objects; where Adam and Eve had no need for knowing the names of things; and where in the ultimate future our souls and bodies are reunited). In other words, an originary past and the future horizon of its imaginary rebirth, resolution, or reconstitution: that which the past is imagined to desire as *its* fulfillment, as if through the agency of us in the present—orthopsychic subjects—who work to bring "it" about, when in fact it is we who are brought about, who are founded in that it.

My contention is that everything art history has been for the past two centuries follows from this psycho-theological dream work, and an appreciation of it is necessary to understanding the history of art history both institutionally as a professional academic discipline and more widely as a component part of correlative institutions and practices (including, minimally, art criticism, history writing, aesthetic philosophy, art making, tourism, urbanism, museology, and the heritage industry). In the long run, the very looseness of the organization of this overall museographical matrix, the opportunistic adaptability of its component practices, and the refracted echoes of one practice in another or others have proved especially effective in naturalizing the very idea of art as a kind of innate and universal human phenomenon, with variable but concordant manifestations from one society to another. Once again, this is, as our poet called it (blessed as she tells us with a "living soul that soars above and contemplates the whole"), a condition of the very visibility of Others in modernity's "common home" and "father's feast" (Figure 29).

All of which has served to legitimize the principal function of art and art history for modernity as a powerful instrument, measure, and frame

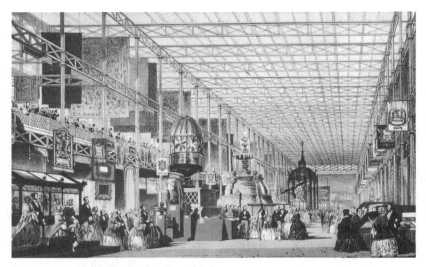

Figure 29. British Nave in the Crystal Palace.

for staging the social, cognitive, and ethical teleologies of all peoples: narrative emplotments linking past and future, origins and ends. The principal disciplinary function of this museography over the past two centuries has thus been the coproduction of modern subjects and objects—and by extension the naturalization of an entire nexus of dyadic concepts resonating with and framing many facets of modern life. Since concepts of the object within the horizons of the Western metaphysical tradition are invariably deponent, being linked indissolubly to coconstructed framings and articulations of the subject, any attempt to understand art history's institutions necessarily entails a certain stereoptical attention to the ways in which this dyadic opposition has functioned in and for the history of art history. But it's more than a question of any simple or direct envisioning, as we'll see shortly.

Understanding the larger social enterprise of modernity—and, perforce, modernity's core problematic, namely, the orchestration of orderly, describable, and predictable relations between subjects and between subjects and objects (the topologist's haunt)—is essential to any attempt to appreciate what art history was all about. In saying "was," I don't mean that art history is now over but rather that it was always already impossible, always grounded in a fiction that is itself tied to the fictions at the heart of the fabrication and maintenance of the self. Even in its perpetuation and contemporary indispensability: we live, in modernity,

in and as that impossibility. Such a project also entails turning art history and its avatars inside out, so to speak, so as to delineate the kinds of subjects that art historical objects produce, the kinds of readers that artifacts evoke.

As already suggested, art history arose historically as one of a series of practices and institutions aimed at addressing the central problem of modernity: namely, the nature and status of the individual as a subject of newly evolving forms of community and fraternity.[14] This problem came to be expressed on two broad fronts—synchronically and diachronically. The art history of the late-nineteenth-century Viennese art historian and curator Alois Riegl occupied a significant juncture in the playing out of this problem, and his theory of art and of art's history constituted an attempt to articulate a kind of organic historicism capable of addressing both facets of this problem.

For Riegl, a universal history aligning together the stylistic features that might be seen at a given time and place (in everything from churches to tchotchkes) was to be the "culminating point of all art historical research."[15] The will to form *(Kunstwollen)* is something that must be shown to be manifested in all aspects of the social and cultural milieu of a time and place. The formational principle of a *Kunstwollen* is imagined to be imposed with equal force and immediacy in every facet of the material culture of a time, place, and people. In this immanentist organicism, Riegl was of course prefigured by Hegel; but Riegl diverged from the Hegelian romantic tradition that constituted so much of art historical theory and practice in the nineteenth century (and that provided the template for academic practice in Europe and America) in two respects. First, in his thesis that in principle all styles are of equal value—a consequence of his position that the significance of an object is a function of the standpoint of the observer. And second, in his articulation of a historicism without a teleology, a notion of the consistency and necessity of artistic development, in which any conflict between (as the twentieth-century French art historian Henri Focillon was to put it) "the timely, the premature, and the superseded" is not resolved in favor of unilinear progress, as in Hegel's evolution of world Spirit toward ever more perfect manifestations in cultural form (for Hegel, in fact, in the forms and formats of worship in north German Protestant Christianity).[16]

For Hegel, the systems and structures of a culture had proximate sources—what he called "national geniuses," or *Volksgeister*—individuals who were in effect mouthpieces of the deeper source, the unfolding

world Spirit. History becomes a genealogy of that Spirit as its effects are manifested in the objects produced by societies through their national geniuses. Heinrich Woelfflin's anonymous art history, or an art history without names, elaborated in the first two decades of the twentieth century, consisted of a genealogy of certain a priori aesthetic categories, such as "seeing," in a manner that was perfectly consistent with Hegelian historicism.

Alois Riegl's aims—though no less historicist and essentialist than those of his near contemporary Heinrich Woelfflin, or his progenitor Hegel—were somewhat more modest, in that for him art's history was a history of solutions to aesthetic and material problems. In this, as the social historian of art Arnold Hauser rightly observed a half century ago, the work of art became an "illustration" of formal problems.[17] The evolution of styles consists of "questions to be decided." What art historians were thought to be faced with, then, were solutions: answers to questions or problems that it is then necessary to reconstruct. Art history, for Riegl, was fundamentally a pantographic practice of double writing or double inscription, in which the art object (in Riegl's case, literally any material cultural formation, from saltshakers to cities) is the occasion, the catalyst, for the larger and greater articulation (the *Wollen*), which is imagined to pervade equally every cultural artifact at a given time and place. The object is the answer, and the art historian was charged with reconstituting the answer's question.

In this regard, Riegl's art history was completely consistent with the historicist project of modernity just briefly sketched out, representing a minor inflection of the immanentist romanticism of the Hegelian tradition. Yet ultimately Riegl is a less interesting and original thinker than Hegel, or his own contemporary, the great French philosopher, historian, and art historian Hippolyte Taine—the person Nietzsche regarded as the greatest nineteenth-century historian. Taine's history of art, seen as an evolution of mentalities, which were manifested as a complex and dynamic triangulation of what he called race, force, and moment, was elaborated in a series of lectures at the Ecole des Beaux-Arts starting in 1865. In this system, which he regarded as part of a larger study of what he called in his lectures "problems in psychological mechanics," the full significance of any artifact was a function of its relationship to its entire cultural context. The central concepts of Ferdinand de Saussure's new linguistics and semiology at the beginning of the twentieth century were taken from Taine's lectures (which Saussure attended as a student

in Paris), and thus it is of no small interest that at the heart of modern language theory are a series of semiotic principles and metaphors taken from nineteenth-century art history.[18]

You've been looking at views of the Great Exhibition throughout my little bit of historiography, and now I'd like to focus more directly on this extraordinary artifice and address some of the themes I've been raising in today's talk—those of the constitution of the modern subject, of representation and its (im)possibilities, and the questions of desire, narcissism, vision, blindness, and the gaze. What I'm about to say is implied both in what I've been saying and in what I've been showing on the screen. And also, as will have become evident, in the great poem we've been attending to here. Listen, as you look at the screen, to these final words of the poem:

> Long did I wander through that fairy place
> By quiet paths I oft had learnt to trace,
> Dwelling on beauteous forms, familiar grown,
> Yet finding still fresh marvels, all unknown—
> Till faint at last with gazing, I began
> To turn from Man's unequalled works—to *Man*
> Then on a quiet bench I sat—and found
> Food for fresh thought in all that passed around:
> Seeking—no hard nor thankless task—to trace
> The *Soul's* unuttered thoughts on every face!
> In many a soft dilating eye, I saw
> Joy mixed with wonder—eagerness with awe!
> While sterner men, with philosophic thought,
> Mused on what labour, led by *Mind,* had wrought,
> And giddy fair ones gazed, but heeded less
> The works of *Art* around them, than the *dress;*
> Finding in gay capote, Parisian shawl,
> Or lace-trimmed robe, more powerful charms than all.[19]

One of the things continually marked in our poem is a certain dualism: a clear distinction made between things seen (as effects) and the forces, minds, and spirits taken as preexistent causes. Not causes as in the particularities of authorship or manufacture that would be commonplace in twentieth-century art historical practice, namely, that this beautiful sculpture or textile may have been Belgian or Chinese, or the work of a particular master, but rather that each and every thing was a product

of "benignant powers of *mind*" (also italicized), and that in each and every thing could be seen "the *great First Cause.*" Another constant theme is the power attributed to "beauty"—by which one can properly understand all that the Great Exhibition had to offer (all those things that "light man here and direct him higher")—to affect character and behavior, since, as she says, that in "Partak[ing] with joy of all that varied store," "How wide so'er their home—uncouth their name, / Or wild their nature, *here* [and the word is italicized in the poem] they feel the same." It didn't matter that you came from some outlandish place or climate, *here* everybody's "bosoms beat with rapture."

And all this was not only a "father's feast" (Prince Albert's, in this case, in which Victoria was more than simply a gracious hostess to her international guests) but a "common home." This was indeed, as the poet tells us, "a fairy world of labour," and one moreover where everyone could "see a type of what the actual world should be." A world as deadly real as Disneyland. Victoria in effect served as a roving or traveling eye, ostensifying a browsing, restless vision, one that in fact seemed to mask the artifice of the whole charade. Her royal progress was followed by scores of visitors bent on seeing what she saw and admired (Figure 30).

Our poet ends on what might be taken as a sad note, where she

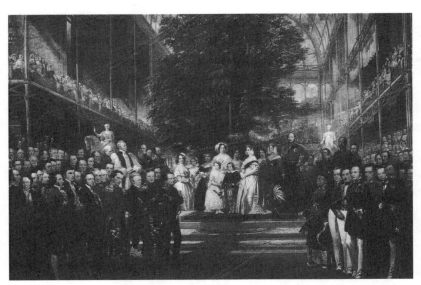

Figure 30. Opening ceremony at the Crystal Palace, with Queen Victoria and Prince Albert.

contrasts the reactions and musings of "sterner men" with "giddy fair ones," the former musing on "what labour, led by *Mind* [again italicized] had wrought," the latter finding in what people were wearing ("lace-trimmed robes"; "Parisian shawls") "more powerful *charms* [italics mine] than all." Yet the sadness of the poet's realization of what some visitors were paying more attention to should not distract us from seeing a fundamental complementarity here between the two reactions to the spectacle: "Mind" and "charm" stand in the same relationship to their material effects—beautiful works of art and fashionable clothing. This points up not so much a contrast between art and commodity as a parallel: both are framed as commodities, the distinction between the artwork and the shawl being one of quality and ostensible functionality. What the Great Exhibition wrought, in other words, was the bringing of all artifacts into mutual alignment within the same frame or system, and, in a complementary fashion, the alignment of the individual citizen—what I've been calling the modern orthopsychic subject—into a proper position and relationship not simply to but at the center of and within this world of artifice: the point of resolution. The interchangeability of subjects and objects in the imaginary space, the abstract stage, of the commodity.[20]

This point might be clarified by thinking with a famous optical illusion that played a prominent role in mid-twentieth-century theories of perception. It was invented by the psychologist and ophthalmologist Adalbert Ames in the 1940s and has since come to be known as an Ames Room (Figure 31). It was an odd arranging together in real space of a variety of full-size trapezoidal forms that, when photographed or viewed through a pinhole, gave the illusion of a normal cube or room—except for the fact that two figures of the same size could be made to seem of radically different size (as you see in the illustration of an Ames Room with identical twins)—a conundrum or impossible scene. In fact, it was the room and its parts that were deliberately skewed: all the walls and furniture were actually fragments of things splayed out in such a way as to make it appear that the two figures were standing next to each other, when in fact the one on the left was quite far away and behind the other. The next illustration (Figure 32) shows how the room is constructed: because of the skewed angle you are looking from (and the fact that you're only using one eye in looking), what you see is the imaginary cubic space (indicated by dotted lines).

What I'm suggesting we imagine here, in looking at the Great

Figure 31. Sketch of an Ames Room.

Viewing Point

Figure 32. Construction of an Ames Room.

Exhibition, is that this great mass and jumble of things presents to its visitors a challenge to sense; a challenge to make sense of this hitherto unimaginable diversity; to find or invent a perspective on the whole so that objects could be made to "stay and lie orderly." To take up a perspective—like the viewer looking into an Ames Room or like the viewer of a painting in Michel Breal's essay quoted at the beginning of this talk who finds the observation point that transforms the gobs of color into the outlines of a figure or a landscape. To become, in short, a correct(ed) or orthopsychic subject. In all this, Victoria herself as imperial browser shows the way.

Or, to use the vocabulary of our discussion of Sir John Soane's Museum, a genius loci: a spirit of (a) place or a perspectival point of resolution. Our poet in effect gives voice to all of this and in that respect was a most astute observer of this great spectacle, this "Muses' seat," as she put it, that she was hardly by any means alone in firmly believing that it "shall *astound* [italics mine] the world throughout all time." The Great Exhibition, as an "impartial instrument, like the infinitesimal calculus," as Freud said a half century later of psychoanalysis, in fact crystallized and put into its proper place an imperial fantasy world or imaginary geography of all peoples and products, with the modern citizen-consumer, the orthopsychic subject, at and as its (imaginary) center. This phallomorphic and Orientalist machinery, this epistemological technology, transformed difference and otherness into stylistic variation and exoticism, blanketing over other realities into a "fairy world" of seemingly endless flavors of the same ice cream. Geography as pantography.

The world was indeed astounded, stunned, by this astonishing artifice and its endlessly proliferating progeny: hypnotized and paralyzed by the parallax created therein. Although the Great Exhibition itself was closed and everything vacated from the Crystal Palace while the organizers, including Prince Albert, decided what to do with the building, it remained in place and empty for about a year, prior to its being dismantled and rebuilt in slightly altered and enlarged form at Sydenham. During its quiescence and before being moved away, the empty building became a destination for countless visitors who, as during the time the exhibition was open, came to marvel at the extraordinary building itself. What the many thousands of visitors saw was in effect the skeleton of a brilliant taxonomic machine: the system of modern order and classificatory logic as such, an experimental laboratory or an abstract stage on which any thing could be shown and compared to any other thing.

The Crystal Palace, this great dazzling and frozen iceberg of a theory of order, was as mesmerizing empty as it was when full. Modernity's methodology, sketched out and inscribed in glass and iron.

The Crystal Palace worked because it was grounded in, and was the epitome of, nineteenth-century historicism, in a new and rapidly embraced rhetoric of art as historical, where art gave form to, and distinguished between, past and present. As the Great Exhibition demonstrated, this was the most effective vocabulary or medium for imagining nation, empire, ethnicity, and identity in a manner that neutralized otherness while simultaneously fetishing differences as but stylistic variations of the same. It was what I've been calling "phallomorphic" in that its logic was not unlike that of the little boy in Freud who, discovering that his sister lacked a part that he possessed, concluded that she was but a deponent "he." Museology has been the Crystal Palace's afterlife and, along with art history and criticism, constitutes the dream work we as orthopsychic subjects in and for modernity endlessly practice, both as sterner minds and as giddy-minded shoppers or fashion junkies. And we show few signs of wanting to relinquish being haunted not only by things but by the Crystal Palace and its effects.

We've never left this building. An 1851 engraving by George Cruikshank (Figure 33) sums up all of this quite succinctly and economically, showing the Crystal Palace astride the earth (London is at the top of the world), absorbing all peoples and their products, shown here arriving from every point on the planet by boat, train, cart, and foot. You can make out on the globe the world's peoples, landscapes, and monuments. Everything, that is, except Europe—the brain of the earth's body, apotheosized solely by the Crystal Palace.

In the next lecture we'll look at how this played out in, and transformed, the non-European world, and how questions of race, nation, and identity gave rise to, and transformed, art historical and museological institutions—including the one we're in today (the University Museum, Oxford), since an even more extraordinary "annex" to this building, the Pitt Rivers Museum, was a key player in the late-nineteenth-century debates on race, nationality, and ethnicity and formed an ideological counterpoint to what was being fabricated for other peoples.

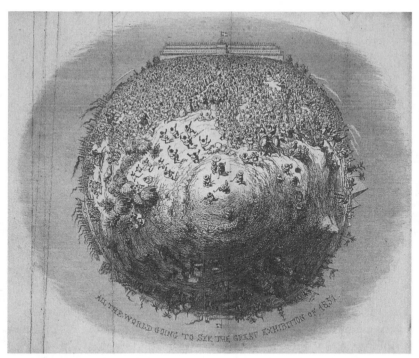

Figure 33. George Cruikshank (English, 1792–1878), *All the World Going to See the Great Exhibition of 1851,* ca. 1851. Engraving, 8⅛ × 10¾ inches. Gift of Nathan H. and Anna Creamer, Colorado Collection, CU Art Galleries, University of Colorado at Boulder, 79.1427 (album). Photograph by Aaron Hoffman, copyright Colorado Collection, CU Art Galleries, University of Colorado at Boulder. Reprinted with permission.

The Museum of What You Shall Have Been

The Parisian Universal Exposition of 1900 was organized spatially in such a manner that the pavilions or "palaces" built to house the products of the two major French colonies of Algeria and Tunisia were situated between the Trocadero Palace on the right bank of the Seine and the Eiffel Tower on the left bank. Looking north from the elevated eye of the tower toward the Trocadero across the river, you would see these colonial buildings embraced by the two arms of the Trocadero's "neo-Islamic" facade. France's North African colonies—indeed, all of them—would appear to occupy a place within the nurturing and protective arms of the French nation, whose own identity would appear to be figured as assimilative, and thus supportive of, the peoples and products that were contained and exhibited in and by these colonial edifices.

Taking up the view from the opposite direction, looking south from the Trocadero toward the exposition ground across the river, there is a markedly different morphology. The entire fairground is dominated by the Eiffel Tower, that gigantic technological feat of modern French engineering. Like a colossus (or a colossal figure of the sublime) dwarfing all the colonial edifices, its four great piers are grounded among the massed buildings of France's colonial possessions as well as other European and American nations. Appearing to have been built up on top of these buildings, the tower, one might say, puts things (back) in a proper perspective . . .[1]

This extraordinary image—a veritable two-way mirror—is a clear and poignant emblem both of the imaginary logic of nationalism (and its imperialist correlates) and of the rhetorical carpentry and museological stagecraft of art historical practice.[2] Consider the following.

From a Eurocentric point of view, art history has been constru(ct)ed as a universal empirical science, systematically discovering, classifying, analyzing, and interpreting specimens of what is thereby naturalized as a universal human phenomenon. This is the ("natural") artisanry or art of all peoples, samples of which are all arranged relative to each other both in museum space and in the more extensive, encyclopedic, and totalizing space-time of art historicism, that distillation and dynamically expanding refraction of universal exposition. All specimens in this vast archive sit as delegates or representatives—that is, as representations—in a congress of imaginary equals, as the myriad of manifestations making up a universal world history of art. To each is allotted a plot and display space, a platform or a vitrine.

And yet if you shift your stance just a bit—say by taking up a position among the objects and histories of non-European (or, in recent disciplinary jargon, "non-Western") art—it becomes apparent that this virtual museum has a narrative structure, direction, and point. All its imaginary spaces lead to the modernity of a European present, which constitutes the apex or observation point, the vitrine within which all else is visible. Europe, in short, *is* the museum space within which non-European specimens become specimens, and where their (reformatted) visibility is rendered legible (the "media").

European aesthetic principles—in the guise of a reinvented generic modern or neoclassicism, or "universal principles of good design,"[3] as promulgated by Ruskin in Oxford and his disciple and friend Charles Eliot Norton at Harvard[4]—constituted the self-designated unmarked center or Cartesian zero point or degree zero around which the entire virtual art historicist edifice circulates, on the wings of which all things may be plotted, ranked, and organized in their differential particularities. There can of course be no "outside" to all this: all different objects are ranked as primitive, exotic, charming, or fascinating distortions of a central classical (European) canon or standard—the unmarked (and seemingly unclassed, ungendered, etc.) point or site toward which all others may be imagined as aspiring. A veritable Eiffel Tower, if you will.

What would be afforded pragmatically by this archive was the systematic assembly or recollection of artifacts now destined to be constru(ct)ed

as material evidence for the elaboration of a universalist language of description and classification: the operating vocabulary of art history. Even the most radically disjunctive differences could be reduced to differential and time-factored qualitative manifestations of some panhuman capacity, some collective human essence or soul. In other words, differences could be reduced to the single dimension of different (but ultimately commensurate) approaches to artistic form (the Inuit, the Greek, the Welsh, etc.). Each work could be construed as approximating, as attempting to approach, the ideal, canon, or standard. The theoretical and ideological justification for a practice that came to be called "art criticism" is thus born in an instant, occluding while still instantiating the magic realisms of exchange value.[5]

In short, the hypothesis of art as a universal human phenomenon was clearly essential to this entire enterprise of commensurability, intertranslatability, and (Eurocentrist) hegemony. Artisanry in the broadest and fullest sense of "design" is positioned—and here, of course, archaeology and anthropology have their say—as one of the defining characteristics of humanness. The most skilled works of art shall be the widest windows onto the human soul, affording the deepest insights into the mentality of the maker, and thus the most clearly refracted insights into humanness as such. The art of art history is thus simultaneously the instrument of a universalist Enlightenment vision and a means for fabricating qualitative distinctions between individuals and societies.

You may well ask: How could this astonishing ideological legerdemain have survived for so long?

Consider again that essential to the articulation and justification of art history as a systematic and universal human science in the nineteenth century was the construction of an indefinitely extendable archive, potentially coterminous (as it has since in practice become) with the "material (or 'visual') culture" of all human groups.[6] Within this vast imaginary museographical artifact or edifice (every slide or photo library as an *ars memorativa*)—of which all museums are fragments or part objects—every possible object of attention might then find its fixed and proper place and address relative to all the rest. Every item might thereby be sited (and cited) as referencing or indexing another or others on multiple horizons (metonymic, metaphoric, or anaphoric) of useful association. The set of objects displayed in any exhibition (as with the system of classification of slide collections) is sustained by the willed fic-

tion that they somehow constitute a coherent "representational" universe, as signs or surrogates of their (individual, national, racial, gendered, etc.) authors.[7]

The pragmatic and immediately beneficial use or function of art history in its origins was the fabrication of a past that could effectively be placed under systematic observation for use in staging and politically transforming the present. Common to the practices of museography and museology was a concern with spectacle, stagecraft, and dramaturgy; with the locating of what could be framed as distinctive and exemplary objects such that their relations among themselves and to their original circumstances of production and reception could be vividly imagined and materially envisioned in a cogent and useful manner. Useful above all to the production of certain modes of civic subjectivity and responsibility. The problematics of historical causality, evidence, demonstration, and proof constituted the rhetorical scaffolding of this matrix or network of social and epistemological technologies.

Needless to say, much of this was made feasible by the invention of photography—indeed, art history is in a real sense the child of photography, which has been equally enabling of the discipline's fraternal nineteenth-century siblings, anthropology and ethnography. It was photography, as we have already seen, that made it possible not only for professional art historians but for whole populations to think art historically in a sustained and systematic fashion, thereby setting in motion the stage machinery of an orderly and systematic university discipline.

Photography also, and most crucially, made it possible to envision objects of art as signs. The impact of photography on determining the future course of art historical theory and practice was as fundamental as Marconi's invention of the wireless radio sixty years later in envisioning the basic concept of arbitrariness in language—which, as linguists of the 1890s rapidly saw, paved the way for a new synthesis of the key concepts of modern linguistics.

As we have seen, a clear and primary motivation for this massive archival labor was the assembly of material evidence justifying the construction of historical narratives of social, cultural, national, racial, or ethnic origins, identity, evolution, and progressive development. The professional art historian was an essential instrument for scripting and giving voice to that archive, providing its potential users, both lay and professional, with secure and well-illuminated access routes into and through it.

Museology itself became a key art of this House of Historicist Memory, evolving as it did as a paradigmatic instrument for the *instituting* of archivable events.

Today I'd like to turn to a consideration of how all this was played out outside of Europe. The most complete information we have comes from the Middle East in the late nineteenth century, in particular from Egypt.

In nineteenth-century Cairo, Egyptians appeared while Europeans looked. The colonialist exhibitionary order and its supportive modes of representation (in which objects are signs of some abstract system of meanings and values, whose reality is in turn made manifest in material things and peoples) not only came to constitute the stagecraft of museums and the disciplinary practices of imperial capitalism, hygiene, and education but also came to provide the paradigm for the massive rebuilding of cities throughout the Middle East and North Africa during the nineteenth and early twentieth centuries. In this new urban order, several features were common to European colonialist enterprises everywhere, and most especially characteristic of French and British colonialism in Egypt.

Most importantly, sharp distinctions were made between a modern, Western quarter and a native or indigenous Arab "old" city, these being endowed with clearly opposed aesthetic and ethical values. The Western town framed was the obverse of the native city. In the words of Henri Pieron in 1911, the older city "must be preserved to show to future generations what the former city of the Caliphs was like, before there was built alongside it an important cosmopolitan colony completely separate from the native quarter. . . . There are two Cairos, the modern, infinitely the more attractive one, and the old, which seems destined to prolong its agony and not to revive, being unable to struggle against progress and its inevitable consequences. One is the Cairo of artists, the other of hygenists and modernists."[8]

Although the colonial order seemed to exclude the older native city of Cairo (Al-Qahira), in reality it included it by defining itself in a direct and indispensably obverse relationship to it. Echoing similar observations by Frantz Fanon, Timothy Mitchell has noted: "The argument that the native town must remain 'Oriental' did not mean preserving it *against* the impact of the colonial order. The Oriental was a creation *of* that order, and was needed for such an order to exist. Both economically

and in a larger sense, the colonial order depended upon *at once creating and excluding its own opposite."*[9]

This dependence on the old city for maintaining the modern identity of the new town made the old city paradoxically essential and integral to the modern city's own identity *as* modern: its invisible core reality. Part of this ordering of itself extends, in short, throughout the fabric of the indigenous town. This is especially clear in the particular work of the Comite de Conservation des Monuments de l'art arab (Committee for the Conservation of Monuments of Arab Art), founded in 1882, and composed of European and Egyptian art historians, archaeologists, architects, and urbanists.

What has become clear in recent years is the extraordinary extent to which the Comite's encyclopedic "restoration" projects were as often as not creations designed to fashion an "old" city in the European image of the picturesque Cairo mentioned by Pieron: a Cairo familiar to the millions of visitors to the many *expositions universelles* in Paris and elsewhere throughout the second half of the nineteenth century that re-created romantic slices of a Cairo street, or that behind the facade of a national pavilion created a confusing labyrinth of picturesquely winding alleys.

In fact it was the construction of the modern Western quarter of Cairo with its high rents and prices that increasingly drove native Cairenes eastward into what was therefore becoming the old city, thus increasing its disorder and poverty, and creating acute overpopulation and congestion beyond any real hope of economically and politically effective amelioration. The Comite's "restorations" of many prominent and obscure buildings in the old city were designed in no small measure to create what can only justly be termed a theme-parked facade of structures visible down the eastern ends of the new boulevards and squares of the Western city, beckoning the European visitor toward an exoticized past. The Comite accomplished literally thousands of such "restorations" throughout the city, "re"-creating a "medieval" past in conformity to European fantasies. It may be added that this dyadic or dualistic urban morphology materially replicates the masculinist geographic discourse recently articulated by geographers such as Steve Pile, in which there is an often violent opposition between the desire for "critical distance" and separation from objects and people, and the desire to get "under the skin" of the Other.[10]

The modern quarter, with its gridded streets, squares, an opera house

(built for the premiere of *Aida,* itself commissioned in an international musical competition—lost by Wagner and won by Verdi—to celebrate the opening of the Suez Canal), streetcars, telegraph and railway stations, cafés and restaurants, was all about transparency and visibility—the lack of any panoptic or panoramic viewpoints in the old city having been a source of great and continuing frustration for tourists and foreigners for decades. (A frustration, in short, that was itself obviously essential to maintaining and sustaining European curiosities and desires.) In fact, the new town visually enframed a medieval past—thereby imposing upon Islam a distinctly Eurocentric chronology—embodied in an old city increasingly morphed as a kind of living urban museum: an embodiment of the European framing or frame-up of Islamic culture as merely a bridge between the West's own antiquity and its modernity, which, after all, was the ultimate point of Orientalism as such.

Such reframings were under way elsewhere in the nineteenth century throughout the eastern Mediterranean, as for example in Greece, where the new nation-state reframed Ottoman Islamic culture as but a foreign interlude between a purely Hellenic antiquity and its anticipated more purely Hellenic modernity. And such reframings continue well into the second half of the twentieth century, when the Jewish colonization of Palestine entailed the symbolic and literal erasure of a millennium and a half of Arab Muslim and Christian culture to materially juxtapose and sew together the archaeological traces of a Judaic antiquity with Israeli modernity (Figure 34).[11]

For the Egyptian colonial system to function properly and efficiently, it required a powerful investment in reframing the past of the country on many fronts. This entailed above all the reorganization of the city itself, as just mentioned, as the simulacrum of a (European) exhibition, an urban space representing Egypt's present and past in juxtaposition. Essential to this exhibitionary order was a series of archival and taxonomic institutions with homologous functions in different media and at different scales—hospitals, prisons, schools, zoos, legal codes, army and police barracks, stock exchanges, a university and a system of primary and secondary education and, of course, museums.

In the previous essay I quoted from an 1868 essay by the linguist Michel Breal, who wrote that, in standing before a picture,

> Our eyes think they perceive contrasts of light and shade, on a canvas lit all over by the same light. They see depths, where everything is on the

Figure 34. Children's archaeological sandbox at the Skirball Museum, Los Angeles.

same plane. If we approach a few steps, the lines we thought we recognized break up and diasappear, and in place of differently illuminated objects we find only layers of color congealed on the canvas and trails of brightly colored dots, adjacent to one another but not joined up. But as soon as we step back again, our sight, yielding to long habit, blends the

colors, distributes the light, puts the features together again, and recognizes the work of the artist.

In the modern enterprise of art historicism, the masses of objects in a museum or exhibition came to be understood as analogous to the gobs of color and the abstract dots and dashes described by Michel Breal on a painted canvas. Only if the viewer takes up a proper perspective and distance may these bits and pieces be seen as joining up to create the image, the figure, the physiognomy, of the character or mentality of a person, people, or period. Recall my demonstration of the optical illusion of the Ames Room in connection with my discussion of the Crystal Palace of 1851. It is precisely this pursuit of such a perspectival position that constitutes the modern discipline of art history as a politics of the gaze, an instrumental technology for fabricating genealogies of value, character, race, spirit, or mentality through the mediating fictions of style, intention, authorship, and reflection.

The museum was the place within which the dramaturgy of the nation's origins and evolution would be staged in the most encyclopedic and synoptic manner, and also in the most dense and minute detail, at the level of the juxtposition of the individual citizen-subject with individual object-relics staged so as to be read as representing moments in the evolving spirit, mentality, will, and mind of the nation. Each such staged and framed fetish object was indeed an object lesson, and a powerfully evocative sign to be consumed by native and foreign viewers, both in the masses of original and authentic artifacts archived in institutional spaces, and in the millions of replicas with which the country of Egypt (and the city of Cairo in particular) came increasingly to be saturated, as it continues today to be awash in masses of tourist garbage.

Just as the reorganized city of Cairo was arranged in such a way as to reveal or represent the abstract object behind the name "Egypt," that idealist or virtual entity knowable through its material embodiments, and legible to those possessing expert knowledge, so too did the history of that object become knowable in the chronological choreographies of landscape, cityscape, and museum space. The museums were organized in such a way that their contents were arranged to reveal a preexisting evolutionary journey, adventure, or plan—each object staged as a sign, and each sign a link in a vast archival con-signment system in which all the elements might articulate a synchronic slice (or a diachronic moment) of Egypt. The museum, in short, was what I recently referred to

as a pantographic instrument for projecting that larger abstraction, "Egypt," up from its relics and minutiae. The museum gallery was (and indeed still remains) one of those spaces within the envelope of urban space where all the confusion of time and history are banished in favor of legibility and narrative and causal sense.

However, there was a problem peculiar to Egypt: to European eyes there was more than one historical Egypt—an original, Pharaonic civilization with its own four-thousand-year history; a Greco-Roman civilization just less than one thousand years long and succeeding and overlapping and partially assimilating the first; a Christian (Coptic) culture, now itself two thousand years old (Egypt being the first officially Christian country, and the language of the Coptic Church being the modern descendant of the ancient indigenous language of the country), partly coterminous with the Greco-Roman, and tracing its ethnic roots to the older Pharaonic society; and an Islamic civilization, introduced by Arab speakers from the Arabian peninsula, and now itself 1,400 years old. Egypt, in short, was historically a multiethnic and polyglot country, the home to not insignificant numbers of various different peoples—Greeks, Armenians, Jews, Italians, Turks, and, over the past five hundred years, other European or Levantine communities, in the two major cities of Cairo and Alexandria.

The colonialist solution to representing this complex social and cultural amalgam, this heterogeneity, as it was perceived by Europeans, was arrived at beginning in the 1880s, largely by the art historians and connoisseurs of the Comite, and realized over the following quarter century. It entailed the formation of four different museum institutions housing the artworks and material culture of the Pharaonic, Greco-Roman, Coptic Christian, and Arab Islamic facets of, or stages in, the modernizing nation's history.

In effect, what the Comite accomplished was to resolve perceived contradictions by crafting narrative fantasy based on evolution and chronology, whose logic was that of hindsight and of the future anterior, grounded in an image of what the country shall have been for what it was imagined to be in the process of becoming—namely, a modern nation-state among a family of distinct nations all modeled on those of Europe (in particular France and England) and positioned as client states on the margins of the central European imperial heartland.

In Egypt, this colonialist/Orientalist enterprise began with Napoleon's invasion of the country at the beginning of the nineteenth century

and was emblematized quite poignantly in the frontispiece of the great Napoleonic publication during the first couple of decades of the century (the *Description de l'Egypte*), which presented a view of the country literally as a bird's-eye look down the Nile from north to south, where famous monuments were repositioned with later ones at the front and older ones toward the back. In short, the entire country was reformatted as a scholarly or tourist itinerary, a journey back through time.[12]

What the Comite accomplished in the last quarter of the nineteenth century was to actually reformat the country as such an itinerary; a European walk through time from the present to the past. Central to this task was the founding of museums specifically organized around then current ideologies of race, ethnicity, and historical evolution. The first museum to be founded was dedicated to the history of ancient Pharaonic Egypt—what a recent television ad referred to as "the oldest and most important civilization in history" (and if you subscribe to their ancient Egypt book club, you will receive monthly a "genuine replica" of a stone antiquity). This is a museum still bearing the name "the Egyptian Museum"; it originally housed artifacts of *all* periods and cultures (Figure 35). It was founded under French patronage quite early—in 1835—near the great Giza pyramids. The museum has a complex history because it immediately outgrew its accommodations thanks to the ex-

Figure 35. The Egyptian Museum, Cairo.

ponential growth of archaeological activity—official and amateur—in Egypt during the nineteenth century. It was soon rebuilt, and in 1845 it was moved to a larger building. In 1863 it was relocated on the east bank of the Nile (in the neighborhood of Boulaq, in a former post office building) and, after returning to the west bank and a brief sojourn in a Giza palace, was refounded in 1900 in its present neoclassical institutional form (as shown here) and reopened in 1902 on one of the modern city's immense central squares (Midan al-Tahrir). Tahrir itself at the time was bounded on its west and south flanks by the barracks of the British military. The chief dedicatory inscriptions over the doorway of the building are in Latin—a language, it might be added, that at best might be legible to about one-thousandth of 1 percent of the population of Cairo, then or now.

The museum's location gave it pride of place among all the cultural institutions of the new city, in a neighborhood of major government ministries and foreign embassies. By its designation as *the* Egyptian Museum, the institution commanded an indigenous national authenticity, distinctiveness, and originality, in comparison to which the cultural institutions and museums dedicated to other facets of the country's immensely long history—the Greco-Roman, the Christian, and the Muslim—were in effect marginalized as somehow less authentic. In being given urban centrality, the pharaonic past of the country constituted that in which the modern West was primarily (and indeed, still today, virtually exclusively) interested.

From the year of its founding in 1882, the Comite also undertook the massive project of separating out the artistic monuments of different ethnic and religious communities and dedicated itself to "exchanging" artifacts of "distinct aesthetic categories" ("des objets *purement* musulmans contre les objets *purement* coptes") so as to quite explicitly "relieve the confusion" of visitors.

This resulted in the virtually simultaneous foundation of separate ethnically marked museums in the 1890s: the Museum of Arab Art in 1893 (today the Islamic Museum), originally formed by the Comite as a collection in 1883 in (what at the time was) the ruined mosque of Al Hakim in the old city (Figure 36); the Coptic Museum, created in 1895 in the Christian quarter of the city (Figure 37); and the Greco-Roman Museum, founded in 1892 in the Mediterranean city of Alexandria (the Greek and Roman capital of Egypt), the latter referred to in twentieth-century guidebooks as the "link" between the Egyptian and Coptic Museums in Cairo (Figure 38). In other words, the ideal tourist visitor

Figure 36. The Islamic Museum, Cairo.

Figure 37. The Coptic Museum, Cairo.

Figure 38. The Greco-Roman Museum, Alexandria.

was urged to visit the history of Egypt from its earlier to later periods by visiting museums in the chronological order of their contents. You started at the Egyptian Museum in Tahrir Square, then took the train to Alexandria to the Greco-Roman Museum, returning to Cairo and the Coptic Museum, ending up in the Museum of Islamic Art. Each museum (apart from the classicizing Egyptian Museum building) was built in a style echoing or evoking the culture and period of its contents.

We have here a clear sense of the urban landscape as itself a phantasmatic topography, as well as a disciplinary order: a simulacrum of the very international exhibitions and expositions that were representing the country in Britain, France, Germany, and America. Perhaps the most famous of these was the "Street of Cairo" exhibition at the Columbian Exposition on the Midway in Chicago. Here, an entire street in the old city was re-created and organized with its striking juxtaposition of the new city and the old. Echoing the midcentury Crystal Palace in London, it featured locals dressed as Egyptian natives.[13] Each day a mock native wedding procession, a musical concert, and other events presented as typical of Egyptian culture were staged. What is interesting about the Chicago "Street of Cairo" was that the facades of buildings were not imitations but actual facades bought up from householders in the old city of Cairo and transported and mounted at the exposition.

This interplay of urban redevelopment in Cairo and international expositions also went in the other direction, as when later in the century the government of Cairo (through the Comite) commissioned French artisans in Paris to supply glass mosque lamps to replace old ones. The replacements were crafted according to stylistic criteria dictated by the Comite itself. The new modern city featured long broad boulevards, which the midcentury ruler of Egypt Muhammed Ali commissioned after viewing the work of Haussmann in Paris. These new arteries were cut through the labyrinth of old streets to the west of what was becoming the old city; they intersected at squares or roundabouts *(rond-points)*, on which came to be sited major governmental institutions and ministries, as well as hotels. Several major Haussmannesque boulevards were also cut through the old city, and the headquarters of the police and the major city prison were placed on the boundary between the old and new quarters.

The Museum of Arab Art was situated in this liminal zone between the old city and the new, facing east and the old quarter, across a new boulevard (formerly a canal) from the police headquarters, on a new

major intersection. The Coptic Museum was situated in the old Coptic Christian quarter to the south, adjacent to several ancient churches, and near the remains of the Roman settlement of Babylon, a town that was the immediate precursor to the first Arab colony in the region, Fustat (641). The city of Cairo (Al-Qahira, the conqueror, referring to the planet Mars) was founded in 969 immediately to the north of Fustat by a new group of rulers from North Africa known as the Fatimids. The southernmost Coptic quarter, prior both to the settlement of Fustat and to that founded later by the Fatimids (Al-Qahira), was now the *older* old quarter (i.e., premodern, pre-Islamic [pre-"medieval"], and postancient) and was also, during both Roman and Arab times, the chief Jewish quarter; and today the principal synagogue in the area, the Ben Ezra Synagogue near the Coptic Museum and the place where the important *geniza* documents were found, still survives in a kind of museological half-life.

These museums had as their primary function the representation of the country's history and the reformatting of its complex (and, to European eyes, confusingly miscegenated and hybrid) identity as an evolutionary narrative, a succession of stages leading inexorably to the present-ness and modernity of the new Westernized nation-state. This new Egypt was in the process of becoming a nation-state controlled by European-educated native elites—both Muslim and Christian—endowed with cultural, financial, and technological aspirations, partnered with their European mentors and advisers, and tied more and more tightly to the global economies of the British and French empires. All of this entailed an empowering of certain portions of the population as the subjects of representation (primarily the Westernized Christian and Muslim elites), and others (the non-Westernized indigenous populations of various religious and ethnic affiliations) as objects of their representation.

Essential to this Orientalist enterprise was the solicitation of the support of indigenous elites in this disciplinary project of representation. In the case of Egypt, this took place through a specific linkage of aesthetics and ethics, within a hierarchical system of values linking together subjects and their objects (and vice versa). It was the writings of the French social theorist and historian Gustave Le Bon—one of the most widely read writers in Egypt during the last quarter of the nineteenth century—that played a key role. Essentially, Le Bon argued (in his book *Lois psychologiques de l'evolution des peuples,* which had run through twelve editions by the turn of the century in French, English, and Arabic) that

"what most differentiates Europeans from Orientals is that only the for-
mer possess an elite of superior men. . . . [This small phalanx of eminent
men found among a highly civilized people] constitutes the *true incarna-
tion of the forces of a race*. To it is due the progress realised in the sciences,
the arts, in industry, in a word in all the branches of a civilization."[14]

The statement could have been written by Hegel, who similarly, half a
century earlier, wrote of a small group of leading thinkers in each country
as embodying the same characteristics, as guiding a people artistically and
culturally because in them was distilled the nation's genius most purely.
So much ethnographic research in the latter half of the nineteenth cen-
tury seemed to demonstrate that the "less-civilized" peoples of the world
were egalitarian in social organization. From this followed the conclu-
sion that modern progress should be understood as a movement toward
increasing *in*equality—which may help explain the enormous populari-
ty of Le Bon's theories among European ruling classes and indigenous
Egyptian elites.

Echoes of the sentiments of Le Bon permeated the *proces-verbales* of
the weekly meetings of the Comite in Cairo in their ongoing discus-
sions about the proper disposition of the hundreds of thousands of arti-
facts and monuments being unearthed and circulated among the newly
founded Cairo museums. These discussions invariably centered on the
worth or value of objects destined for display, and there was a clear (and
unanimously shared) attitude toward the role of the Cairo museums in
exhibiting only the best works of art, by which was specifically meant
those works that the members of the Comite regarded as the "truest"
representations and the most authentic effects of a people's spirit or
mind. All the rest were to be sold, given away as souvenirs to foreign
dignitaries, or simply discarded. The museums in fact contained a sale
room precisely for such a purpose, to aid the ongoing refinement of the
collection so that it might encompass only the most aesthetically wor-
thy objects. These practices effectively ceased by the end of the 1940s. A
process of the refinement of objects that was not inconsistent with the
culling and marginalizing of inferior subjects and subject peoples.

Back to Oxford.

We saw in the foregoing essay how at midcentury the Crystal Palace
powerfully put all of this in the proper scale and perspective for all to see.
In so doing, this supreme taxonomic and comparative instrument was
arguably the first fully realized modernist institution. The Crystal Palace
is in fact the historical realization and the implicit ideal, the ur-form and

Gesamtkunstwerk, of what Cairo (and other colonial institutions, notably in India) echoed and played out as the century progressed.

I'd now like to turn to what is around us here, and in particular to look at another solution to the formatting of ethnicity, progress, evolution, artistic development, and cognitive specificity, in this case right here within the nineteenth-century imperial heartland. I'd like us to consider the Pitt Rivers Museum (Figure 39) and the work of its founder, Lieutenant General Augustus Henry Lane Fox, born in 1827 and died in 1900, assuming the name Pitt Rivers as a requirement of his succession to the Rivers property—the 25,000-acre Cranborne Chase—on the borders of Wiltshire and Dorsetshire at the death of the sixth Lord Rivers in 1880. He was fifty-three at the time.

His museum was founded in 1884 to promote his views on cultural evolution as an index of racial, social, and cognitive differences among peoples. His views achieved their first major synthesis in a book he published in 1875 called *The Evolution of Culture*,[15] which reflected the opinion, common at the time, that so-called savage or primitive races were surviving relics of the early history of the human species, and that they bore a relationship to the peoples of modern Europe—and in particular the upper classes of Victorian England—that was complementary to the relationship of different species in biological evolution. The varying degrees of development in artifacts and implements that Pitt Rivers collected

Figure 39. Interior view, Pitt Rivers Museum, Oxford.

from all over the world bore for him a direct relationship both to cultural development and for the relative capacities of different peoples to achieve progress toward civilization.

Believing essentially that the savage was "doomed" and "morally and mentally an unfit instrument for the spread of civilization" (and in his view not unlike the British lower classes as well as all non-Protestant Europeans), Pitt Rivers saw it as his mission to preserve these "relics" of barbarism so as to educate his contemporaries in the ways in which the progressive stages of human development could properly be identified. His collection was installed in 1874 in a branch of the South Kensington Museum in Bethnal Green—itself a reflection of that museum's mission to educate East Londoners—in a building that now houses the Bethnal Green Museum of Childhood, itself yet another structural descendant of the great Crystal Palace.

It moved to larger quarters in South Kensington in 1878, and eventually (in 1884) Pitt Rivers bequeathed his collection to Oxford with the stipulation that the university build an appropriate building for it and appoint someone to lecture in it. The university added an annex to the museum we are in at the moment to house Pitt Rivers's collection, and it appointed its first lecturer in anthropology, Edward Burnet Tylor, and a young Trinity College research student named Henry Balfour as the collection's curator. The present museum opened in 1891. For nearly fifty years Balfour was in charge of the museum, and its subsequent state—and the vastly increased size of its holdings—owed as much to Balfour's vision as to Pitt Rivers's original intentions.

But let's return to that original vision. Pitt Rivers's aim was to display the hierarchy of human cognitive development he had laid out in 1875 in his study of human cultural evolution as a direct index of both cognitive advancement and the cognitive capacity of different peoples and races to achieve civilization. What resulted in his museum was a kind of treasure house of obsolete technologies (and, by implication, obsolete peoples and cultures), grouped together typologically, according to the type of instrument, object, or function—travel by water, objects of religious veneration, burial customs, screwdrivers and doorknobs, weapons of many different types, and so forth. The overall aim was to arrange in exhibitionary space evolutionary development from the simple to the complex. The driving force in this cultural "survival of the fittest" was the human "struggle for mastery with brute creation," as Pitt Rivers put it.

As he put it in 1874, in an essay on the principles of classification,

"progress is like a game of dominoes: all that we know is that the fundamental rule of the game is sequence"—a view curiously and coincidentally echoed in the work of the writer and traveler in Egypt W. J. Loftie, who in his 1879 book *A Ride in Egypt,* praised the Egyptian Museum in Cairo (then in a small building in Boulaq) because of its concerted effort to arrange its objects in strict developmental sequence of style and complexity.[16] What Loftie also commented on, in addition to saying that it was "hopeless for us to expect the British Museum to be so enlightened" (as to arrange its collection so logically), was that the curator of the Egyptian Museum, the archaeologist Mariette, was able to thereby cope with the widely recognized "scandal" of Egyptian art history, namely, that the farther back in time one traces Egyptian art, the better is its quality (according to criteria based on a classical Greek canon).

The point I wish to make here in concluding this lecture is that what is *absent* from the Pitt Rivers Museum is in fact its determining principle or canon—namely, the contemporary world outside the museum that informs the art and artifice of the modern European world. Europe as the brain of the earth's body, in contrast to which everything and everyone exterior to it was anterior to it. To leave Europe was in fact to enter into the past—the past of what we shall have been for what we were in the process of becoming, to once again evoke Lacan. Europe was the horizon of the present, that toward which all these sad little superseded societies, cultures, and peoples might be imagined to aspire but in the end went the way of the dodo. A Europe, in short, whose burden, whose *mission civilatrice,* was to curate and preserve the rest of the world for its own good. Pitt Rivers quite seriously believed that a half century from his own death, all traces of savagery and of primitive societies and customs would have disappeared from the face of the earth.

The phantasmatic Cairo bequeathed us by the Comite should come as no surprise. Our own sense of this astonishing museum is of course quite different, and I will use a quotation from an article about the museum published in *Smithsonian* magazine about a decade and a half ago to illustrate this.

> The General's single-minded determination to substantiate his racist theory is from an era long past. Today's Pitt Rivers speaks to the collective creativity of people everywhere, to the wealth and range of concepts that various cultures have to offer. Finding better ways to do things has been, needless to say, very different in the Arctic, the desert, and the

jungle, but the end result is a communality of invention the world over, invention that has been amended and improved, and succeeded by newer and better, generation by generation.[17]

You may well ask whether being happy campers in a globalized multi-culturalist reservation or theme park is an improvement upon Pitt Rivers's vision, or on the ethnocentrist sectarianism—which at first glance seems like the antithesis of Pitt Rivers's mission—promoted in Cairo by the Comite at the same time.

In the next and final lecture, I'll try to foreground a collection of anamorphic perspectives back on what we've seen, so as to shed a more lucid and raking light both on where we've been and on where all this might seem to be going.

The Limit(s) of (Re)presentation

I begin with a quotation from Ernst Gombrich that Mary Grant of Exeter College has kindly brought to my attention: "If art were only an expression of personal vision, there could be no history of art." In fact, the modern discipline of art history is built precisely on the denial of that "impossibility," in ways that I have been trying to demonstrate throughout these eight lectures.

When I began these lectures, I said, "At the heart of that two-century-old practice of the modern self we call art, the science of which we've called art history or museology, and the theory of which we've called aesthetics, lie a series of knots and conundrums, the denial of which we call the relationship between subjects and objects."

One of the things I promised was to try to untie the knot of that opening sentence. I hope it will have become clear since then that to untie such a knot would be to unravel the narratives that sustain the fantasies of the self that have constituted the keystone of the modernities we've built ourselves into since the eighteenth century. The time is now ripe to follow through with these further unravelings. I will read Ernst Gombrich (who knew uncannily how to point toward where answers might be found) against the grain, so to speak, but I would like you to keep his observation in mind as we proceed. My discussion will take up a perspective that in my view has not been sufficiently explored or elaborated.

137

What I've been doing here has been to demonstrate and ostensify, by using the common trope of what are called case studies, and in a manner conjointly verbal and visual, what I argued were certain deep conundrums and contradictions in the practices and thus the theories and methods constituting art history and museology. What I want to do in this final lecture is to open up an anamorphic perspective (to evoke one of that set of what I've been calling epistemological technologies that have haunted these lectures) on what you've been both hearing and seeing throughout this series. My aim is to evoke more explicitly the basic and, I believe, the invariant features—what might be called the topological principles—of the quite extraordinary landscape on which art history and museology have been erected: a ground that, as a result of those unrelenting constructions, has been rendered largely invisible, if not ghostly. If indeed as I claimed we have been haunted by things, then our art historical and museological practices have themselves been haunted by the ghostly and repressed ground on which and in relation to which they have been erected.

In other words, what I want to do is bring to the surface some of what has been most deeply at stake in the invention of art; in the mounting (both discursively and museologically) of what art historians generally consider a history for art; and of that history's pantographic social and cultural projections, in the crafting of the epistemological technologies designed to fabricate and factualize, to *realize,* the modern practices of the individual subject, the modern self.

One of the central theses of these lectures and demonstrations has been that art history and museology are unthinkable and inoperable— indeed, fundamentally incomprehensible—apart from a system of be- liefs (not always unarticulated) that at times I've been calling a secular theologism (the co-implicative complement of what I've called a theo- logical aestheticism), which insists that the fantasy of the self as selfsame is *not* a fantasy. I argued (and will argue more directly here) that this was the echo; what I called an allomorph of the fantasy that something really does exist behind representation. Both beliefs are underwritten and fueled by a deeper need to believe that the universe can make sense only as the artifact of a divine artificer, of a distinct, independent, and selfsame pan- tographic pantocratic principle, situated topologically behind the screens and veils of our existence, beyond the next corner, beyond the limits of our peripheral vision. I'll continue here to probe and pry apart some of these circularities.

We've examined a variety of institutions that came into being in

no small measure in connection with the fabrication and maintenance of diverse inflections of these beliefs during the course of that longer nineteenth century that stretched not from 1800 to 1900 but from the time of the French Revolution to the beginnings of the First World War, from 1789 to 1914. We began with the extraordinary project of what I termed that astrolabe of the Enlightenment, John Soane's Museum in London. As we shall see (in retrospect of earlier presentations), Soane's mission was to make sense of, and chart a possible safe passage through, the freshly minted conundrums of early modernity, and especially to leave open a possible escape from the massive topography of historicism that his age was increasingly painting itself into. Soane's Museum was a heroic attempt to forestall the growing gloom that was to triumph so completely in Victorian historicism by midcentury, a decade and a half after his death.

We looked at that triumph then, in perhaps the most significant and lastingly influential institution and cultural artifact of the nineteenth century, the Crystal Palace, the apotheosis and unsurpassable horizon, the summa and crystallization of the historicist project, the degree zero and veritable unconscious of the art histories and museologies that have unfolded over the subsequent century, down to our own times. I argued that this six-month exhibition was a "brief and blinding flash at midcentury that, like a torch in the night, illuminated an uncanny landscape"—the complete landscape of *capital* as such. At the same time it imprinted on the Euro-American optic nerve an indelible eidetic image of an imaginary encyclopedic taxonomy of unlimited applicability, an image of wholeness and coherence sketched out in glass and iron, coterminous with the landscape of imperialism, in which all things might find their true and proper place. I argued, in fact, that the artifice of the Great Exhibition finally and fully figured what the aesthetic and historical theories of Winckelmann, Kant, and Hegel had prefigured. It was not, of course, unique as a crystallizing artifact—one can point to a number of institutions that effected, by design or otherwise, a panoptic and synoptic vision of modernist notions of the subject and of the national social cosmos—but the London exhibition was the most complete, the most encyclopedic, and the most influential: its effect was indelible and universal. It was, in a word, the dark side of the force of the Enlightenment project of commensurability.

We then examined several late-nineteenth-century art historical institutions as instances of what I referred to as the aftermaths of the Crystal Palace both outside the orbit of the imperial European heartlands, in

the case of the four nineteenth-century museums founded in Cairo and Alexandria, and right here, in the case of that remarkable critical artifact, the museum founded by Pitt Rivers less than a hundred meters to the east of the auditorium where the Slade Lectures were delivered; the artifact that I referred to in the last essay as the belated and displaced conceptual centerpiece of the building we are presently in—the human vortex around which the natural world in this building circumambulates.

I want to stress another thing that these lectures have hopefully made explicit and demonstrated as a key aspect of our conjoint or stereoscopic critical history of art history and museology—namely, that each constitutes not an independent field but a deponent disciplinary practice, contingent for its cogency on its explicit or implicit linkages with its twin. I also argued that historiographic accounts of the development of art history and museology that narrativize their histories so as to construe their institutional formations as the contingent effects of preexistent theories have proved to be as deadly as they are fictive. As I've tried to show, they recapitulate precisely the phantasmatic syntax of the modernist self, imputing to its institutional and discursive effects, its *capta,* the status of *data.*

My original plan for this series of lectures had them ending with a consideration of an institution whose ostensible subject matter was that which has been taken canonically as being beyond representation; namely, the United States Holocaust Memorial Museum in Washington, D.C. What remains of that original plan is in large part the title of today's lecture, namely, "The Limit(s) of (Re)presentation," with its none too subtle poststructuralist parenthesizing of the "Re" of representation.

But on the way to this week's talk, several things happened to alter that original plan. Perhaps the most dramatic event was the one recounted in my fourth lecture ("Romulus, Rebus, and the Gaze of Victoria"), namely, how my photographing of that museum in preparation for this lecture was derailed by my discovery of a photo of my father in the permanent exhibition. This then triggered a consideration of the issues I discussed in that talk, in particular our prying apart of Derrida's critique of the archival act in its relationship to bodily inscription, genital mutilation, and gender formation.

But I haven't abandoned the issues and problems that were raised quite powerfully by the Washington museum. Not the least of its effects is a shattering of the crystallizations instantiated by the Great Exhibition of 1851. I'll talk in a moment about what I mean by this claim. But I do

not mean to suggest that there can be no museology, no art history, after Auschwitz; rather, what was rendered impossible—which is what is precisely ostensified in the Washington museum—is an unambiguous belief in the possibility of representation itself in the first place, and a consequent reopening of the problematics of the subject; of a self, one that (as I've tried to sketch out here) reaches back to reconnect with some of what was buried and rendered ghostly by the institutions and practices we've been discussing, but nonetheless continues to haunt us. This ghost of a lost wisdom of the subject lost in a world of objects; a world in which the metronomic oscillation of (to cite but one example or allomorph) *being* a body and *having* a body was not an either-or proposition but a creative tension of the both-and, in the sense that became familiar in our consideration of Soane. I'll delve more deeply into this in a moment. But once again I do not mean to claim a direct descent or straight line from Winckelmann to Auschwitz, however tempting that continues to be for some. I do mean to suggest that the modernist conflation of aesthetics and ethics has historically entailed the kind of social dream work that has resulted in not a few holocausts, and by no means only in Europe.

I've tried here to ostensify and exhibit what might in shorthand be termed a counterrepresentationist and counterhistoricist methodology (please note my successful sidestepping of the "post") regarding both art and its institutions, by using them instrumentally to reckon with. I've also tried to exemplify my argument in the manner of my presentations as well as in their contents, to use a familiar but not unproblematic distinction. My motivations for doing so have as much to do with the need to get past the poverties of contemporary art historical theory and criticism as a service industry of globalized capital as with the pressing need to radically rework the expectations of interpretation itself in such a world.

To put it bluntly, what I want to do here is propose a new framework for constru(ct)ing what I'll call the psycho-semiotic foundations of artistic production and reception—how things mean, in other words, and what the responsibilities of the historian and critic might be or could be today.

So let's jump into the thick of things straightaway.

In "The Astrolabe of the Enlightenment" I spoke at some length about the climactic confrontation staged at and as the heart, the epistemological,

artifactual, and conceptual core, of Sir John Soane's Museum—that astonishing confrontation between (the bust of) (the) John Soane and (the cast of) (the) Apollo Belvedere. I spoke of this scenography as ostensifying certain key tenets of Freemasonry, which I argued was a key element and motivating force in the foundation of virtually all public museums in Europe and America in the late eighteenth and early nineteenth centuries: the ground zero of museology as we know it today. We considered the position of Soane, in the person of his bust at the east side of the two-story skylighted atrium known as the Dome, as ostensifying the place and persona of a genius loci, of the *punctum* or point from which, as if from the point of resolution in a figural painting, everything you can see and remember of the place falls into its proper system or syntax of relationships. Like the central piazza in an ideal city plan, from this central point all things fall into their proper place relative to each other and to the position of the viewer, whose simulacrum or stand-in, whose alter ego, is Soane's bust, the sculptural fiction of John Soane, architect. The persona of what we as visitors shall have been for what, during the course of our wandering in this maze of part objects and half-truths, and like Soane himself, we were in the process of becoming.

What we considered, in other words, was the scenography of Soane's Museum and of his confrontation with Apollo across the three-story Dome at whose bottom lies the sarcophagus of Seti I, the emblem of the death and burial of the ego as a necessary prerequisite to enlightenment—itself signaled by the vertical increase in illumination climaxing in the brilliant vaulted dome of white light above. Here we'll consider what that scenography itself implies: that is, the dramaturgy of the place—what was only hinted at earlier in our investigation of the museum and its significance as a thought piece and a catalyst for a substantive rethinking of art historicism and museology, for getting beyond what I might call the psycho-semiotic double bind of aesthetics (about which you may recall the words of Giorgio Agamben that I quoted in the first essay). The eighteenth-century invention of aesthetic philosophy constituted not simply the springboard of the modern discourse on art and visual culture but its foundational dilemma.

In looking now at all this, I'd like to call attention to some of the vocabulary I've been using, in particular the term "ostensify." I've been using this word a lot. In fact, I've not been using it as a fancy alternative to "showing" or "revealing." I've been using it in a fairly strict fashion, to indicate a mode of signification that in modern linguistics and semi-

ology is commonly considered to lie outside the referential structure of sign types such as icon, index, and symbol—that tripartite system of sign types; that is, the three modes of relationship between signifiers and signifieds foregrounded in the work of Charles Sanders Peirce that are commonly taken to cover the range of possible sign relations.[1]

By contrast, ostensification was taken to be a mode of dumb and direct presentation as such, of simple showing. But I would like to argue that what is commonly reduced to being taken as simple showing is often a mask for a whole complex set of significative relationships particularly pertinent for understanding the fabrication of visual meaning. The linguist and semiotician Roman Jakobson demonstrated that Peirce's tripartite sign system of icon, index, and symbol actually resolved itself into two clear sets of relational oppositions, which then became the basis in the subsequent decade and a half for articulating in both literature and the graphic arts the so-called Klein set of logical relations.[2]

A good example of this work in art history was that of Rosalind Krauss and some of the writers associated with the New York art journal *October,* of which she was cofounder, and which became notable for its introduction of then-recent texts by French critical theorists to American art critics and historians.[3] But I don't want to pursue those attempts or the sad fate of postmodernist theory in art history and museology or of the antiaesthetic aesthetic of "Octoberist" art history and criticism whose critical thrust had for complicated reasons been derailed by the middle of the 1980s. Nonetheless it would be worthwhile to pick up again what looked at the time as if it would become an entirely new line of critical thinking about visual signification, by returning to the largely unacknowledged source of that old postmodernist critique, namely, Jakobson's critique of modern linguistics, semiotics, and poetics.

What Jakobson did in the lecture I referred to was to demonstrate something that, because of time, I will just briefly summarize here; namely, that index and symbol occupy the two poles of a single conceptual axis, one related to relationships of contiguity or metonymy, and that the two poles represent an opposition between what he called "factual" and "imputed" (or conventional or virtual) relations between signifiers and what they signify.

On the complementary level or axis of sign relations, "icon" could be seen to occupy the cross-axis of factual relations between things, but it implies its own complement on the same axis of relationships of similarity

or metaphoric relations. In other words, there is a missing term in the equation: a sign type that indicates relationships of "imputed similarity." Jakobson arrived at this through an extensive investigation of visual imagery in nineteenth- and twentieth-century poetry in English and in Russian. But the foundations of this had already been laid down in Prague in the 1930s when Jakobson was associated with a remarkable group of philosophers, artists, linguists, poets, and architects collectively known as the Prague school. He termed this fourth mode of signification "artifice," which corresponds to some of what I've been referring to from time to time as "ostensification" (Figure 40).

Jakobson never published very much about visual signification as such, except for a good deal of writing about early cinema, but that was in the 1920s and 1930s. Nor did he ever publish anything about artifice in the visual realm. But I did have the occasion to interview him extensively about this during a time when we were both visiting fellows at a residential retreat for artists and writers on Ossabaw Island, near Savannah off the coast of Georgia, in the early 1980s. In the course of conversations that lasted over several weeks, we tried to flesh out the implications of what he saw as the central flaw in Peircean semiology, both for language and poetics on his part and for art and architecture on mine.

Those conversations were not recorded (except in my notebooks), nor have they been published, and I've not followed up on this extensively until the past decade, when my work on the foundations of early art his-

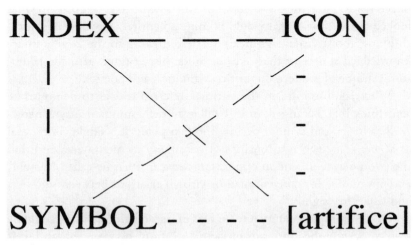

Figure 40. Diagram of sign types and interrelationships.

tory and museums began to put me back in touch with aspects of ancient and medieval philosophy and rhetoric, in particular the scholastic and Aristotelian traditions. What I want to suggest here is that Jakobson's prying apart of the early-twentieth-century Peircean tripartite paradigm of semiotic forms—since become a kind of orthodoxy in that field—revealed a window back onto an ancient, medieval, and early modern tradition of meaning construction since forgotten or obscured. This is one that in my view may be eminently suitable for understanding and articulating the kinds of semiotic structures that frequently dominate visual or artistic practices. I'll spend a little time exploring this, since, as I hope to show, it relates directly to the critical, historiographic, and theoretical issues we have been dealing with throughout these essays.

My contention is that Jakobson's notion of artifice elicits a mode of rhetorical or semiological practice common in medieval and ancient times—and, as Mary Carruthers has lucidly argued,[4] strikingly divergent from modern practices—with respect to issues of communal memory and meaning construction, whose crucial role is to complete uninformed individual experience. Such a notion was basic to Aristotle's view of politics as the life of the individual completed in society; completed, that is, through the individual subject's access to the historical continuum of communal meaning. Essential to this was a principle of decorum derived from Aristotle's *Nicomachean Ethics,*[5] in which there exists a representational relationship between words and things, or, as the scholastic dictum put it, *veritas est adaequatio verbi et rei* (where *res* can mean not only thing or object but thought, feeling, or opinion).[6]

The key term is the relational one of *adaequatio,* or adequation, which means "fitting" or "adjustment"; it contrasts with the term *aequatio* and its adjective *aequalis,* with the root meaning of "equal" or "identical." The truth—the veritas—in words or things is always one of *adaequatio* or approximation or a tending toward, an as if. *Aequatio* admits only of true or false; by contrast *adaequatio* is not a formal or quantifiable identity but an imputed or virtual likeness between two nonidentities, a going toward (in Greek, this is *pros to ison*). Carruthers in fact observes that *adaequatio* "has more in common with a metaphor or a heuristic use of modeling than with an equal sign."[7]

In other words, it would seem that Jakobson's attempt to isolate the missing fourth part of the modern (tripartite) paradigm of signification—what he named artifice—harks back to the Aristotelian, scholastic, and early humanist mode of significative relationships marked by the term

"adequation." And that suggested by the term I've been using, namely, "ostensification." Or, in a word, the "presentation" root covered by the concept and term of "representation."

What Soane was doing in his "studies for my mind," as he put it, his presentations, his artifice, was that which was historically covered over and displaced by the paradigm of representation. This is the opposition between artifice, in Jakobson's sense, and icon. An iconic sign relationship (and we need to be clear that all of these terms, all these signs, refer to relationships between things, not kinds of things) is primarily one of factual or literal similarity; an artific(i)al sign is one of imputed similarity, of adequation rather than equality. Of course once again these terms are all relative, and in practice objects and things necessarily differ from each other in respect to what kinds of sign relationships are dominant and which are subordinate. All of that can reach a degree of complexity that is beyond the scope of this lecture to more than simply hint at and leave to your imagination.

I have been drawn to this notion of artifice in no small measure because it allows us to deal with the extraordinary complexities—the fluid and open-ended relativities—of visual meaning in a clear yet nonreductive manner. This starkly contrasts with the old attempts to fit visual things into one or another of the three traditional modern sign types of symbol, index, or icon (is a Russian icon an icon, index, or symbol?), which exercised art historians and aesthetic philosophers for so long, and it also contrasts with the decades-long and ultimately unsatisfying attempts to apply a verbocentrist or linguistically based semiotic model or theory to art (is this wall a phoneme, a morpheme, or a whole text?).

I say this from my own early experience with the rise and ultimate petering out of visual semiotics and in particular the semiotics of art and architecture. Or rather, its running into a brick wall with no apparent way through the reductivist verbocentric models of semiology current well into the 1980s, which with only one or two exceptions constituted attempts to apply the categories of linguistic signification to visual practices.[8] It should be remembered that among those calling for an intensive investigation of signification in art and architecture on its own terms rather than importing categories from linguistics was Ernst Gombrich himself, in his A. W. Mellon Lectures at the National Gallery in Washington, some four decades ago.[9]

The notion of artifice and of its correlative relationships of adequation, ostensification, decorum, and presentation may also allow us to

articulate the coconstructedness of visual objects, their frequently open-ended signification, and their uniquely subtle and dynamic stagings of communal memory and meaning. It may also allow us to appreciate more clearly what the object permanence of objects allows or entails in regard to why things may seem to have a significance that transcends the time and place of their origins or production—thereby deconstructing the long-standing disciplinary oppositions, the double bind, if you will, between an old social history of art that claimed that the true meaningfulness of a work is fixed and localized in its original circumstances of production and reception, and critical histories and theories of art grounded in the investigation of the "afterlife" of works and their dynamically evolving pertinence and individually and collectively constructed and reconstructed meanings.

It is precisely here that we may begin to understand, finally and succinctly, the nature of the dramaturgy behind the extraordinary scenography of John Soane's practice, and, I would quietly suggest, the manner by which visual objects, visual artifacts, can in fact serve as the ground, basis, stage, scene, or site of communal memory and meaning production, as the locus of working on memory and meaning as processes of adequation. The reason why art is so commonly misunderstood is because it is naively taken to represent an answer to something that only its maker really knows, when in fact artworks are questions posed and adequations mooted, soliciting engagement. Soane knew this very clearly and tried to stage the dramaturgy of meaning so as to put us in his place. So that, in other words, we may learn to *see*.

What I've been describing and suggesting here is intended equally to pertain to the questions we've been dealing with in regard to the fabrication and maintenance of modern subjectivities. Time here doesn't permit saying much more about this, but it should be clear in what I've been talking about that subjects and objects are mutually entailed, that objects are the occasions for communal entailment among subjects, and that the representational side of the semiotic coin is precisely the denial of these knots and condundrums; these adequations, to return to the mantra with which I began these lectures.

The dilemma of representation is consequently the key problem of art history and museology that perforce admits of no resolution except, I would suggest, by historicizing its deponency, its dependency on an adequation that is its occluded substrate.

Figure 41 shows an exhibit in the Holocaust Memorial Museum in

Washington, D.C., and I would like you to consider that its exhibitionary order is that of artifice rather than representation, a decorum of presenting the unrepresentable.

It's time to conclude.

When I said earlier that modern art history and museology were un-

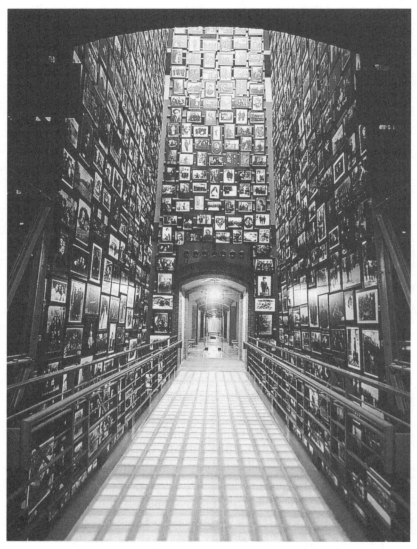

Figure 41. Tower of Faces exhibit, United States Holocaust Memorial Museum, Washington, D.C.

thinkable apart from the context and subtext of a secular theologism that was the co-implicative obverse of a theological aestheticism that imputed authorship to the world taken as an artifact (the two relate to each other like the two poles of an oscillating optical illusion), I meant precisely what I said. Art history has been grounded in the repression of the impossibility of representation. I hope to have made clear that there are indeed alternatives. And that to take up these alternatives entails not only a change of direction in our understanding of how art works but also a reconnection with traditions of aesthetics, philosophy, and rhetoric buried and occluded, at least to art history as an institutionalized discipline, by developments essential to the establishment, legitimization, and maintenance of the modern nation-state.

I began with a quote from Ernst Gombrich and will end with one from Jacques Lacan to sew up both what we have done in this lecture and to reiterate what this series of Slade Lectures has itself sought to ostensify. And as I also used this quote at the beginning of these talks, it will mark our coming full circle. He said, "Certainly, we must be attentive to the 'un-said' that lies in the holes of discourse, but this does *not* mean that we must listen as if to someone knocking on the other side of the wall."[10] You may remember that I once paired this statement by Lacan with an old midrash that says that "praying is turning toward the wall." Of course we invariably *do* listen as if to a hidden voice, and it's in this "as if" that we may begin to appreciate what is most deeply at stake today in understanding art and artifice.

Soane's Apollo—which in Lacanian terms was an instance of the gaze or the *objet petit a* that appears to look back at us from behind the veils of representation, standing in for our desire for coherence in the first place—was an artifice of coherence; an adequation of what the viewer, ostensified in the locus of Soane as genius loci, projected from the position of fragmentation and incoherence (Figure 42). It's commonly forgotten that Lacan also used the term *agalma* for this imaginary and in this case Apollonian point of projection behind things. It is not without some interest; indeed, Lacan's choice of this term is more than an inexplicable curiosity, for the word *agalma* is Greek for statue. It may help us to see Lacan's project about the fabrication and maintenance of the modern self or subject *as* a "statuesque fiction," as in one sense another reflex of the attempt to open a window back to the more complex pre-Enlightenment models of signification that came to be papered over by the paradigm of *re*presentation, ostensified for us here by the Crystal

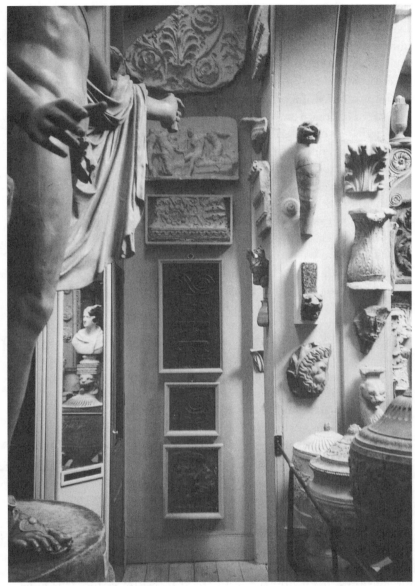

Figure 42. Bust of Soane reflected in mirror to left of Apollo.

Palace in its service of national and imperial capital: what in fact art history came to be for in our modernity, and what it continues, hyperbolically, to be for in our own age of global capital and increasingly feudalized nationalisms. It's now time, finally, to own up to this by putting art history and museology back into their proper historical perspective.

I hope that these theses regarding the nature of artifice, visual meaning, and the notions of adequation and decorum will allow what we've seen throughout these lectures to itself fall into place, and, like Soane on his balustrade, provide us with a clearer sense of how all the pieces relate to each other in the same frame. Like the carpentered pieces making up an Ames Room illusion.

At the very least, the notion of artifice and of adequation may provide us with more solid bases for appreciating what is at stake both in art and in the ignorance of art and its history and prehistory. Seeing through art history, in the double sense of the phrase that has framed these lectures, is a task of collective memory.

Notes

Haunted by Things

1. Jacques Lacan, *Ecrits: A Selection,* trans. Alan Sheridan (New York: W. W. Norton, 1977), 93.

2. Donald Preziosi, *Rethinking Art History: Meditations on a Coy Science* (New Haven: Yale University Press, 1989).

3. Giorgio Agamben, *The Man without Content,* trans. Georgia Albert (Stanford: Stanford University Press, 1999), 6.

4. Plato, *Republic,* trans. Paul Shorey (Cambridge: Harvard University Press, 1953), 2.607c. Discussed in Agamben, *The Man without Content,* 3–5.

5. Arthur Danto, writing in *The Nation,* 1997.

Practicing the Self

1. Discussed in Preziosi, *Rethinking Art History,* 73–77.

2. Sir John Summerson, *What Is a Professor of Fine Art?* (Hull: University of Hull, 1961), 17.

3. On which see D. Preziosi, "Putting Up (with) Meaning," *Oxford Art Journal* 13, no. 2 (1990): 121–24.

4. Cyril Stanley Smith, *A Search for Structure* (Cambridge: MIT Press, 1981), 327.

5. On which see Judith Butler, *Bodies That Matter: On the Discursive Limits of "Sex"* (New York: Routledge, 1993), esp. chap. 3, "Phantasmatic Identification and the Assumption of Sex," 93–120.

HOLY TERRORS AND TELEOLOGIES

1. A discussion of this issue may be found in the introduction to Donald Preziosi and Claire Farago, eds., *Grasping the World: The Idea of the Museum* (London: Ashgate, 2003).

2. A useful introduction to these issues may be found in D. Preziosi, *Rethinking Art History,* esp. chaps. 4 and 5, 80–155. See also D. Preziosi, *The Art of Art History* (Oxford: Oxford University Press, 1998), esp. chap. 5, 227–76.

3. See Thomas Keenan, "The Point Is to (Ex)Change It: Reading *Capital,* Rhetorically," in *Fetishism as Cultural Discourse,* ed. Emily Apter and William Pietz (Ithaca: Cornell University Press, 1993), 152–85; and William Pietz, "Fetishism and Materialism: The Limits of Theory in Marx," in the same volume, 119–51.

4. On which see Eugenio Donato, "Flaubert and the Quest for Fiction," in *The Script of Decadence* (New York: Columbia University Press, 1993), 64. See also Henry Sussman, "Death and the Critics: Eugenio Donato's *Script of Decadence,*" *Diacritics* 25, no. 3 (fall 1995): 74–87.

5. See D. Preziosi, "Archaeology as Museology," in *The Labyrinth Revisited: Rethinking "Minoan" Archaeology,* ed. Yannis Hamilakis (Oxford: Oxbow Books, 2002).

6. See the interesting hypotheses developed by Whitney Davis in his essay "Winckelmann Divided: Mourning the Death of Art History" (*Journal of Homosexuality* 27, nos. 1–2 [1994]: 141–59, and reprinted in D. Preziosi, *The Art of Art History*) regarding this mode of erotic conflation. If Davis is correct, then Winckelmann's move resonates quite clearly with certain strains of the ancient Europeran arts of memory, in particular the work of *lectio* as propounded by Hugh of St. Victor, who defines such "tropological" interactions with textual entities as that of transforming a text onto and into one's self. See M. Carruthers, *The Book of Memory: A Study of Memory in Mediaeval Culture* (Cambridge: Cambridge University Press, 1990), chap. 5, "Memory and the Ethics of Reading," 156–88, and appendix A, 261–66.

7. On which see D. Preziosi, *Rethinking Art History,* 102.

8. A key nineteenth-century exemplar is the Pitt Rivers Museum in Oxford.

9. It may be asked if certain theoretical positions within the modern academic discipline of art history correspond to different emphases upon one or another dimension of this social and epistemological enterprise.

10. In one sense, these are all solutions to the problem of designing a memory, whether one's own or a machine's. In which case, they represent recent metamorphoses of an ancient and rich European tradition; see Carruthers, *The Book of Memory,* 16–45, and chap. 5, 156–88.

11. On which see Michel de Certeau, "Psychoanalysis and Its History," in *Heterologies,* trans. Brian Massumi (Minneapolis: University of Minnesota Press, 1986), 3–16.

12. On the semiotic status of the disciplinary object as irreducibly ambivalent, see D. Preziosi, "The Question of Art History," *Diacritics* 18, no. 2 (winter 1992): 363–86; and "Collecting/Museums," in *Critical Terms for Art History,* ed. R. Nelson and R. Schiff (Chicago: University of Chicago Press, 1996), 281–91.

13. Lacan, *Ecrits,* 86.

14. On relativism versus relativity, see "The Astrolabe of the Enlightenment," in this volume, on Sir John Soane's Museum (preserved in its final state at Soane's death in 1837) as the first fully realized art historical instance of the latter.

15. Carruthers, *The Book of Memory,* 162.

16. The relationship of early modern portrait sculpture to the practices of late medieval reliquaries and relic veneration is a vexed one. For an introduction to some of the key issues, see Hans Belting, *Likeness and Presence: A History of the Image before the Era of Art,* trans. Edmund Jephcott (Chicago: University of Chicago Press, 1994); Peter Brown, *The Cult of Saints: Its Rise and Function in Latin Christianity* (Chicago: University of Chicago Press, 1981); Caroline Walker Bynum and Paula Gerson, "Body-Part Reliquaries and Body-Parts in the Middle Ages," *Gesta* 36, no. 1 (1997): 3–7; and in the same issue, Barbara Drake Boehm, 8–19, and Cynthia Hahn, 20–31.

ROMULUS, REBUS, AND THE GAZE OF VICTORIA

1. Walter Benjamin, *Illuminations,* trans. Harry Zohn (London: Jonathan Cape, 1970), 257.

2. On the museum itself, see Edward T. Linenthal, *Preserving Memory: The Struggle to Create America's Holocaust Museum* (Harmondsworth: Penguin Books, 1995); Andrea Liss, *Trespassing through Shadows: Memory, Photography, and the Holocaust* (Minneapolis: University of Minnesota Press, 1998); on Holocaust memorials more generally, see James E. Young, *The Texture of Memory: Holocaust Memorials and Meaning* (New Haven: Yale University Press, 1993); also see Dominick LaCapra, *Representing the Holocaust: History, Theory, Trauma* (Ithaca: Cornell University Press, 1994).

3. Italo Calvino, *Invisible Cities,* trans. William Weaver (New York: Harcourt Brace Jovanovich, 1974), 96–97.

4. Jacques Derrida, *Archive Fever: A Freudian Impression,* trans. Eric Prenowitz (Chicago: University of Chicago Press, 1996), 42.

5. See Butler, *Bodies That Matter,* esp. chap. 3, "Phantasmatic Identification and the Assumption of Sex," 93–120.

THE ASTROLABE OF THE ENLIGHTENMENT

An earlier version of this essay appears as "Telling Perspectives: Seeing Soane Seeing You," in *Compelling Visuality: The Work of Art in and out of History,*

ed. Claire Farago and Rob Zwijnenberg (Minneapolis: University of Minnesota Press, 2003).

1. Stephen Bann, *The Clothing of Clio: A Study of the Representation of History in Nineteenth-Century Britain and France* (Cambridge: Cambridge University Press, 1984); *Under the Sign: John Bargrave as Collector, Traveler, and Witness* (Ann Arbor: University of Michigan Press, 1994). See also Mieke Bal, "Telling Objects: A Narrative Perspective on Collecting," in *The Cultures of Collecting,* ed. John Elsner and Roger Cardinal (London: Reaktion Books, 1994), 97–115.

2. Soane's assistant George Wightwick (1853), quoted in Susan Feinberg Millenson, *Sir John Soane's Museum* (Ann Arbor: UMI Research Press, 1987), 117–18.

3. Adolf Michaelis (1882), quoted in Millenson, *Sir John Soane's Museum,* 95.

4. Soane donated his museum to the state with the stipulation that it remain in perpetuity as it was at his death (1837).

5. A good history of Soane's Museum, and the definitive guide to the building and collection, is that of the late former director of the institution, John Summerson, *A New Description of Sir John Soane's Museum,* 7th rev. ed. (London: Trustees of Sir John Soane's Museum, 1991). Millenson, *Sir John Soane's Museum,* and updated version of Susan Feinberg, "An Analysis of the Architect's House-Museum in Lincoln's Inn Fields, London" (Ph.D. diss., University of Michigan, Ann Arbor, 1979), provides a useful introduction to some of the issues surrounding the evolution of the building. The best critical introduction not only to Soane's relationship to the neoclassical tradition in art and architecture in Britain but also to the relationship of early museology to the evolving discourse of aesthetics and art history is Wolfgang Ernst, "Frames at Work: Museological Imagination and Historical Discourse in Neoclassical Britain," *Art Bulletin* 75, no. 3 (September 1993), 481–98; see also John Elsner, "A Collector's Model of Desire: The House and Museum of Sir John Soane," in *The Cultures of Collecting,* ed. John Elsner and Roger Cardinal (London: Reaktion Books, 1994), 155–76; David Watkin, *Sir John Soane: Enlightenment Thought and the Royal Academy Lectures* (Cambridge: Cambridge University Press, 1996); and Pierre de la Ruffiniere du Prey, *John Soane: The Making of an Architect* (Chicago: University of Chicago Press, 1977). On museums and the origin of aesthetics, see Bann, *The Clothing of Clio;* and Jean-Louis Deotte, *Le musee, l'origine de l'esthetique* (Paris: Harmattan, 1993). See John Soane, *Description of the House and Museum on the North Side of Lincoln's Inn Fields, the Residence of John Soane* (London: Sir John Soane's Museum, 1830, 1832, 1835), for a complete description of the museum shortly before Soane's death in 1837. *Soane's Lectures on Architecture: Delivered to the Students of the Royal Academy from 1809 to 1836 in Two Courses of Six Lectures Each,* ed. Arthur T. Bolton (London: Sir John Soane's Museum, 1929), contains his lectures on architecture at the Royal Academy. An excellent recent biography is that of Gillian Darley, *John Soane: An Accidental Romantic* (New Haven: Yale University Press, 1999).

6. Discussed by Ernst in "Frames at Work," 486, in commenting on Soane's own 1812 manuscript (unpublished at the time), "Crude Hints towards a History of My House in Lincoln's Inn Fields," imagining his museum as a future ruin—a text whose allegorical implications recall issues investigated by Walter Benjamin in his study of the German mourning play, or *Trauerspiel,* in *The Origin of the German Tragic Drama* (London: Verso, 1977).

7. The principal exception to this, and still the most perceptive study of Soane's relationships specifically to early museology, aesthetics, and art history, is Ernst, "Frames at Work." Excellent discussions of the museum's architecture may be found in John Summerson, *Sir John Soane, 1753–1837* (London: Art and Technics, 1952), and his *New Description of Sir John Soane's Museum;* John Summerson, David Watkin, and G. Tilman Mellinghoff, *John Soane* (London: Academy Editions Monograph, 1983); Arthur T. Bolton, *The Works of Sir John Soane, F.R.S., F.S.A., R.A. (1753–1837)* (London: Sir John Soane's Museum, 1924); Dorothy Stroud, *Sir John Soane, Architect,* 2d ed. (Boston: Faber and Faber, 1996); and George Teyssot, "John Soane and the Birth of Style," *Oppositions: A Journal for Ideas and Criticism in Architecture* 14 (1978): 67–75.

8. Unless otherwise noted, all illustrations are by the author.

9. Andrew Ramage and Nancy Ramage, *Roman Art: Romulus to Constantine* (Englewood Cliffs: Prentice Hall, 1991), 121–49.

10. Summerson, *A New Description of Sir John Soane's Museum,* 22–30. Perhaps the most famous paintings in the room are William Hogarth's two series, *A Rake's Progress* (1732–1733) and *An Election* (1754), the former purchased by Mrs. Soane at Christie's in 1802.

11. A good example being Adolf Michaelis, *Ancient Marbles of Great Britain,* trans. C. A. M. Fennell, 2 vols. (Cambridge: Cambridge University Press, 1882).

12. See Ernst, "Frames at Work," 486.

13. On the origins and history of which see Henry Shelly, *The British Museum: Its History and Treasures* (Boston: L. C. Page, 1911); Mordaunt J. Crook, *The British Museum: A Case-Study in Architectural Politics* (London: Allen Lane, 1972); Marjorie Caygill, *The Story of the British Museum* (London: British Museum Publications, 1981); and Edward Miller, *That Noble Cabinet: A History of the British Museum* (London: Deutsch, 1973). On the Louvre, see Andrew McClellan, *Inventing the Louvre: Art, Politics, and the Origins of the Modern Museum in Eighteenth-Century Paris* (Cambridge: Cambridge University Press, 1994).

14. On which see Douglas Crimp, *On the Museum's Ruins* (Cambridge: MIT Press, 1993); Donald Preziosi and Claire Farago, eds., *Grasping the World: The Idea of the Museum* (London: Ashgate Press, 2003); and Donald Preziosi, "Museums/Collecting," in *Critical Terms for Art History,* ed. Robert Nelson and Richard Shiff (Chicago: University of Chicago Press, 1996).

15. Summerson, *A New Description of Sir John Soane's Museum,* 17; Millenson, *Sir John Soane's Museum,* 103–4. The increasingly precarious pasticcio,

which included a "Hindu" capital among Greek and Roman pieces, was dismantled in 1896.

16. Summerson, *A New Description of Sir John Soane's Museum*, 48. The cast was made for Lord Burlington and stood in his villa at Chiswick until given to the architect John White, who in turn gave it to Soane, who installed it in the Dome in 1811.

17. Giovanni Belzoni, *Narrative of the Operations and Recent Discoveries within the Pyramids, Temples, Tombs, and Excavations in Egypt and Nubia* (London: J. Murrary, 1820); Summerson, *A New Description of Sir John Soane's Museum*, 41–43; Millenson, *Sir John Soane's Museum*, 88, 101–2.

18. Summerson, *A New Description of Sir John Soane's Museum*, 41. Soane's arrangement of the basement crypt was influenced by Belzoni's "Egyptian Exhibit" at Piccadilly Hall in 1821, according to Millenson, *Sir John Soane's Museum*, 101. See also David Watkin, "Freemasonry and John Soane," *Journal of the Society of Architectural Historians* 54, no. 4 (December 1995): n. 7. That exhibition included a replica of the Seti sarcophagus, the original being in the possession of the British Museum's trustees as that institution was contemplating its purchase. Soane bought it once the British Museum rejected it because of cost.

19. Summerson, *A New Description of Sir John Soane's Museum*, 19. In 1813 Soane was appointed grand superintendent of works at the United Fraternity of Freemasons. On Soane's relationship to Freemasonry, see Watkin, "Freemasonry and John Soane"; Darley, *John Soane: An Accidental Romantic*, 222–23; and John Taylor, "Sir John Soane: Architect and Freemason," *Ars Quatuor Coronatorum* 95 (1983): 194–202. On the United Grand Lodge building, see James Stubbs and T. O. Hauch, *Freemasons' Hall: The Home and Heritage of the Craft* (London: United Grand Lodge of England, 1983). On Freemasonry in England more generally, see W. Kirk MacNulty, *Freemasonry: A Journey through Ritual and Symbol* (London: Thames and Hudson, 1991); James Stevens Curl, *The Art and Architecture of Freemasonry* (Woodstock, N.Y.: Overlook Press, 1993); Colin Dyer, *Symbolism in Craft Freemasonry* (London: Ian Allen, 1986); Margaret Jacob, *Living the Enlightenment: Freemasonry and Politics in Eighteenth-Century Europe* (Oxford: Oxford University Press, 1991); J. A. Leo Lemay, ed., *Deism, Masonry, and the Enlightenment: Essays Honoring Alfred Owen Aldridge* (London and Toronto: Associated University Presses, 1987); and R. Wiolliam Weisberger, *Speculative Freemasonry and the Enlightenment: A Study of the Craft in London, Paris, Prague, and Vienna*, East European Monographs no. 367 (New York: Columbia University Press, 1993). On relationships between Enlightenment architecture and Freemasonry, see Joseph Rykwert, *The First Moderns: The Architects of the Eighteenth Century* (Cambridge: MIT Press, 1980); and Anthony Vidler, *The Writing of the Walls* (Princeton: Princeton University Press, 1987).

20. Bann, *The Clothing of Clio;* and his "The Sense of the Past: Image, Text, and Object in the Formation of Historical Consciousness in Nineteenth-

Century Britain," in *The New Historicism,* ed. H. Vesser (New York: Routledge, 1989).

21. The classic study of such episodic chains is Carol Duncan and Alan Wallach, "The Museum of Modern Art as Late Capitalist Ritual: An Iconographical Analysis," *Marxist Perspectives* (winter 1978): 28–51.

22. Millenson, *Sir John Soane's Museum,* 106–18, cites a number of published observations, including some appearing in the contemporary *Penny Magazine,* on which see also Elsner, "A Collector's Model of Desire," 160.

23. Alexandre Lenoir, *Musee des monuments français,* 8 vols. (Paris: Imprimerie de Guilleminet, 1800–1821), and his *La franche-maconnerie rendre à sa veritable origines, ou, L'antiquite de la franche-maconnerie* (Paris: Fournier, 1814); Watkin, "Freemasonry and John Soane," 404, and his *Sir John Soane;* see also Vidler, *The Writing of the Walls,* 167–73, on Lenoir's Museum of French Monuments.

24. Discussed in A. V. Simcock, "Part II: A Dodo in the Ark," in *Robert T. Gunther and the Old Ashmolean,* ed. A. V. Simcock (Oxford: Museum of the History of Science, 1983), 77. See also C. H. Josten, *Elias Ashmole (1617–1692): His Autobiographical and Historical Notes, His Correspondence, and Other Contemporary Sources Relating to His Life and Work,* 5 vols. (Oxford: Clarendon Press, 1966).

25. A useful introduction to the literature on Schinkel's museum may be found in Crimp, *On the Museum's Ruins,* 292–302; see also Jacob, *Living the Enlightenment,* for a general background on continental Freemasonry, including Germany and the Low Countries.

26. The best critical introduction to early museums in the United States and their Masonic connections is Ellen Fernandez Sacco "Spectacular Masculinities: The Museums of Peale, Baker, and Bowen in the Early Republic" (Ph.D. diss., UCLA, 1998), chap. 4. The Masonic skeleton of American revolutionary institutions is quite clear, albeit largely forgotten today.

27. Claude Nicolas Ledoux, *L'architecture considerée sons le rapport de l'art, des moeurs, et de la legislation* (Paris: H. L. Perronneau, 1804); Lenoir, *La franche-maconnerie rendre à sa veritable origines.* See also Watkin, "Freemasonry and John Soane," 402.

28. Macnulty, *Freemasonry,* 15–32.

29. A useful discussion of tracing-board symbolism may be found in MacNulty, *Freemasonry.*

30. MacNulty, *Freemasonry,* 28–33.

31. On the narratological nature of collecting, see Bal, *Telling Objects,* 97–115.

32. John Soane, *The Union of Architecture, Sculpture, and Painting: Exemplified by a Series of Illustrations, with Descriptive Accounts of the House and Galleries of John Soane* (London: John Britton, 1827); on which see John Summerson, "The Union of the Arts," *Lotus International* 35, no. 2 (1982).

33. Donald Preziosi, "The Crystalline Veil and the Phallomorphic Imaginary," *The Optics of Walter Benjamin, De-, Dis-, Ex-,* no. 3 (1999): 120–36.

34. Donald Preziosi, *The Art of Art History* (Oxford: Oxford University Press, 1998), 507–25; Preziosi, "Museums/Collecting," 281–91; and the introduction to Preziosi and Farago, *Grasping the World.*

THE CRYSTALLINE VEIL AND THE PHALLOMORPHIC IMAGINARY

1. [Caroline Leigh Smith Gascoigne], *Recollections and Tales of the Crystal Palace* (London: Shoberl, 1852), 3–6. This remarkable 150-page poem by the author of the previously published *Belgravia, A Poem,* is divided into six parts, devoted, respectively, to an overview of the year of the Great Exhibition from its opening on 1 May to its autumn close, morning in the Crystal Palace (with the joyous arrival of the Queen), a discussion of the building's resemblance to great edifices of ice seen by Arctic mariners, the lamentation of a mother for her daughter lost in the crowds, a description of the progress of two anonymous persons through the exhibition one day, and closing with a discussion of "the ties that exist between a great Author and those of his Readers who appreciate his works" (137). See the excerpt quoted at the end of this essay. The Crystal Palace opened on 1 May 1851 and closed on 12 October, 165 days later. Earlier versions of this essay were presented as lectures at Central St. Martin's School of Art, University of London; New York University's Kevorkian Middle Eastern Studies Center; and the School of Architecture, University of California at Berkeley, in 2000.

2. These issues are taken up at length in my *The Art of Art History: A Critical Anthology,* especially in the essay "The Art of Art History," 507–25.

3. A useful introduction to the building and to a representative sample of both older and more recent literature is John McKean, *Crystal Palace: Joseph Paxton and Charles Fox* (London: Phaidon, 1994). See also *The Crystal Palace Exhibition: Illustrated Catalogue* (London: Crystal Palace, 1851); Christopher Hobhouse, *1851 and the Crystal Palace* (New York: E. P. Dutton, 1937); and Marshall Berman, "The Crystal Palace: Fact and Symbol," in *All That Is Solid Melts into Air* (New York: Simon and Schuster, 1982), 235–48. An earlier version of the present essay appeared under the title "The Crystalline Veil and the Phallomorphic Imaginary: Walter Benjamin's Pantographic Riegl," *De-, Dis-, Ex-,* no. 3 (1999), devoted to "The Optic of Walter Benjamin," 120–36.

4. Sigmund Freud, *The Standard Edition of the Complete Psychological Works,* ed. James Strachey, vol. 21 (London: Hogarth Press, 1953–1974), 36.

5. See Tony Bennett, "Pedagogic Objects, Clean Eyes, and Popular Instruction: On Sensory Regimes and Museum Didactics," *Configurations* 6, no. 3 (1998): 345–71; and Paula Findlen, *Possessing Nature: Museums, Collecting, and Scientific Culture in Early Modern Italy* (Berkeley and London: University of California Press, 1994), 100–109.

6. The best introduction to the interrelations between art and consumer-

ism, and a comparative critical history of the British Museum and Selfridfge's department store in London, is Neil Cummings and Marysia Lewandowska, *The Value of Things* (Boston: Birkhauser, 2000).

7. As recorded in McKean, *Crystal Palace,* 42.

8. On the history of art as an inescapably Orientalist enterprise, see my "The Art of Art History."

9. My perspectives here are indebted to the work of, and to work in the wake of, Luce Irigaray. See the special issue of *Diacritics* 28, no. 1 (1998), devoted to her work, and especially the article by Anne-Emmanuelle Berger, "The Newly Veiled Woman: Irigaray, Specularity, and the Islamic Veil," 93–119; and see also Luce Irigaray, "The Blind Spot of an Old Dream of Symmetry," in *Speculum of the Other Woman,* by Luce Irigaray, trans. Gillian C. Gill (Ithaca: Cornell University Press, 1985), 41–68.

10. Walter Benjamin, *Das Passagen-Werk,* ed. Rolf Tiedemann, vol. 5 of *Gesammelte Schriften,* ed. Rolf Tiedemann and Hermann Schweppenhausen, with the collaboration of Theodor W. Adorno and Gerschom Scholem (Frankfurt: Suhrkamp, 1982), 494.

11. Michel Breal, "Les idées latentes du langage," in *Melanges de mythologie et de linguistique* (Paris: Hachette, 1887), 321. Regarding affinities between latenineteenth-century linguistic and art historical theories (and theoreticians), see D. Preziosi, *Rethinking Art History,* 80–121.

12. Among many useful introductions to Lacanian psychoanalytic theory, one of the more lucid for our purposes is Joan Copjec's *Read My Desire: Lacan against the Historicists* (Cambridge: MIT Press, 1994), esp. chap. 2, "The Orthopsychic Subject: Film Theory and the Reception of Lacan," 15–38, and chap. 8, "Sex and the Euthanasia of Reason," 201–36.

13. Cited in Susan Buck-Morss, *The Dialectics of Seeing: Walter Benjamin and the Arcades Project* (Cambridge: MIT Press, 1989), 324 and n. 137.

14. On relationships between the origins of the modern museum movement in the late eighteenth century and European Freemasonry, particularly in Britain and France, see "The Astrolabe of the Enlightenment," in this volume.

15. Alois Riegl, "Kunstgeschichte und Universalgeschichte," in *Gesammelte Aufsaetze* (1898; Augsburg: Dr. B. Filser, 1929), 7.

16. Henri Focillon, *Vie des formes,* 3d ed. (Paris: Presses Universitaires de France, 1947), 82–83. English translation: *The Life of Forms in Art,* 2d ed., trans. Charles Beecher Hogan and George Kubler (New York: Wittenborn, 1948).

17. Arnold Hauser, *The Philosophy of Art History* (London: Routledge and Keegan Paul, 1958), 162.

18. See Preziosi, *Rethinking Art History,* 88–90, 115–16.

19. *Recollections and Tales of the Crystal Palace,* 34–35.

20. My use of the term "orthopsychic" is indebted to the work of Joan Copjec.

THE MUSEUM OF WHAT YOU SHALL HAVE BEEN

1. I owe this image to a fine paper by Zeynip Celik, "'Islamic' Architecture in French Colonial Discourse," presented at the 1996 UCLA Levi Della Vida Conference, Los Angeles, 11 May 1996. See Celik's *Displaying the Orient: Architecture of Islam at Nineteenth-Century World's Fairs* (Berkeley and Los Angeles: University of California Press, 1992), esp. 70–71, 90–91. The images referred to are reproduced on pp. 90–91, originally having been published in the exposition's official guidebook of 1900, *Exposition universelle internationale de 1900, vues photographiques* (Paris: Exposition universelle, 1900). On the sublime, see Jacques Derrida, "The Colossal," part 4 of "Parergon," in his *The Truth in Painting,* trans. Geoff Bennington and Ian McLeod (Chicago: University of Chicago Press, 1987), 119–47.

2. On individuals as/on exhibit, see Timothy Mitchell, *Colonising Egypt* (Cairo: American University in Cairo Press, 1988); and Meg Armstrong, "'A Jumble of Foreignness': The Sublime Musayums of Nineteenth-Century Fairs and Expositions," *Cultural Critique,* no. 23 (winter 1992–1993): 199–250. In the latter is a fascinating discussion of the exhibition of a living Turk.

3. Which can be discovered or unearthed in the "best" of, say, the carvings of the Inuit peoples, or in Aboriginal bark paintings, and can be marketed as such: as "classic" examples of a (native) genre. The marketing itself constitutes a mode of canonizing and classicizing of the "typical," which characteristically feeds back on the contemporary production of marketable typical (i.e., classical) examples of a (reified) genre.

4. On Charles Eliot Norton and the founding of a Ruskinian Department of Fine Arts at Harvard, see D. Preziosi, *Rethinking Art History,* 73–74.

5. See Thomas Keenan, "The Point Is to (Ex)Change It: Reading Capital, Rhetorically," in Apter and Pietz, *Fetishism as Cultural Discourse,* 152–85; and that of William Pietz in the same volume, "Fetishism and Materialism: The Limits of Theory in Marx," 119–51.

6. On the question of the archive, see Michel Foucault, *The Archaeology of Knowledge,* trans. A. M. Sheridan Smith (New York: Pantheon Books, 1972), esp. part 3, "The Statement and the Archive," 79–131. Also see Jacques Derrida, "Archive Fever: A Freudian Impression," *Diacritics* 25, no. 2 (summer 1995): 9–63; and *Archive Fever: A Freudian Impression,* trans. Eric Prenowitz (Chicago: University of Chicago Press, 1996).

7. On which see Eugenio Donato, "Flaubert and the Quest for Fiction," in *The Script of Decadence* (New York: Columbia University Press, 1993), 64; and Henry Sussman, "Death and the Critics: Eugenio Donato's *Script of Decadence,*" *Diacritics* 25, no. 3 (fall 1995): 74–87. On collection as narration, see Mieke Bal, "Telling Objects: A Narrative Perspective on Collecting," in Elsner and Cardinal, *The Cultures of Collecting,* 97–115.

8. Henri Pieron, "Le Caire: Son esthetique dans la ville arabe et dans la ville moderne," *L'Egypte contemporain,* no. 5 (January 1911): 512.

9. Mitchell, *Colonising Egypt.*

10. See Steve Pile, *The Body and the City: Psychoanalysis, Space, and Subjectivity* (New York: Routledge, 1996).

11. Illustrated, for example, in the Skirball Museum in Los Angeles with an exhibition made up of an "archaeological dig," pictured here, which enables children to uncover imitations of ancient Jewish artifacts suspended in an ahistorical and ethnically cleansed sandbox of time.

12. Recently reissued in a facsimile edition of plates, *Description de l'Egypte: Publiée par les ordres de Napoleon Bonaparte* (Cologne: Benedikt Taschen, 1994). The frontispiece is reproduced on p. 34, "Perspective de l'Egypte, d'Alexandrie à Philae."

13. See the discussion of the World's Columbian Exposition of 1893 in Chicago in Celik, *Displaying the Orient*, 80–85.

14. Gustave Le Bon, *Lois psychologiques de l'evolution des peuples*, 12th ed. (Paris: Felix Alcan, 1916). English edition published as *The Psychology of Peoples* (New York: Macmillan, 1898).

15. Pitt Rivers, *The Evolution of Culture, and Other Essays by the Late Augustus Lane-Fox Pitt-Rivers*, ed. J. L. Myers, introduction by Henry Balfour (Oxford: Clarendon Press, 1906).

16. W. J. Loftie, *A Ride in Egypt, from Sioor to Luxor in 1879* (London: Macmillan, 1879).

17. John Reader, "An Odd Collector's Odd Collections," *Smithsonian* 18, no. 4 (July 1987): 116.

THE LIMIT(S) OF (RE)PRESENTATION

1. James Hooper, ed., *Peirce on Signs: Writings on Semiotics* (Chapel Hill: University of North Carolina Press, 1991); Nathan Houser and Christian Kloesel, eds., *The Essential Peirce: Selected Philosophical Writings*, 2 vols. (Bloomington: Indiana University Press, 1992–1998); Kenneth Laine Ketner, ed., *Charles Sanders Peirce: Complete Published Works, including Selected Secondary Materials* (Greenwich, Conn.: Johnson Associates, 1977).

2. See Roman Jakobson, "Linguistics and Poetics," in *Style in Language*, ed. Thomas Sebeok (Bloomington: Indiana University Press, 1960), 360–77; *Coup d'oeil sur le developpement de la semiotique: Rapport à l'ouverture du premier Congres de l'Association internationale de semiotique, Milan, 2 juin 1974* (Bloomington: Indiana University Press, 1975); and *Six Lectures on Sound and Meaning* (Six leçons sur le son et le sens), trans. John Mepham, with a preface by Claude Lévi-Strauss (Cambridge: MIT Press, 1978).

3. See especially Rosalind Krauss, "Sculpture in the Expanded Field," *October* 8 (spring 1979): 31–44. See also A.-J. Greimas and F. Rastier, "The Interaction of Semiotic Constraints," *Yale French Studies* 41 (1968): 86–105.

4. Mary Carruthers, *The Book of Memory: A Study of Memory in Medieval*

Culture (Cambridge: Cambridge University Press, 1990), 24. See also Giorgio Agamben, *Stanzas: Word and Phantasm in Western Culture,* trans. Ronald L. Martinez (Minneapolis: University of Minnesota Press, 1993), esp. 63–158.

5. Aristotle, *Nichomachean Ethics,* ed. and trans. Horace Rackham, Loeb Classical Library (Cambridge: Harvard University Press, 1934), sec. 2.6.

6. See Carruthers, *The Book of Memory,* 295 n. 39, on decorum as an adjustment or adequation of mind to object, discussing Augustine's concept of the sign.

7. Ibid., 26. See also Agamben, *Stanzas,* 141–49.

8. Attempts to model architectural semiotics on internally generated structural relations include Martin Krampen, *Meaning in the Urban Environment* (London: Pion, 1979); D. Preziosi, *The Semiotics of the Built Environment* (Bloomington: Indiana University Press, 1979). See also Jan Mukarovsky, "On the Problem of Functions in Architecture," in *Structure, Sign, and Function: Selected Writings of Jan Mukarovsky,* ed. J. Burbank and P. Steiner (New Haven: Yale University Press, 1978), 236–56, originally published in Prague in the 1930s. A review of some of this literature may be found in Preziosi, *Rethinking Art History,* 122–55.

9. Ernst Gombrich, *Art and Illusion: A Study in the Psychology of Pictorial Representation,* Bollingen Series no. 35, the A. W. Mellon Lectures in the Fine Arts (New York: Pantheon, 1960).

10. Lacan, *Ecrits,* 93.

Index

Donald Preziosi is research associate in art history and visual culture at Oxford University and professor of art history at the University of California, Los Angeles, where he developed and directs the art history critical theory program and the museum studies program. Among his books are *Rethinking Art History: Meditations on a Coy Science; The Art of Art History: A Critical Anthology; Aegean Art and Architecture* (with Louise Hitchcock); *Grasping the World: The Idea of the Museum* (with Claire Farago); and a forthcoming collection of essays, *In the Aftermaths of Art: Aesthetics, Ethics, and Politics.*